Anthony van Dyck: 130 Paintings and Drawings

By Jessica Findle

First Edition

Anthony van Dyck: 130 Paintings and Drawings

Copyright © 2014 by Jessica Findley

Anthony van Dyck

Foreword

Sir Anthony van Dyck (1599 – 1641) was a Flemish Baroque artist who became the leading court painter in England. He is most famous for his portraits of Charles I of England and his family and court, painted with a relaxed elegance that was to be the dominant influence on English portrait-painting for the next 150 years. He also painted biblical and mythological subjects, displayed outstanding facility as a draftsman, and was an important innovator in watercolour and etching. Anthony van Dyck is also considered to be one of the most brilliant colorists in the history of art.

Van Dyck was born on March 22, 1599, in Antwerp, son of a rich silk merchant, and his precocious artistic talent was already obvious at age 11, when he was apprenticed to the Flemish historical painter Hendrik van Balen. He was admitted to the Antwerp guild of painters in 1618, before his 19th birthday. He spent the next two years as a member of the workshop of the Flemish painter Peter Paul Rubens in Antwerp. Van Dyck's work during this period is in the lush, exuberant style of Rubens, and several paintings attributed to Rubens have since been ascribed to van Dyck.

Jessica Findley

From 1620 to 1627 van Dyck traveled in Italy, where he was in great demand as a portraitist and where he developed his maturing style. He toned down the Flemish robustness of his early work to concentrate on a more dignified, elegant manner. In his portraits of Italian aristocrats-men on prancing horses, ladies in black gowns-he created idealized figures with proud, erect stances, slender figures, and the famous expressive "van Dyck" hands. Influenced by the great Venetian painters Titian, Paolo Veronese, and Giovanni Bellini, he adopted colors of great richness and jewel-like purity. No other painter of the age surpassed van Dyck at portraying the shimmering whites of satin, the smooth blues of silk, or the rich crimsons of velvet. He was the quintessential painter of aristocracy, and was particularly successful in Genoa. There he showed himself capable of creating brilliantly accurate likenesses of his subjects, while he also developed a repertoire of portrait types that served him well in his later work at the court of Charles I of England.

Anthony van Dyck

Back in Antwerp from 1627 to 1632, van Dyck worked as a portraitist and a painter of church pictures. In 1632 he settled in London as chief court painter to King Charles I, who knighted him shortly after his arrival. Van Dyck painted most of the English aristocracy of the time, and his style became lighter and more luminous, with thinner paint and more sparkling highlights in gold and silver. At the same time, his portraits occasionally showed a certain hastiness or superficiality as he hurried to satisfy his flood of commissions. In 1635 van Dyck painted his masterpiece, Charles I in Hunting Dress (Louvre, Paris), a standing figure emphasizing the haughty grace of the monarch.

Van Dyck was one of the most influential 17th-century painters. He set a new style for Flemish art and founded the English school of painting; the portraitists Sir Joshua Reynolds and Thomas Gainsborough of that school were his artistic heirs. He died in London on December 9, 1641.

Jessica Findley

Paintings and Drawings

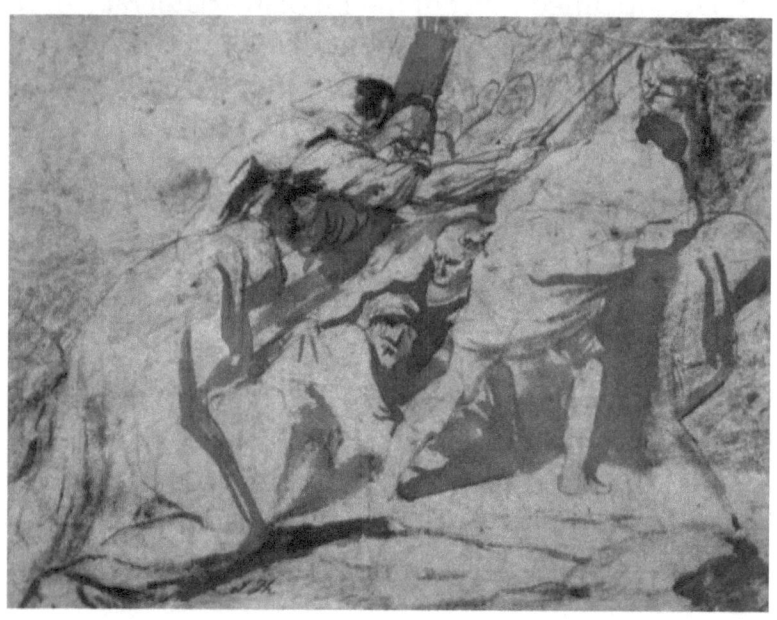

Cross, 1617, Washed pen and ink drawing on white paper

Anthony van Dyck

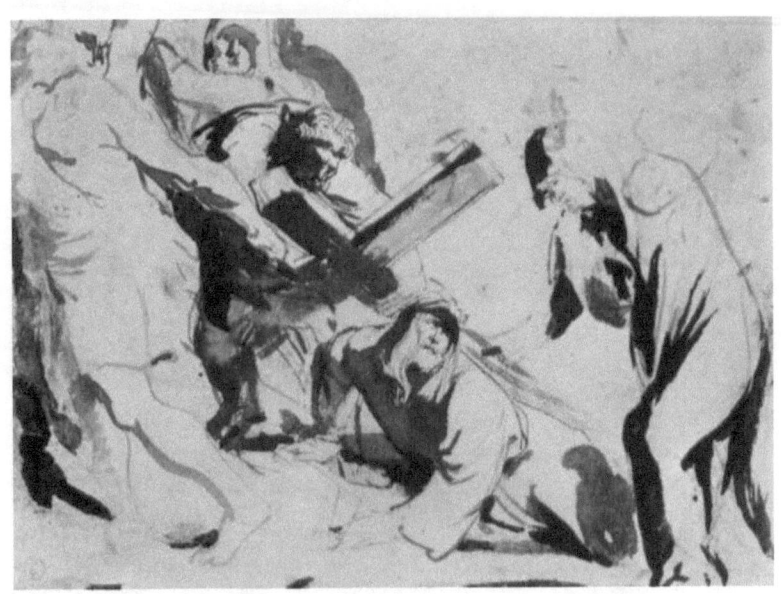

Cross, 1617, sepia wash over pencil

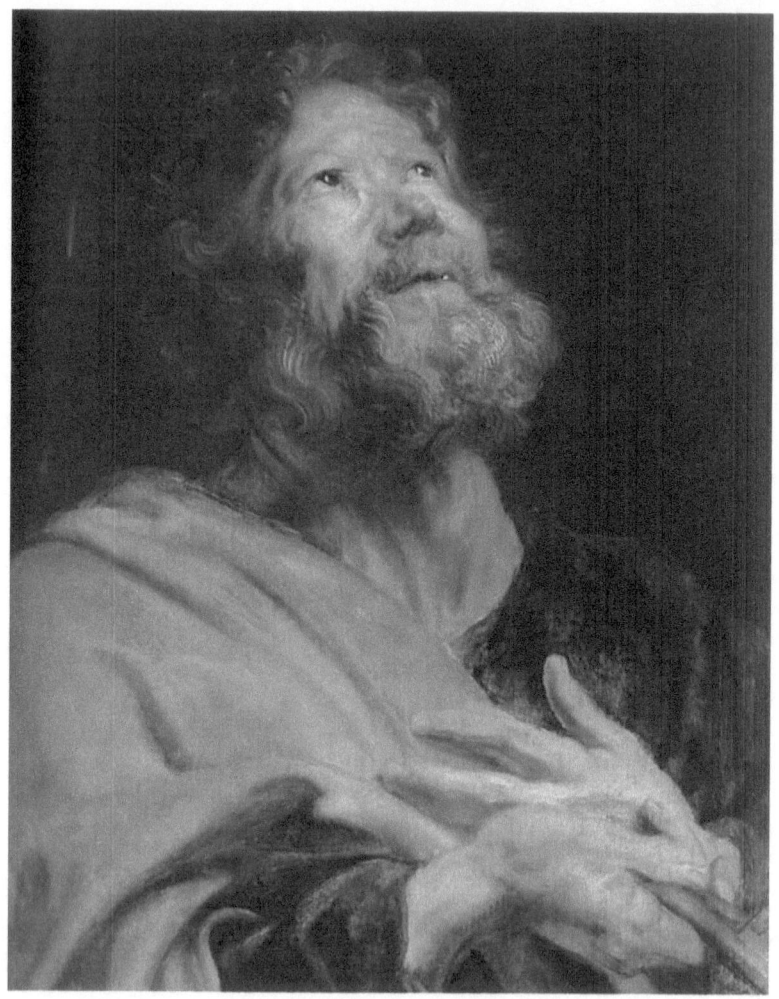

The Penitent Apostle Peter, 1618, oil on canvas

Anthony van Dyck

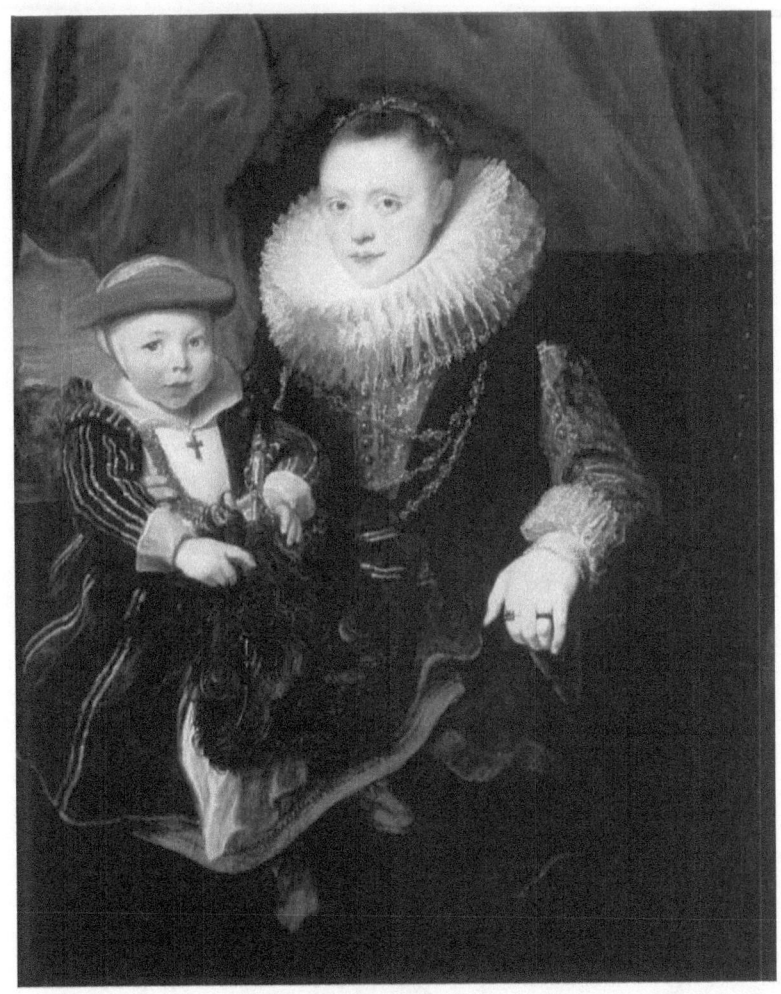

Young Woman with a Child, 1618, oil on canvas

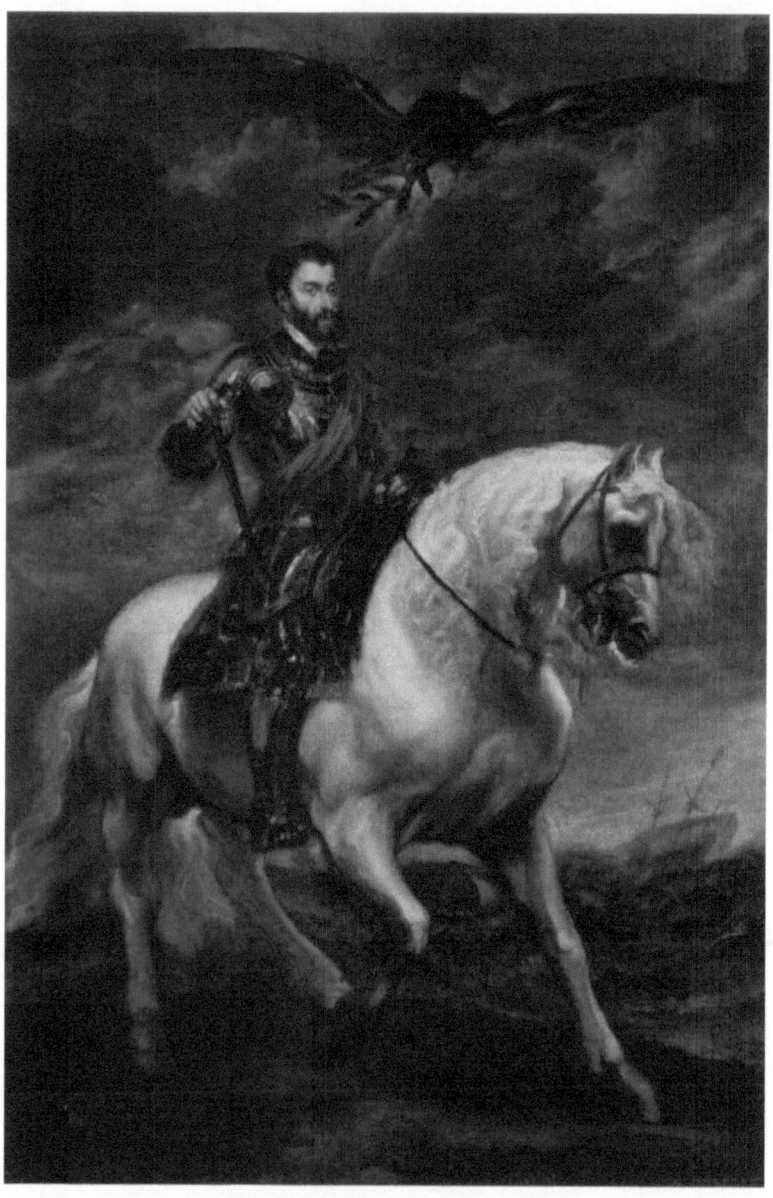

Emperor Charles V on Horseback, 1620, oil on canvas

Anthony van Dyck

Van Dyck was no more than twenty-one when he painted the most important man in Christendom. Charles was precocious too: king of Spain, then Holy Roman emperor before he was twenty. During the religious wars, this Catholic sovereign of much of Europe made peace with the Protestants and captured Rome and the second Medici pope, Clement VII.

Jessica Findley

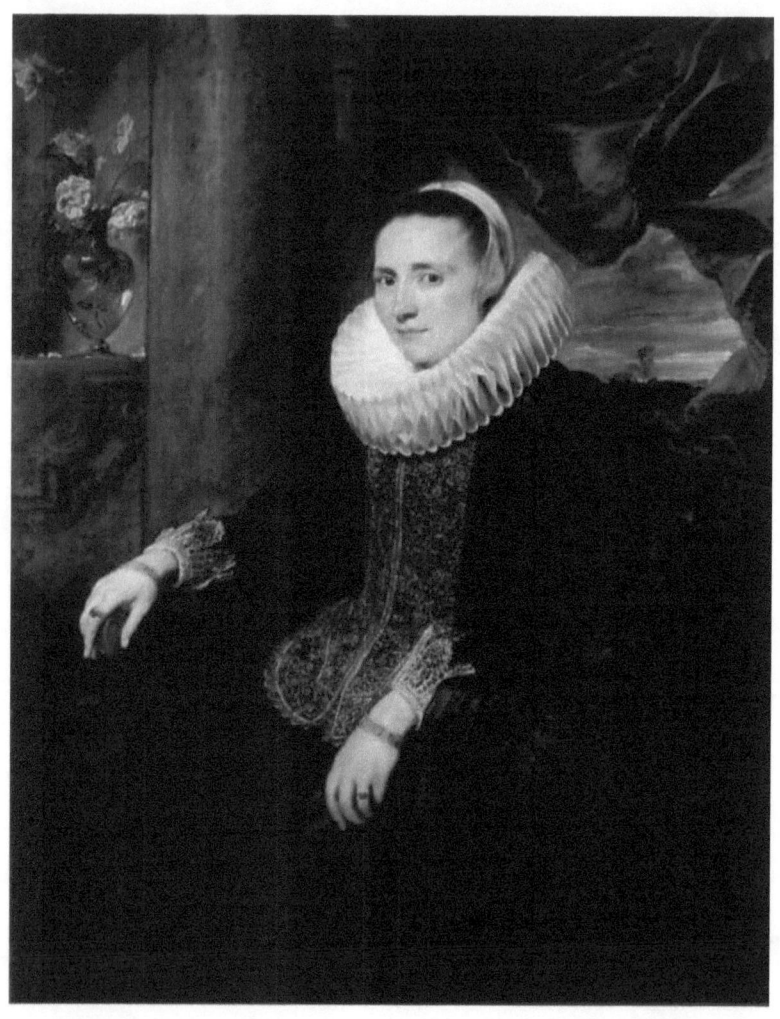

Margareta Snyders, 1620, oil on canvas

Anthony van Dyck

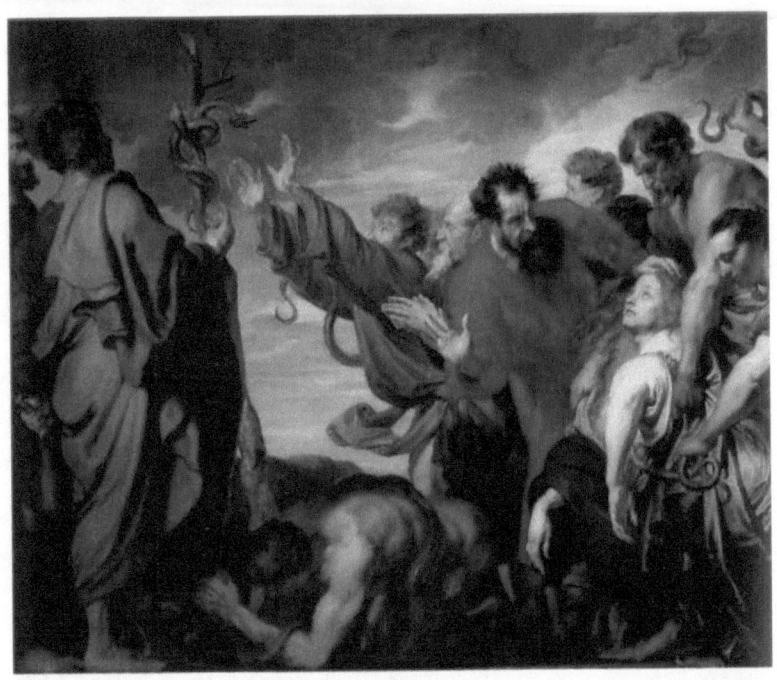

Mozes and the brass snake, 1618, oil on canvas

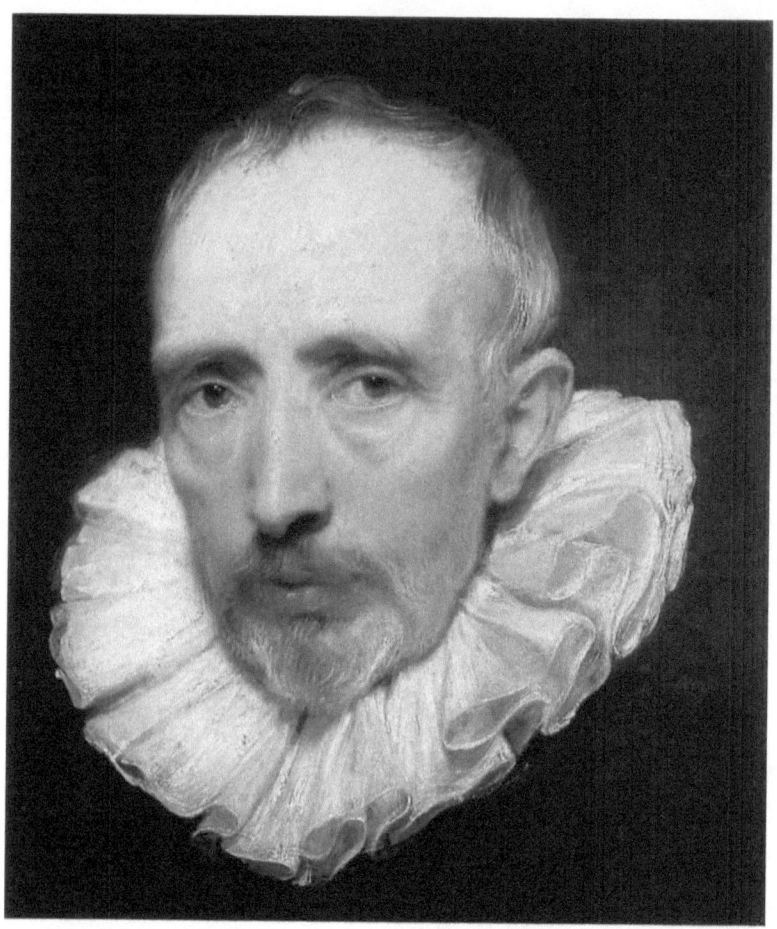

Portrait of Cornelis van der Geest, 1620, oil on canvas

An early work by Van Dyck, pupil of Rubens that time. Cornelis van der Geest was a merchant and art collector in Antwerp, and the friend of Rubens.

Anthony van Dyck

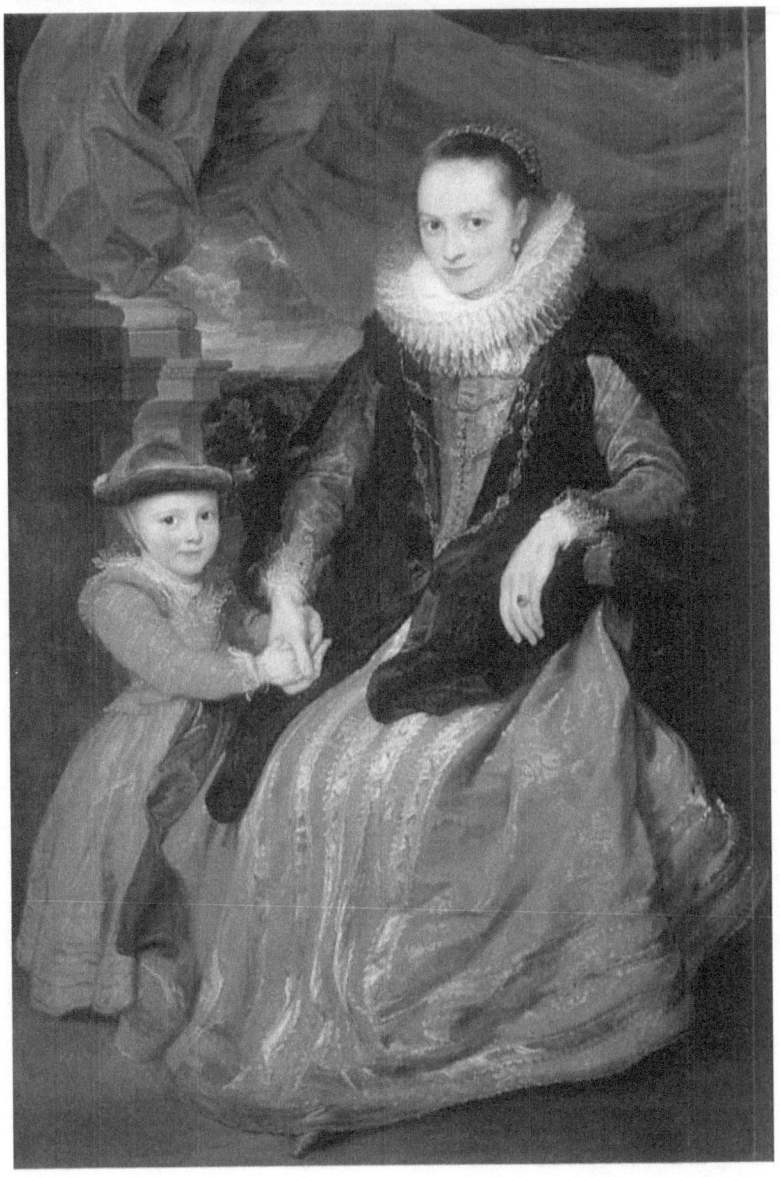

Portrait of Susanna Fourment and Her Daughter, 1620, oil on canvas

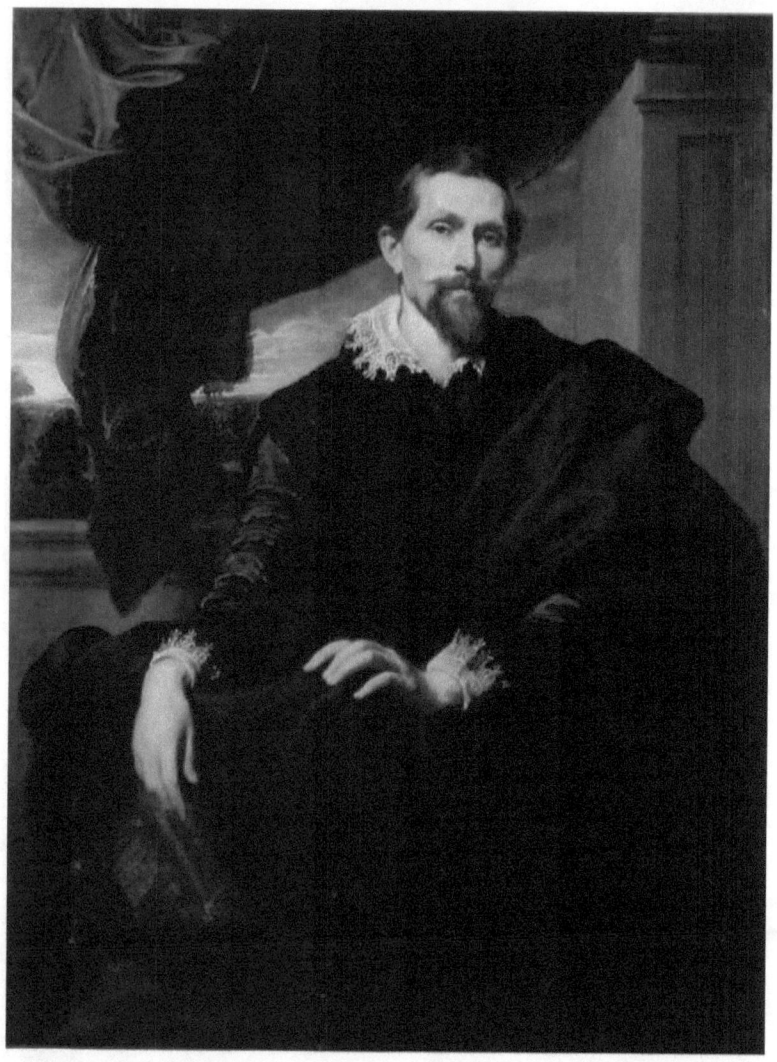

Snyders, 1620, oil on canvas

Anthony van Dyck

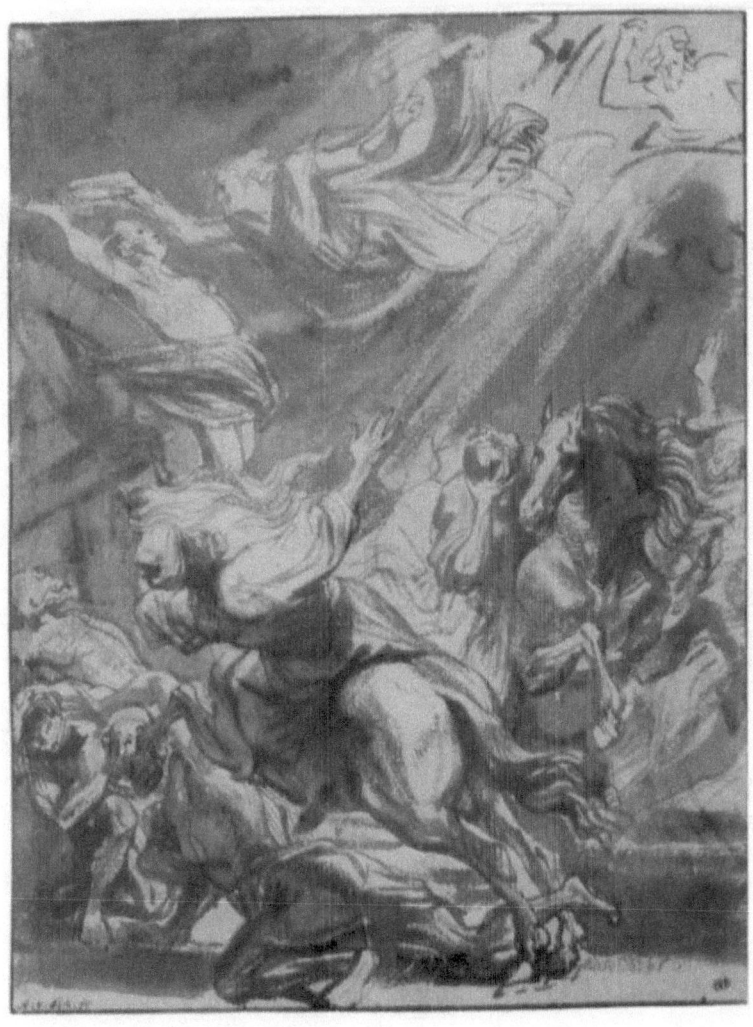

Martyrdom of St. Catherine, 1620-40, Black chalk, pen and wash on paper

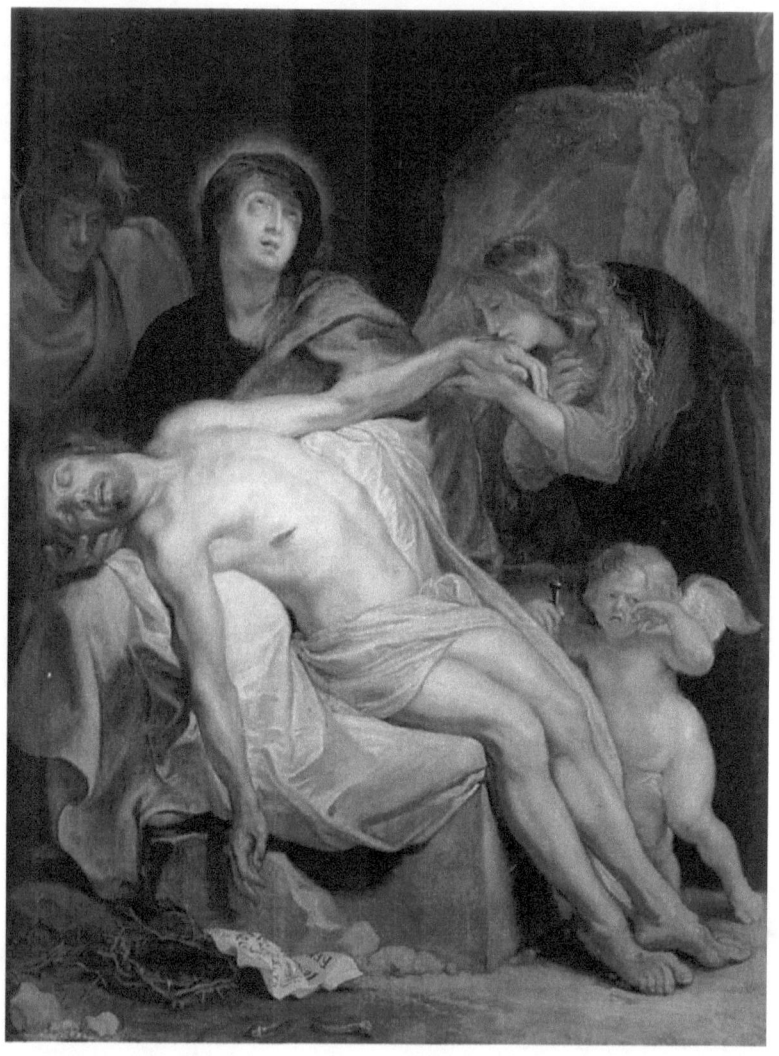

The Lamentation, 1620, oil on canvas

Anthony van Dyck

The outpouring of the Holy Spirit, 1620, Pen and brush in brown paper

The Mystic Marriage of St. Catherine, 1620, Pen, brush and brown ink on paper

Jessica Findley

Figure Study for a Christ Crowned with Thorns, 1620, Black chalk, passed over red chalk and white chalk on paper

Anthony van Dyck

The Entombment, 1620-1630, Pen and brush, heightened with white body color, red chalk, on paper

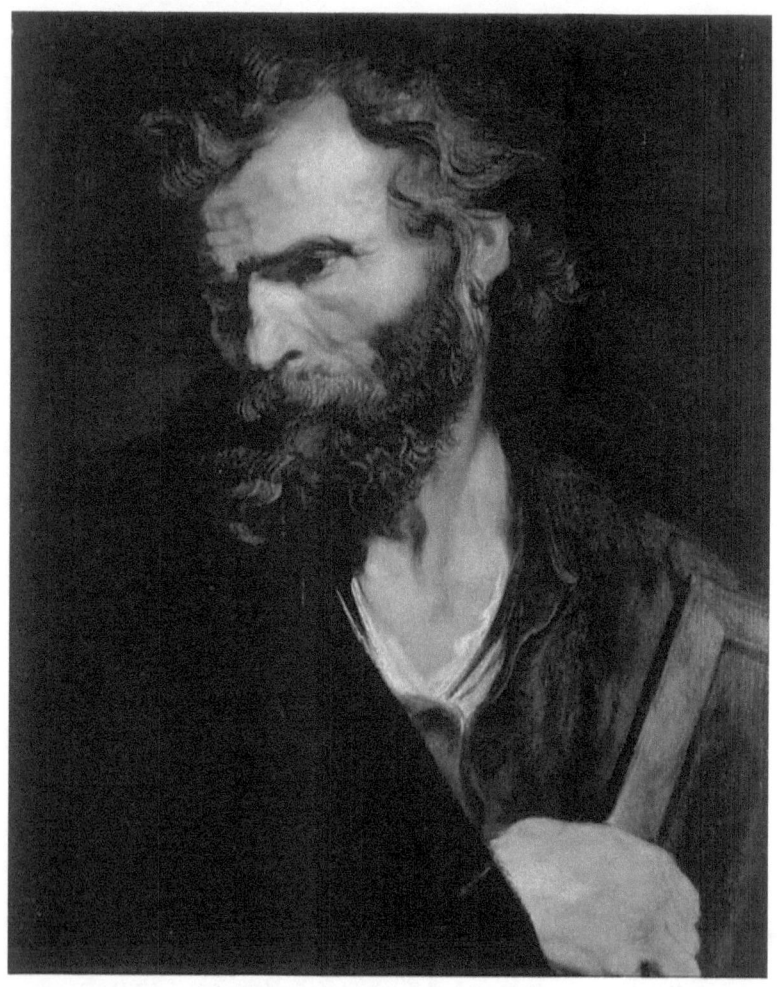

Apostle Jude, 1621, oil on canvas

Anthony van Dyck

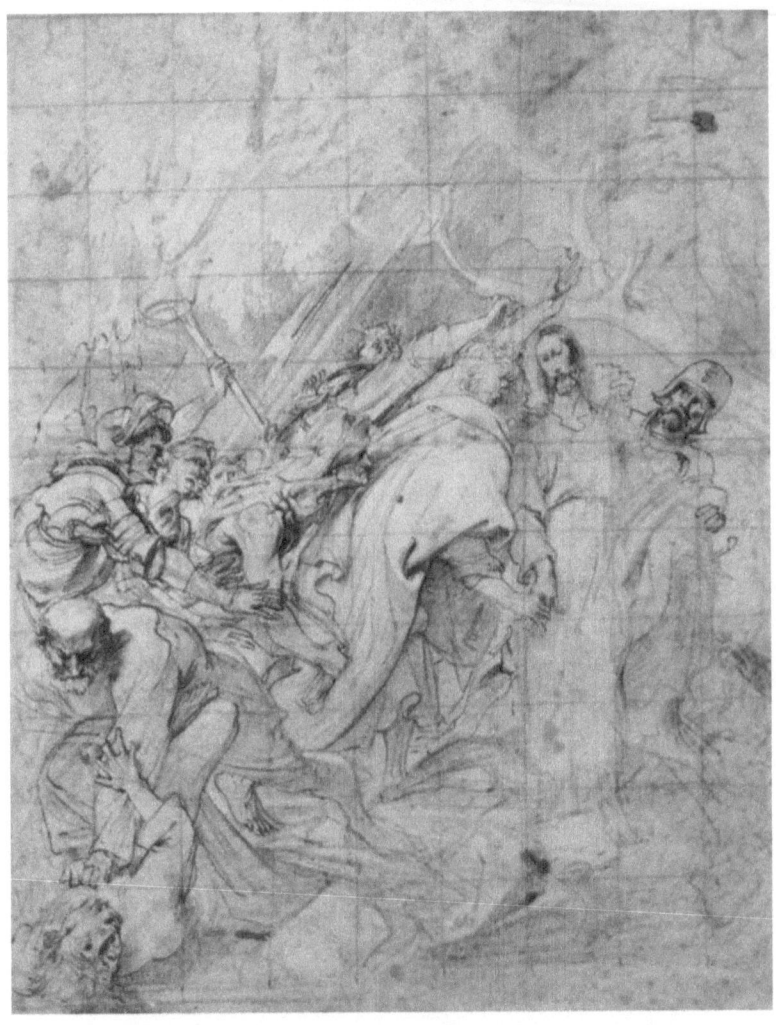

The Betrayal of Christ, 1621, Black chalk, pen and black ink, red ink, and wash on paper squared for enlargement

Jessica Findley

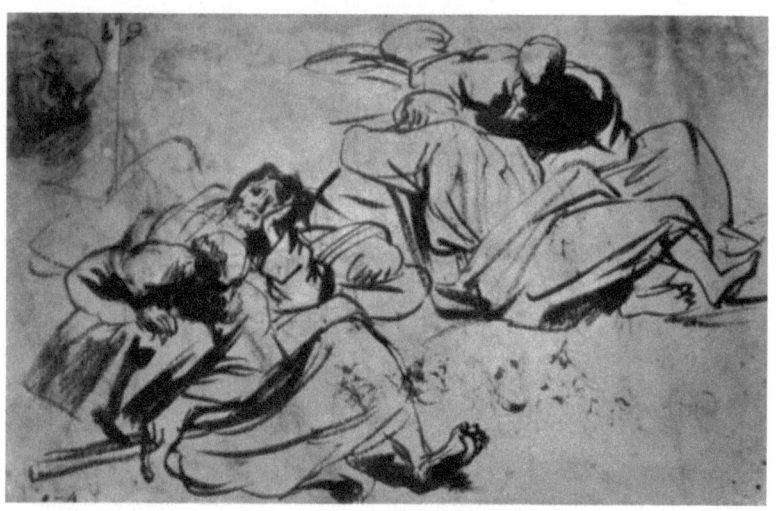

Sleeping disciples, 1621, Brush and brown ink, on paper

Anthony van Dyck

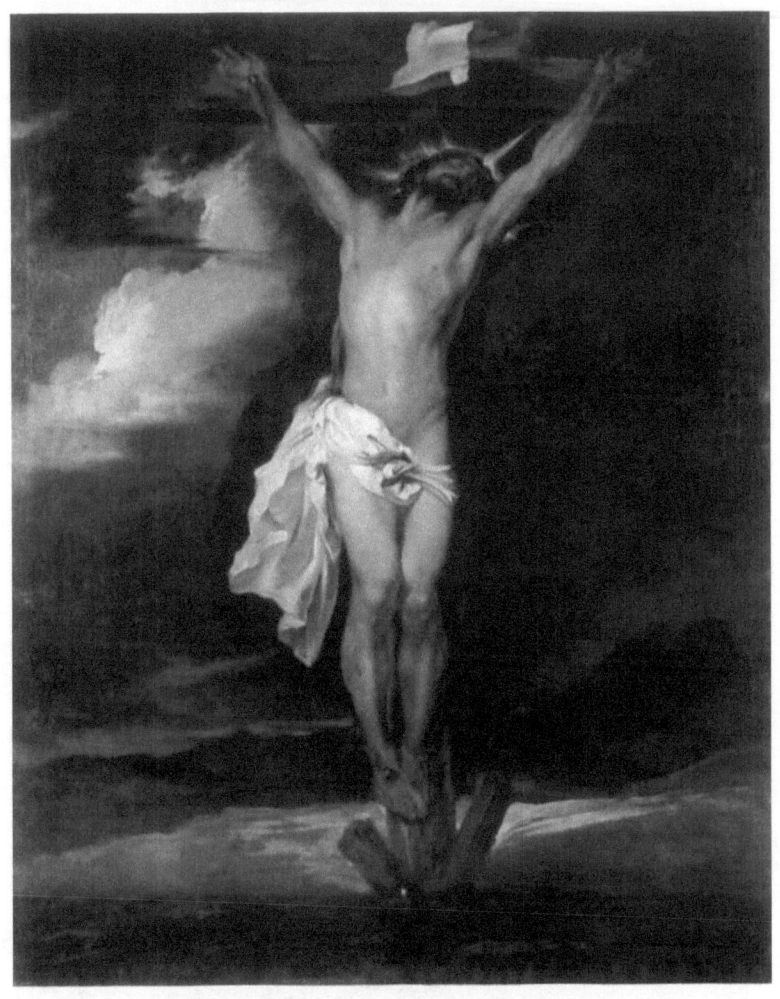

Crucifixion, 1622, oil on canvas

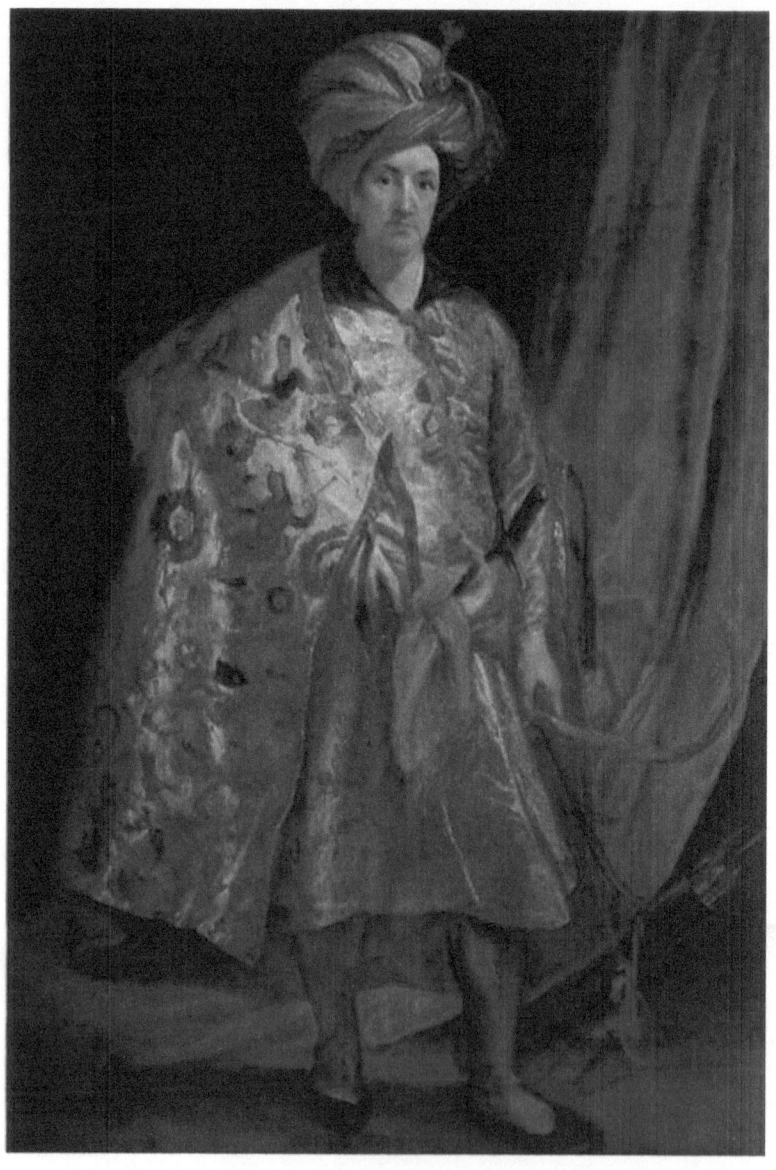

Sir Robert Sherly, 1622, oil on canvas

Anthony van Dyck

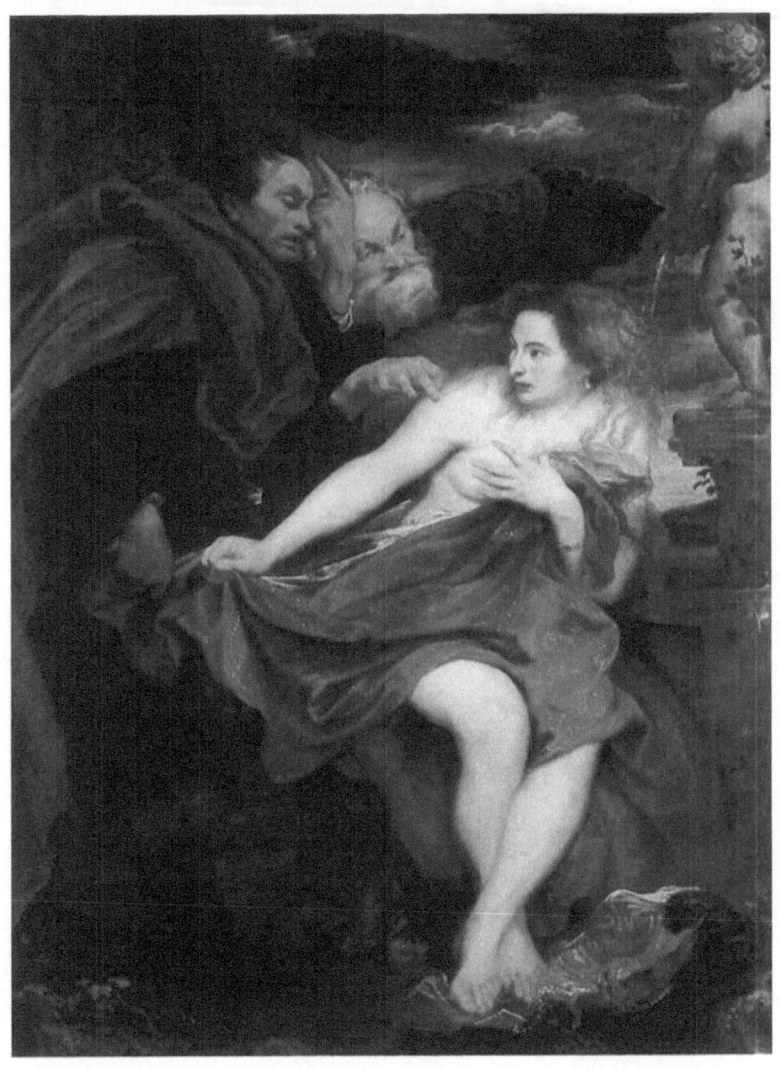

Susanna and the Elders, 1622, oil on canvas

Jessica Findley

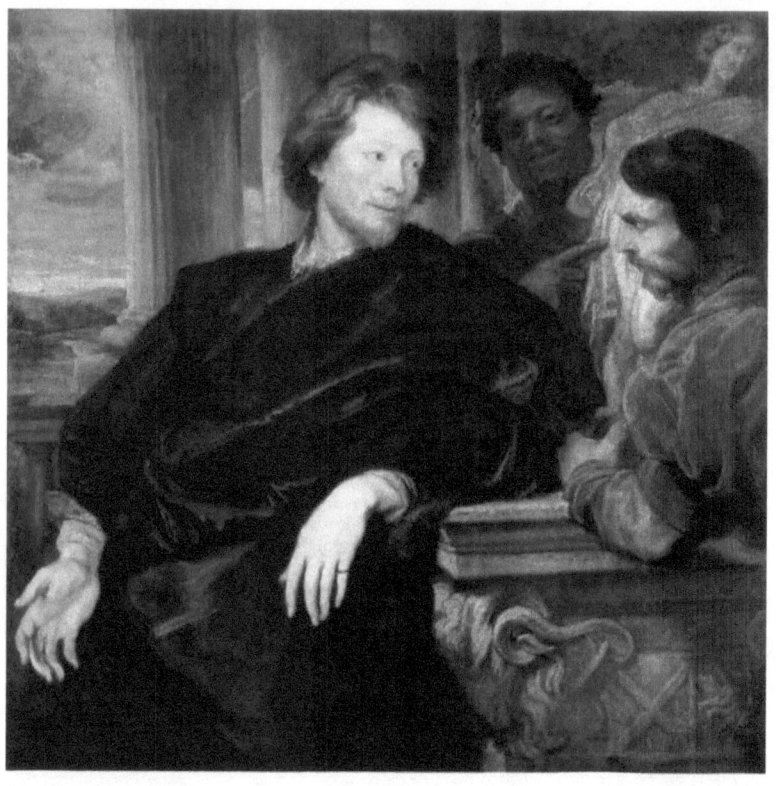

George Gage with Two Men, 1623, oil on canvas

Anthony van Dyck

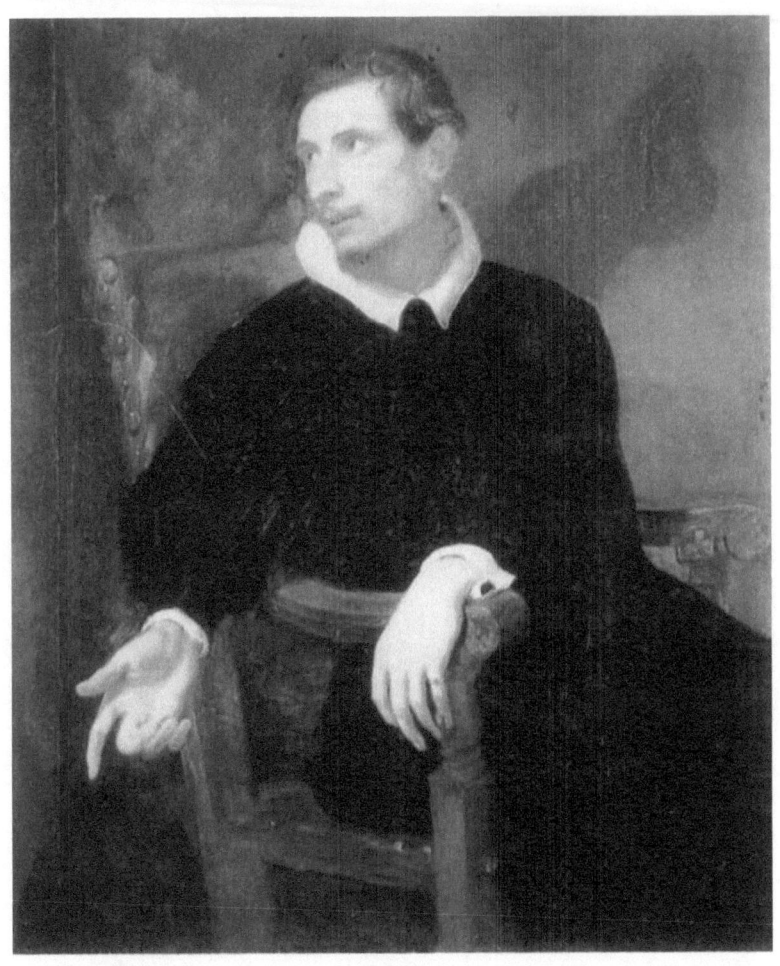

Portrait of Virginio Cesarini, 1623, oil on canvas

The sitter of this portrait is the poet Virginio Cesarini (1594-1624). He was one of the most interesting personalities in Rome towards the end of the 1610s, being close not only to Cardinal Maffeo Barberini but also to Galileo Galilei, who dedicated his groundbreaking volume Il Saggiatore to him in 1623. Van Dyck's portrait reveals tremendous intelligence and sensitivity shining through a frail physique.

Anthony van Dyck

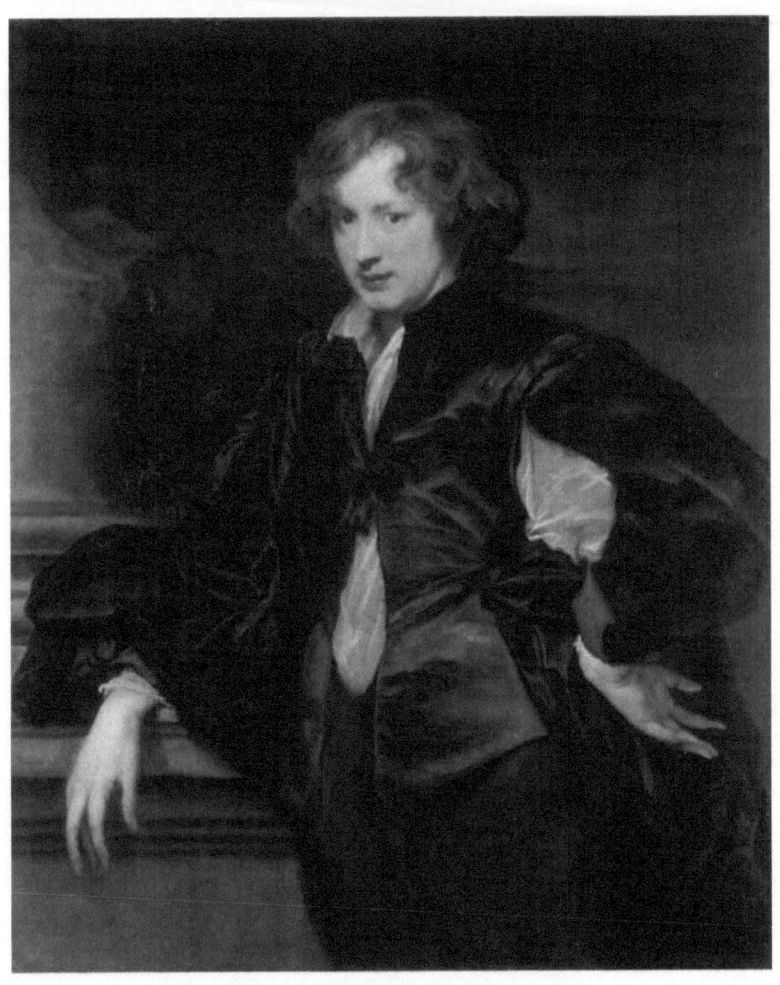

Self Portrait, 1623, oil on canvas

In the early 1620s van Dyck began his career as a society portraitist in Genoa, taking commissions from the local aristocracy while studying the legacy of the Renaissance masters. The young artist's haughty pose shows unshakeable self-confidence, which had good foundation: his style was already brilliant, both figuratively and literally. His virtuoso brush invests everything - from the material of the cloak to the glowing youthful skin - with the luster of solid prosperity. The painting represents the painter at 20, although it was painted later. The picture is based on an earlier, now lost, study. There are two other versions of the painting in Munich and in a private collection in New York, respectively.

Anthony van Dyck

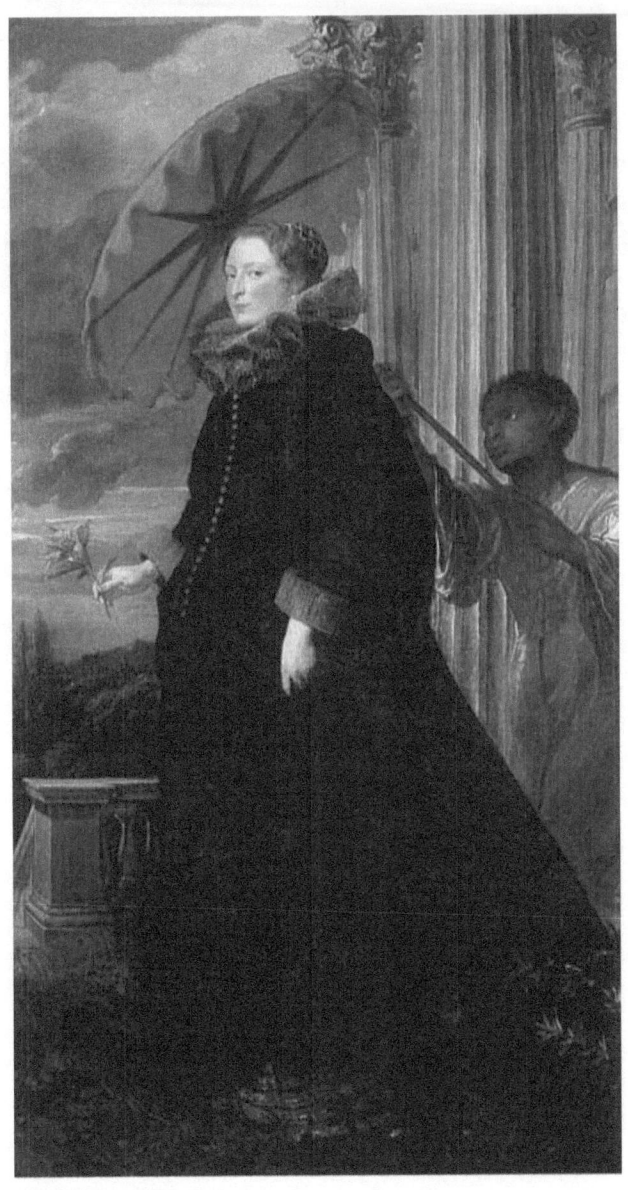

Marchesa Elena Grimaldi, c. 1623, Oil on canvas

The Genoese noblewoman is shown on the terrace of her palace. The soaring columns and cloud-swept sky add a sense of height and dignity to the majestic figure, while the brilliant red parasol relieves the otherwise somber colour scheme. The Genoese nobility, wealthy from the trade of its powerful merchant marine, had many ties with members of the Spanish court and adopted many customs from them, including the sumptuous but sober fabrics of courtly dress. Van Dyck, in these portraits of his Genoese period, has immortalized the dignity and splendid scale of living of his patrons.

Anthony van Dyck

Portrait of a Member of the Balbi Family, 1625, oil on canvas

Portrait of Cardinal Guido Bentivoglio, 1625, oil on canvas

Anthony van Dyck

Cardinal Guido Bentivoglio (1579-1644), an Italian cardinal, statesman and historian, commissioned this portrait of himself. As papal nuncio, he had work for peace between the Catholics and the Protestants in Flanders, and the Catholics and the French Protestants (the Huguenots) in France. Van Dyck, refining the robust style of his master, Rubens, specialized in long, sensitive fingers and the lush treatment of fabrics - note the sitter's robe.

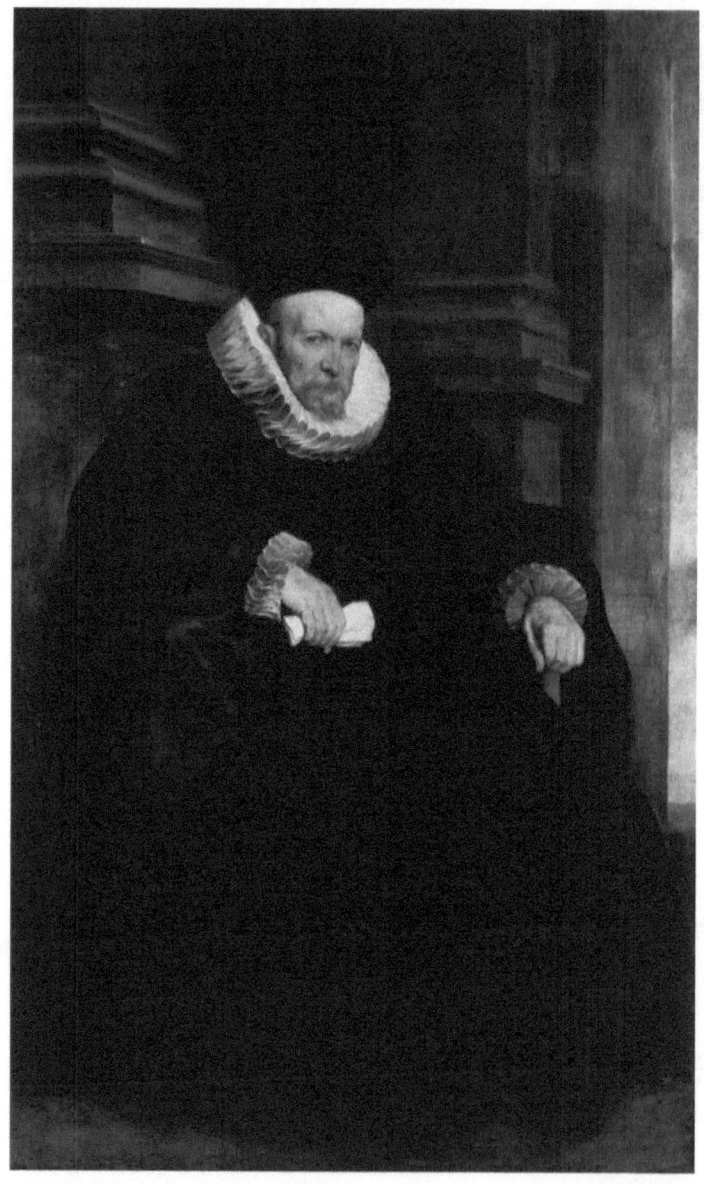

An Aristocratic Genoese, 1626, oil on canvas

Anthony van Dyck

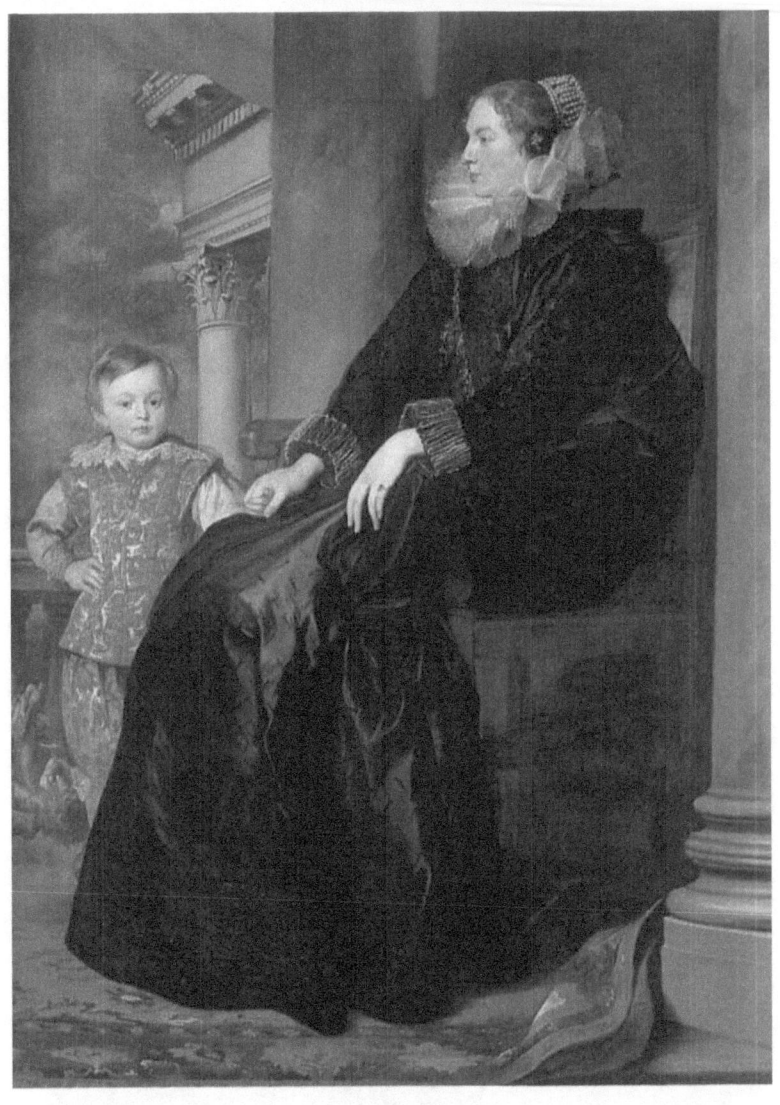

Genoese Noblewoman with her Son, 1626, oil on canvas

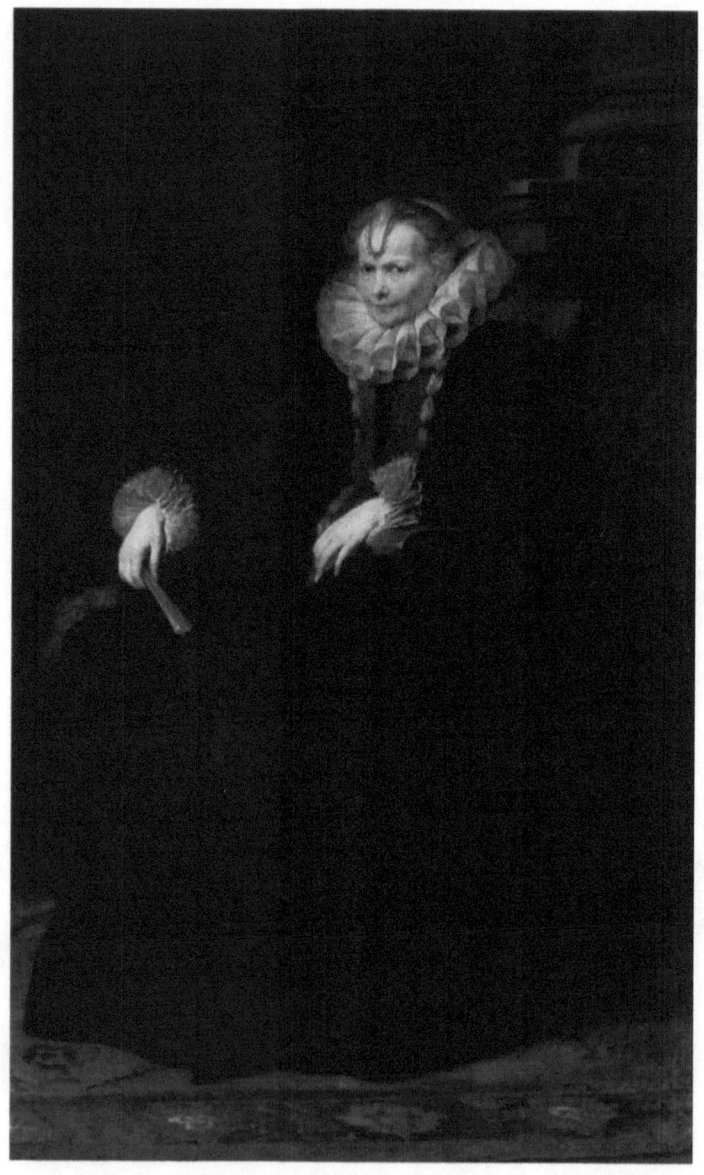

Wife of an Aristocratic Genoese, 1626, oil on canvas

Anthony van Dyck

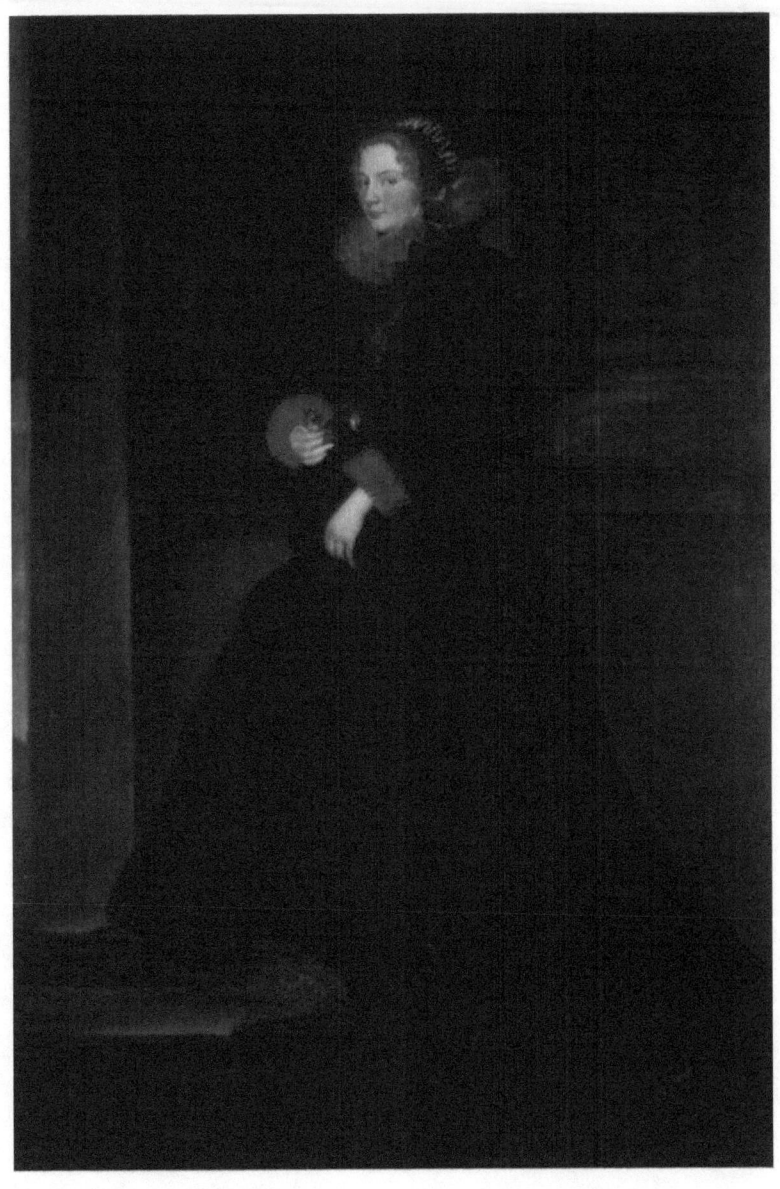

Marchesa Geronima Spinola, 1624-26, Oil on canvas,
226 x 152 cm

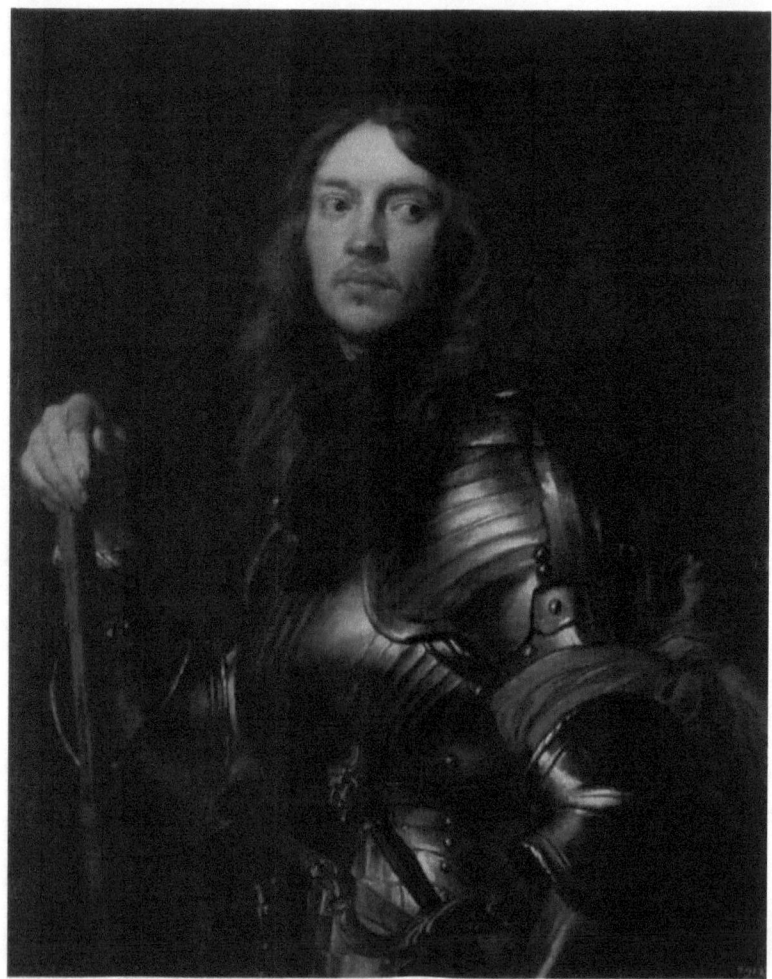

Portrait of a Man in Armour with Red Scarf, 1627, oil on canvas

Anthony van Dyck

During his extended stay in Italy from 1621 to 1627, spending the majority of his time in Genoa, Van Dyck made his mark as a portraitist, and numbered many important families from the upper strata of Genoese society among his clients. It has yet to be clarified whether or not the Portrait of a Man in Armour with Red Scarf was one of these commissions; various attempts to identify the man in the picture have been inconclusive. It is also possible that the painting is not a portrait but an allegory.

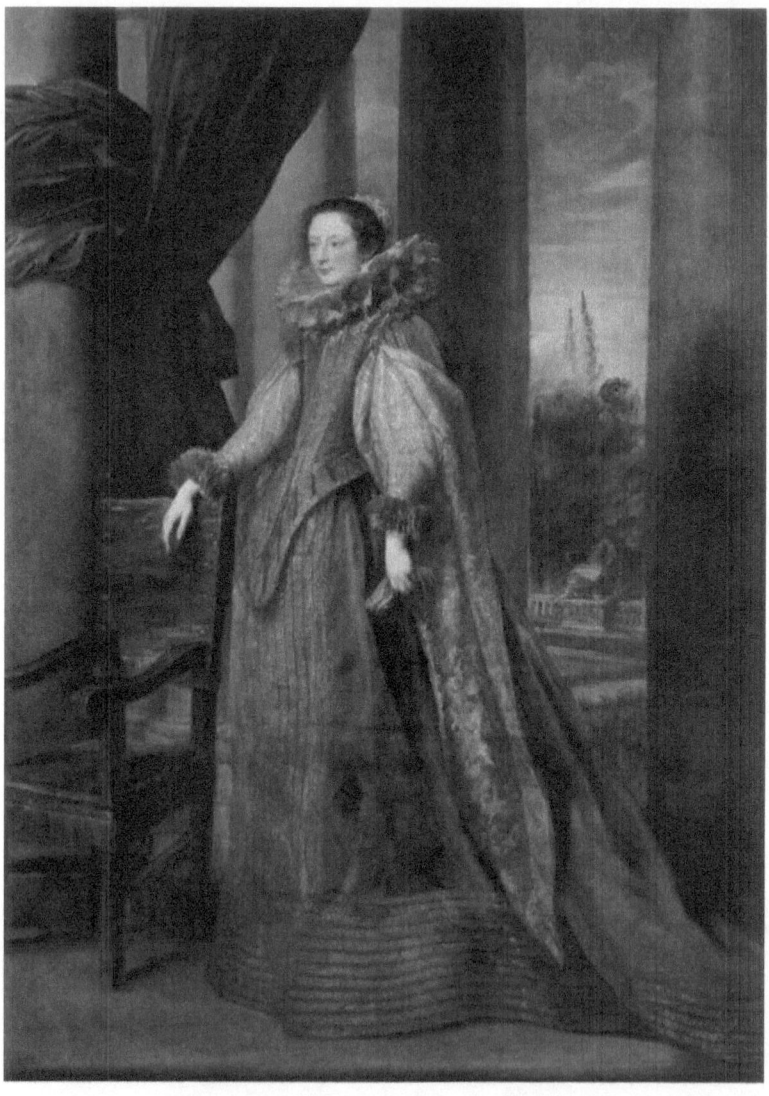

Portrait of a Noble Genoese Lady, 1627, oil on canvas

Anthony van Dyck

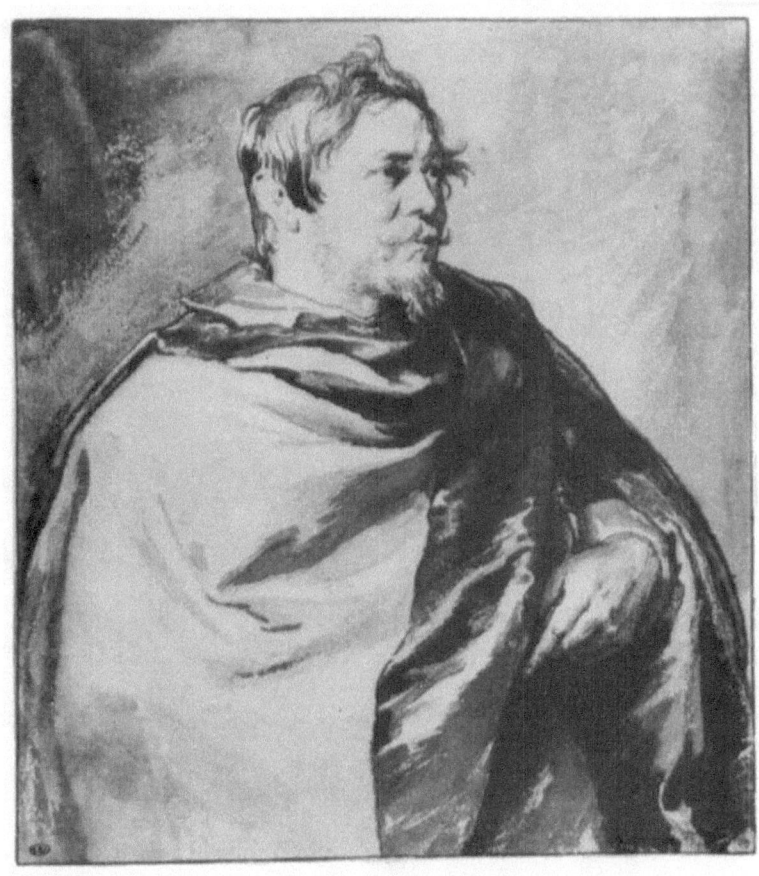

Portrait of the painter Gerard Seghers, 1627-35, Black chalk with Chinese ink wash, on paper

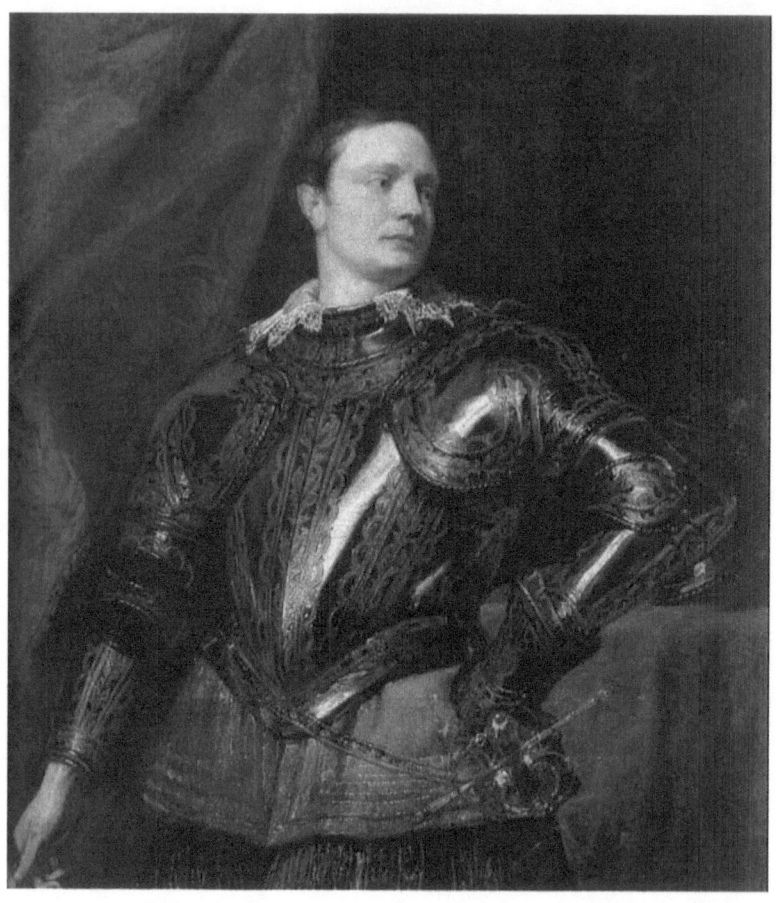

Portrait of a Young General, 1627, oil on canvas

Anthony van Dyck

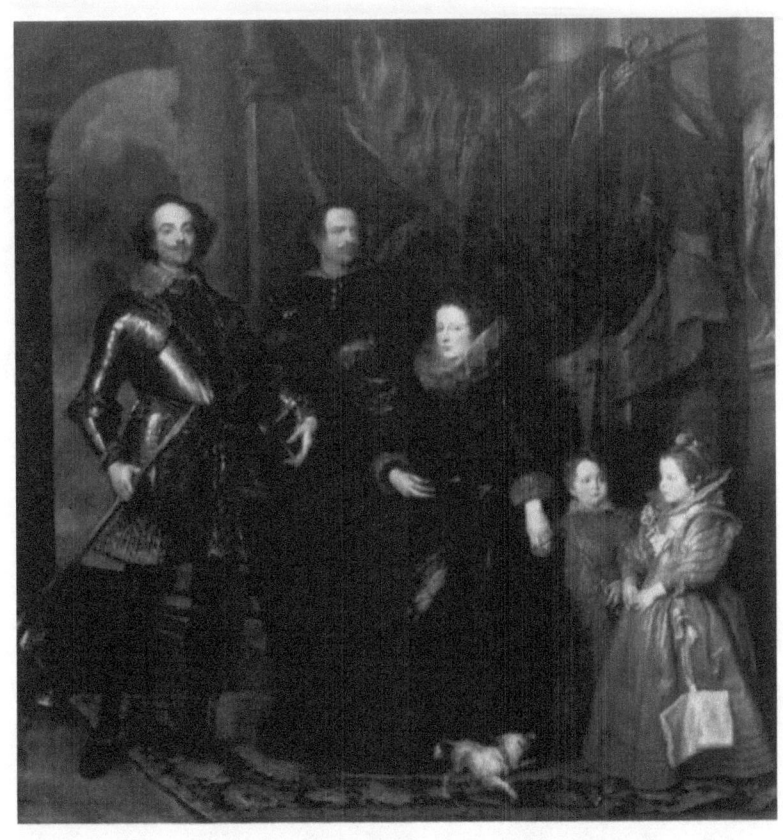

The Lomellini Family, 1627, oil on canvas

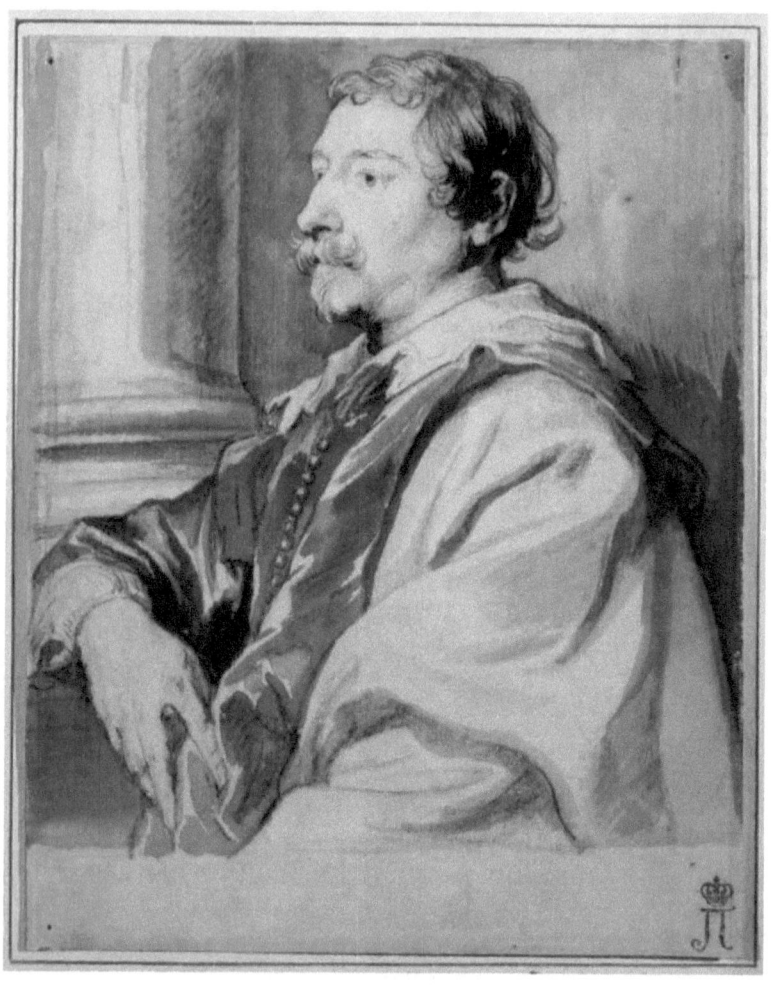

Cornelis Schut, 1628-1636, black chalk, brush and brown wash

Anthony van Dyck

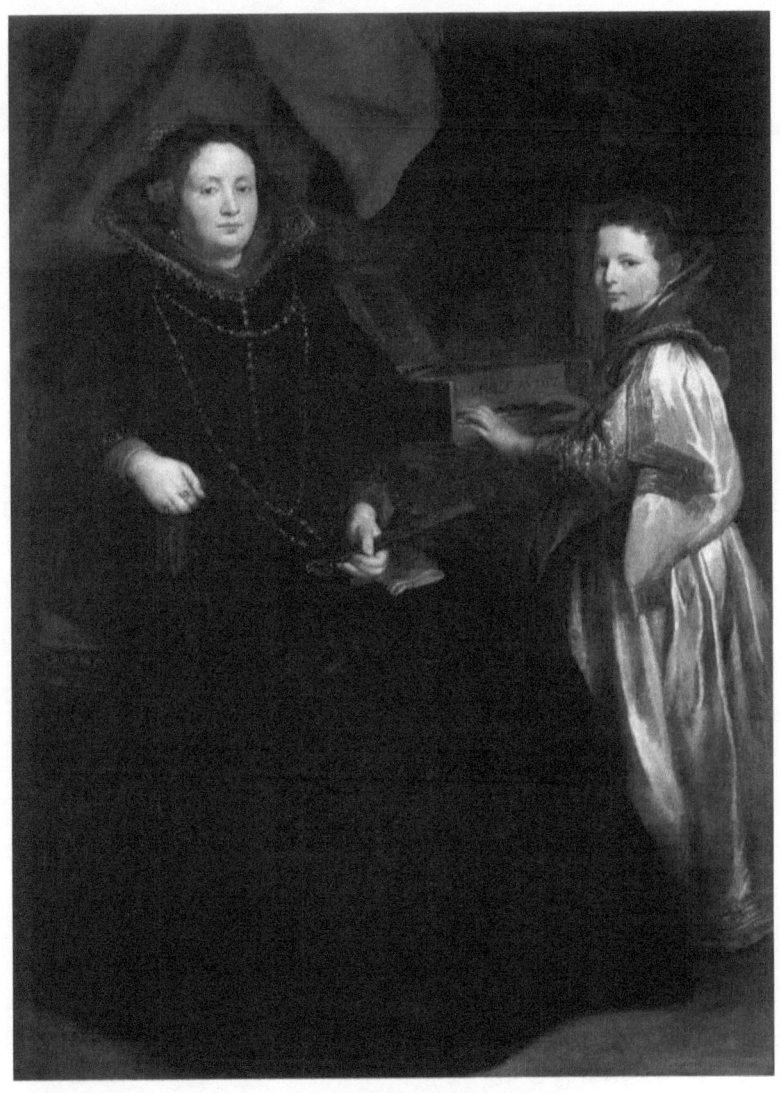

Portrait of Porzia Imperiale and Her Daughter, 1628, oil on canvas

Jessica Findley

Holy Women at the cross, 1628, Pen and brown ink, on paper

Anthony van Dyck

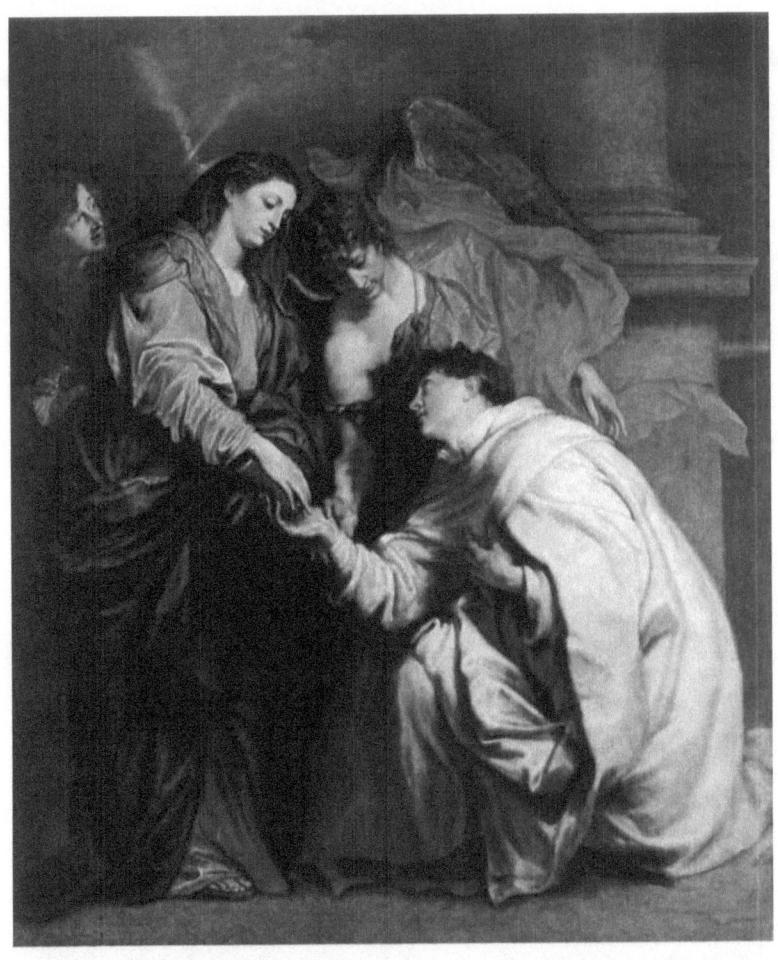

Blessed Joseph Hermann, 1629, oil on canvas

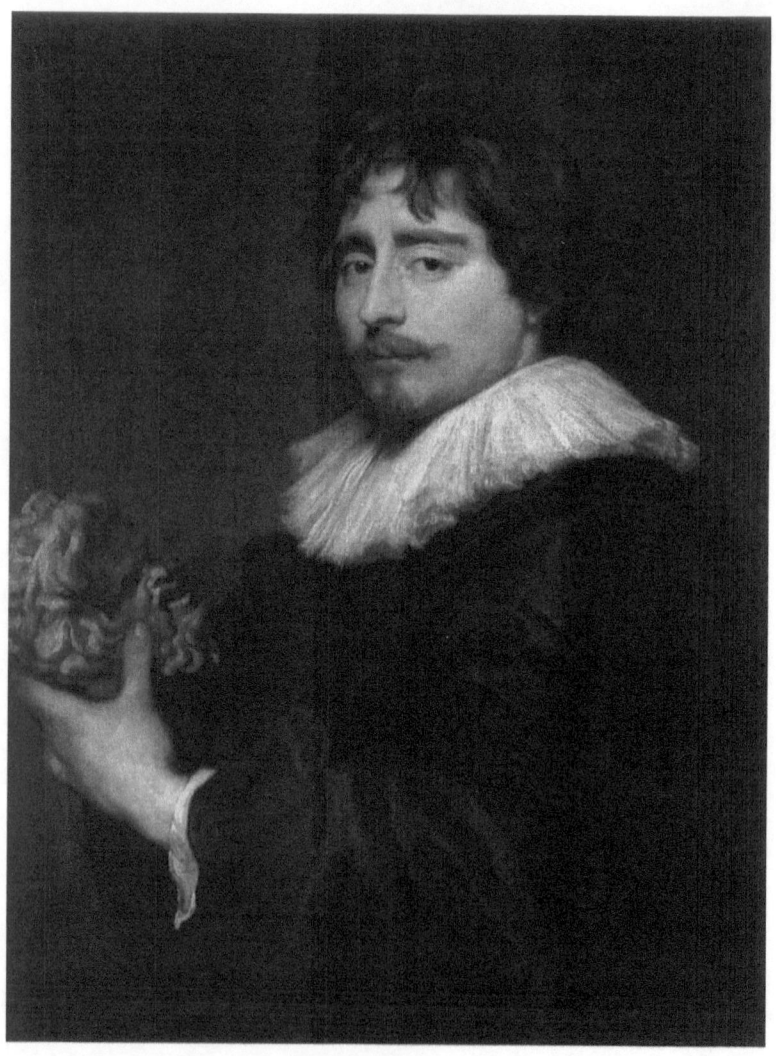

Porrtrait of the Sculptor Duquesnoy, 1627-1629, oil on canvas

Anthony van Dyck

In this portrait by Anthony van Dyck, a brown-haired man, wearing a beard and a moustache, is represented in three-quarter profile, turned to the left against a dark, uniform background. He is wearing a dark cloth garment, decorated with a ruff and white cuffs, and holds a stone sculpted head representing a satyr. The dark colours serve to emphasise the sitter's attentive gaze and elegant hand, whilst the vivacity of the face contrasts with the immobility of the sculpture. For a long time this painting was held to be a portrait of the Brussels sculptor Fran3ois Duquesnoy, who lived and worked in Rome from 1618 to 1643, where he developed a classical style that was strongly influenced by his study of antique sculpture and by the works of French painter Nicolas Poussin. This portrait would then have been painted during a trip that Anthony van Dyck made to Rome around 1622/23, where he supposedly struck up a friendship with the sculptor.

However, this famous painting presents problems as to the date of painting and in particular the identity of the sitter. The traditional identification was based on an engraving by Pieter van Bleeck in 1751 from the portrait in the Brussels museum, with an inscription mentioning the sculptor's name and a short biographical text. This has recently been called into question. Bellori's biography of the sculptor, published in 1672, mentions neither a friendship between the two men in Rome, nor a portrait of his compatriot by Van Dyck. What the biography does mention is that Duquesnoy was fair-haired and had blue eyes. Moreover, the engraved portrait illustrating his text, repeated in 1675 by Joachim von Sandrart in the Teutsche Academie, shows little resemblance neither to the present portrait, nor to the late engraving from it by Pieter van Bleeck. In addition, stylistic analysis has shown that the picture could not belong to Anthony van Dyck's Italian period, but must be placed in his second Flemish period, where the colour range was more contained. This portrait is indeed by Van Dyck, but after his Italian trip, around 1627/29, when the painter was back in the country to which the Brussels sculptor never returned.

Anthony van Dyck

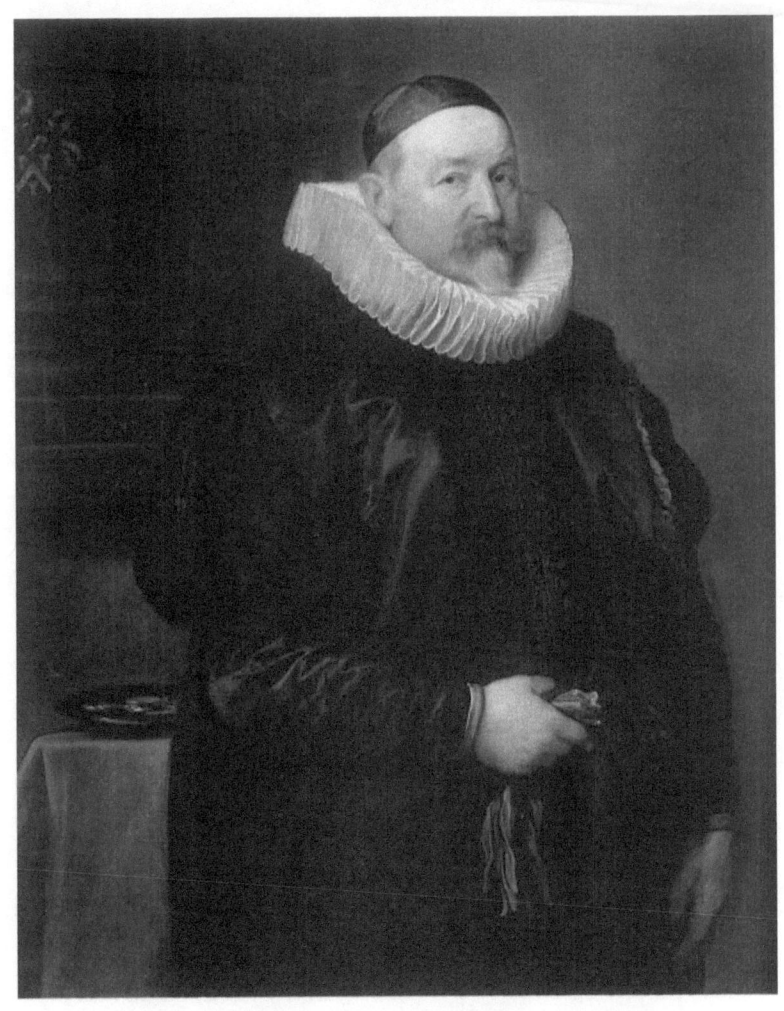

Portrait of Adriaen Stevens, 1629, oil on canvas

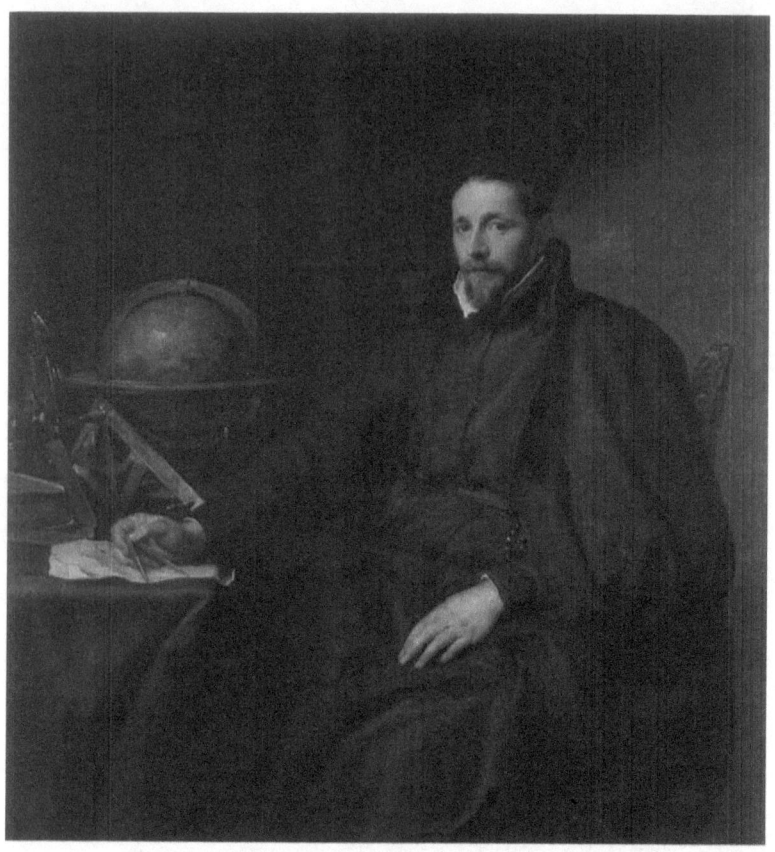

Portrait of Father Jean Charles della Faille, 1629, oil on canvas

Anthony van Dyck

Van Dyck portrayed the Jesuit Jean-Charles della Faille with, as very prominent attributes, the instruments on the table to his left. The learned divine, from a wealthy Antwerp merchant family, entered the Company of Jesus in 1613. At the highly-reputed Antwerp school he advanced his mathematical skills with two famous teachers and fellow-Jesuits, Franciscus Aguilonius and Gregorius a Sancto Vincentio, going on to teach the subject himself at Leuven and Lier, until summoned in 1629 to lecture at Philippe IV's recently founded Collegium Imperiale in Madrid. His activities in Spain were not limited to theory and teaching and from 1637 he served the court as a cosmographer and a specialist in warfare. It was commonplace in the early 17th century for a mathematician to master also related, often practical disciplines such as surveying and astronomy, and the instruments with which he is portrayed can be used in all these areas.

Next to a celestial globe we recognise a Dutch circle, a quadrant and plumb line, a compass in his hand and some scientific writings. The sector is from the workshop of Antwerp instrument maker Michiel Coignet. Jean-Charles della Faille kept up a regular correspondence with his fellow-cosmographer at the Spanish court in Brussels, Michael Florentius van Langren. In his position as a military engineer, the Jesuit father travelled to regions in rebellion against the Spanish crown, among them Portugal, Naples and Catalonia, but never returned to his native Netherlands. We can thus assume that Van Dyck portrayed him shortly before his departure in 1629, probably as a commission by his family. This is also the date mentioned on the canvas, together with the age of 32. Although of a later hand, both data appear to be acceptable.

This lively portrait records the inquisitive look of the Jesuit, presented in three-quarter profile. Two engravings of this painting are also preserved, a 17th century one by Adriaan Lommelin and a 19th century one by Francois de Meersman. The latter print belonged to a series of Belgian mathematicians, which is surprising bearing in mind that in the 20th century della Faille's importance in scientific history was hardly known.

Anthony van Dyck

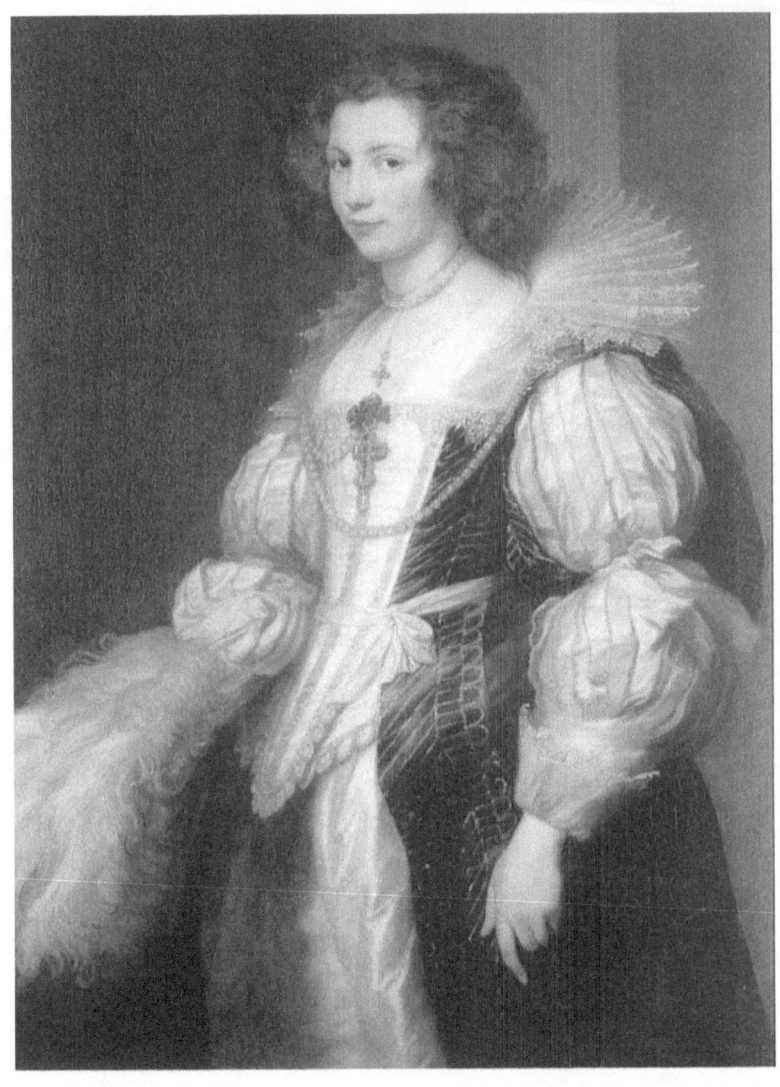

Portrait of Maria Lugia de Tassis, 1629, oil on canvas

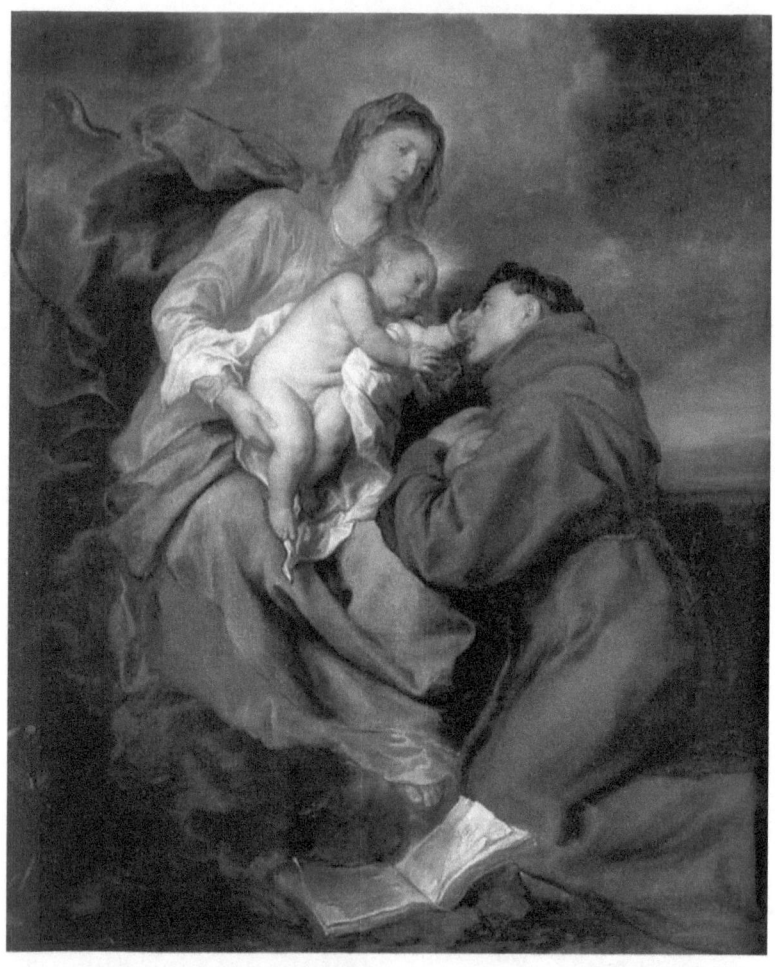

The Vision of St Anthony, 1629, oil on canvas

Anthony van Dyck

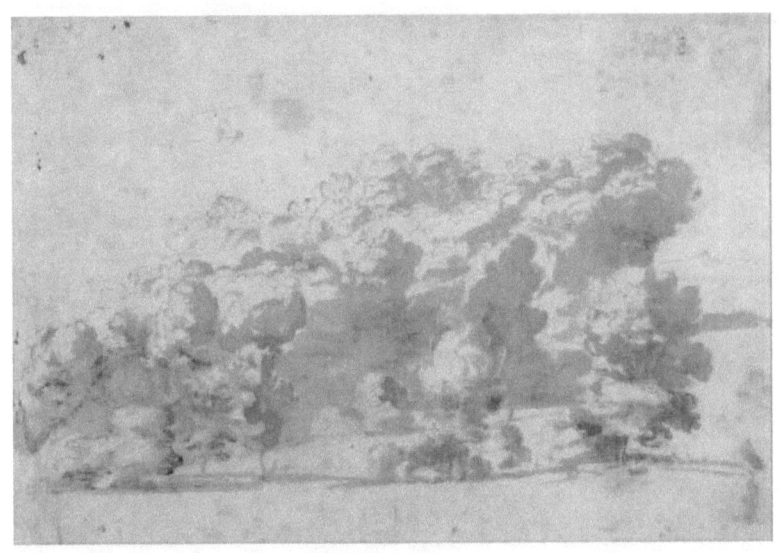

A wooded ridge, 1630s?, pen & brown ink, brown ink wash on paper

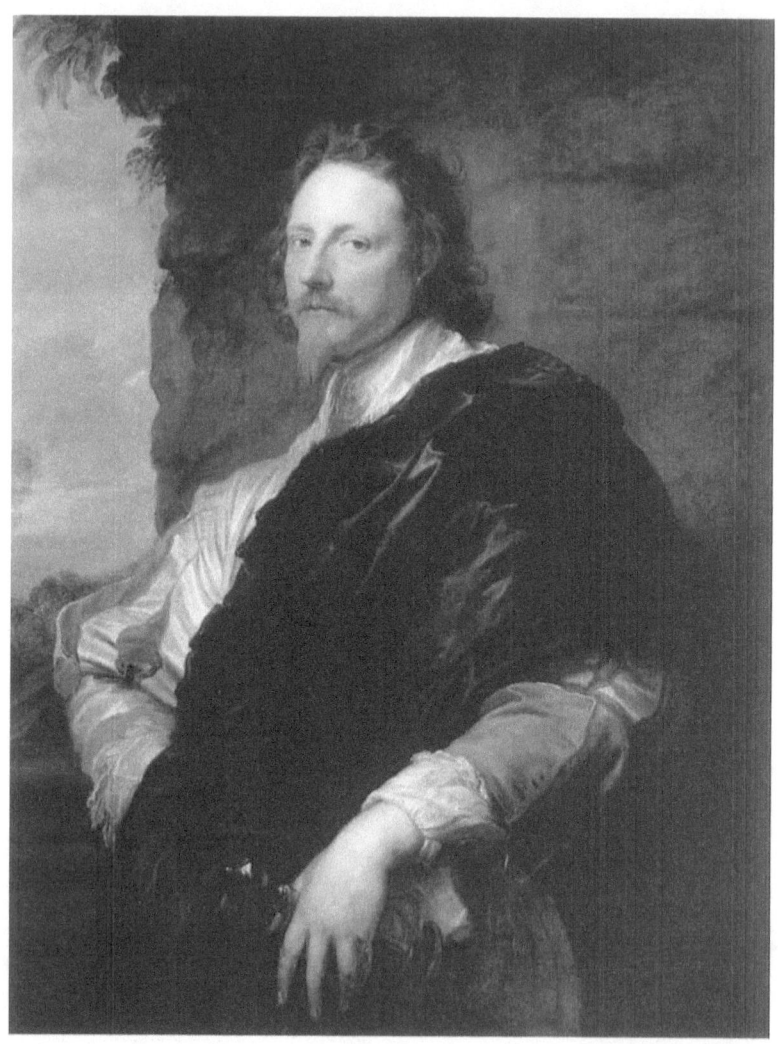

Nicholas Lanier, 1630, oil on canvas

Anthony van Dyck

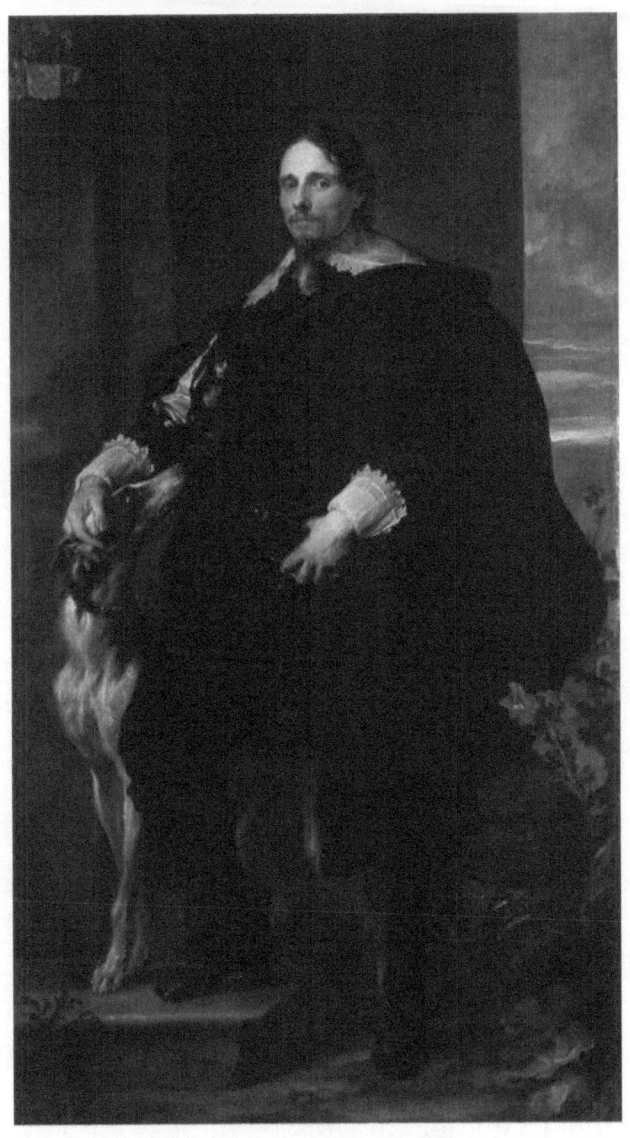

Philippe Le Roy, 1630, oil on canvas

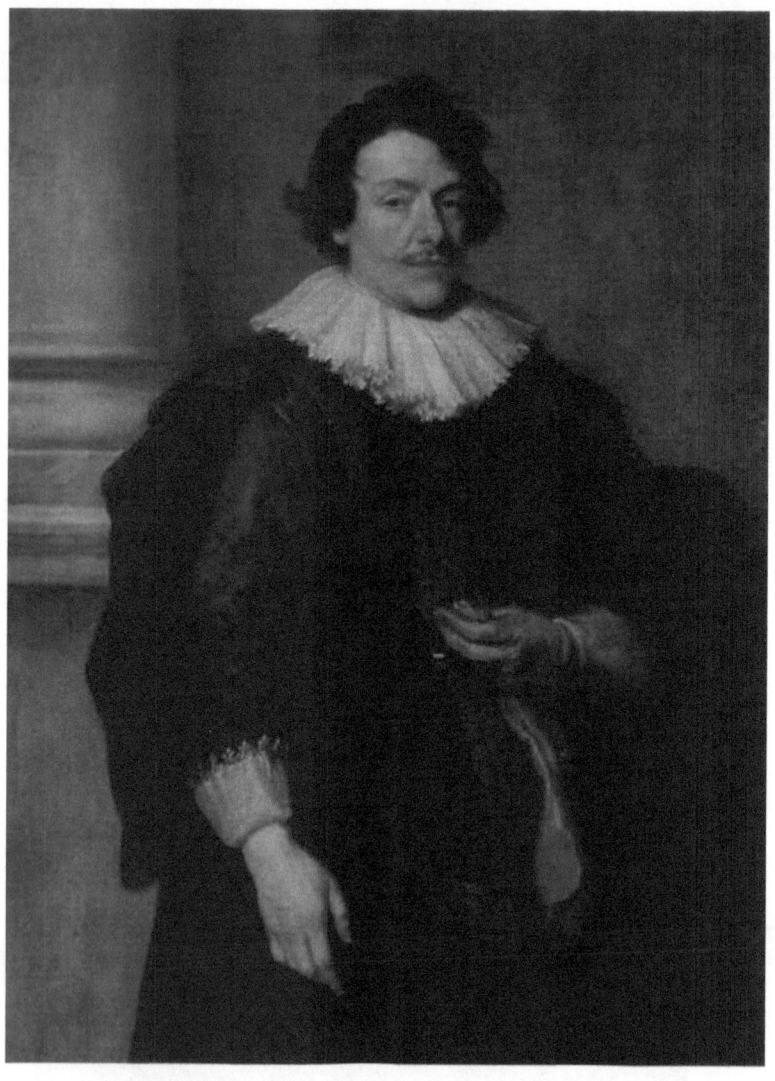

Portrait of a Gentleman Dressed in Black, in Front of a Pillar, 1630, oil on canvas

Anthony van Dyck

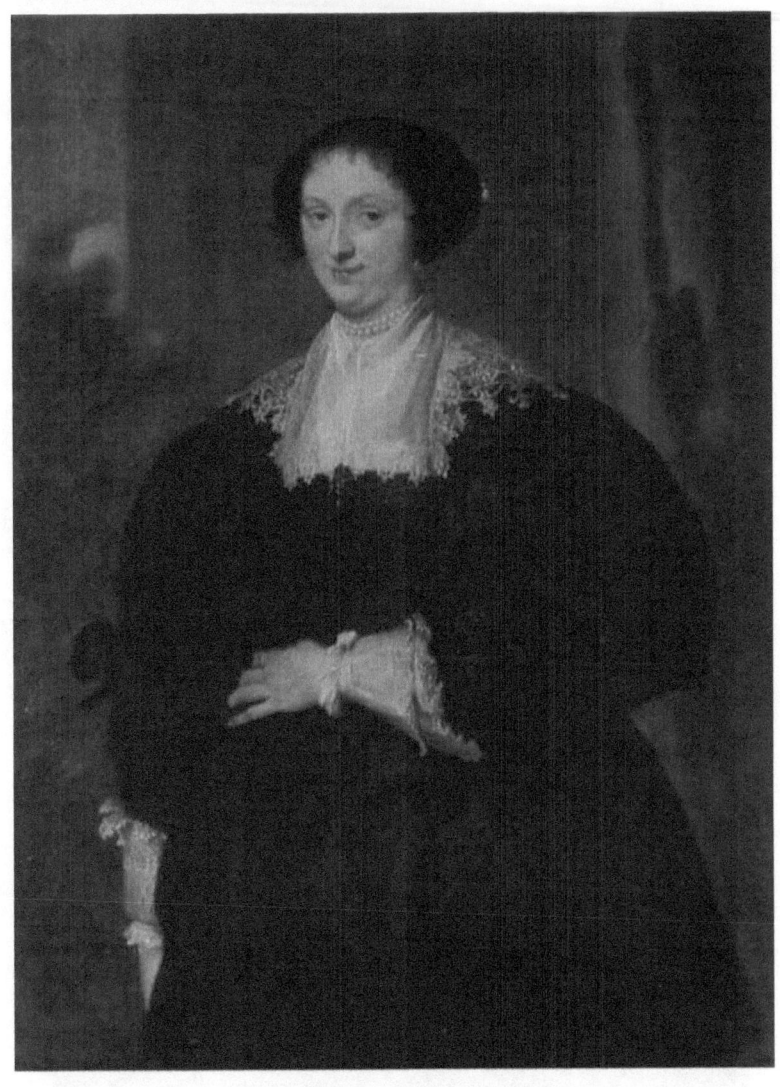

Portrait of a Lady Dressed in Black, Before a Red Curtain, 1630, oil on canvas

Jessica Findley

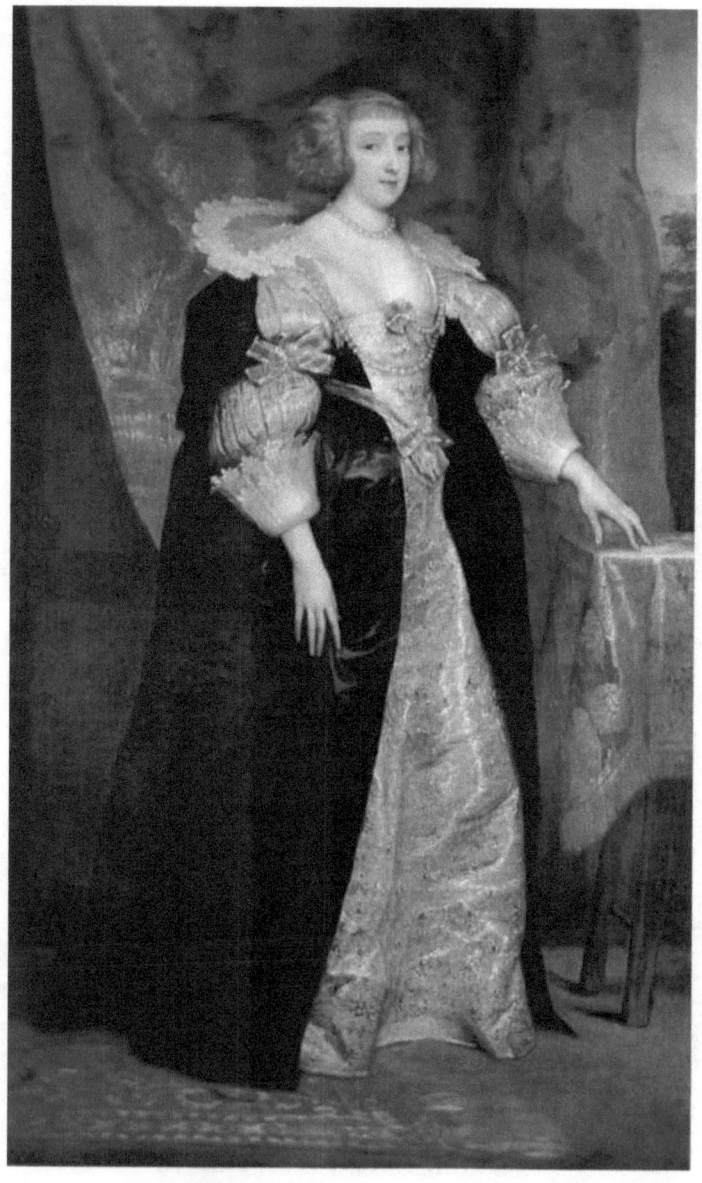

Portrait of an Unknown Woman, 1630, oil on canvas

Anthony van Dyck

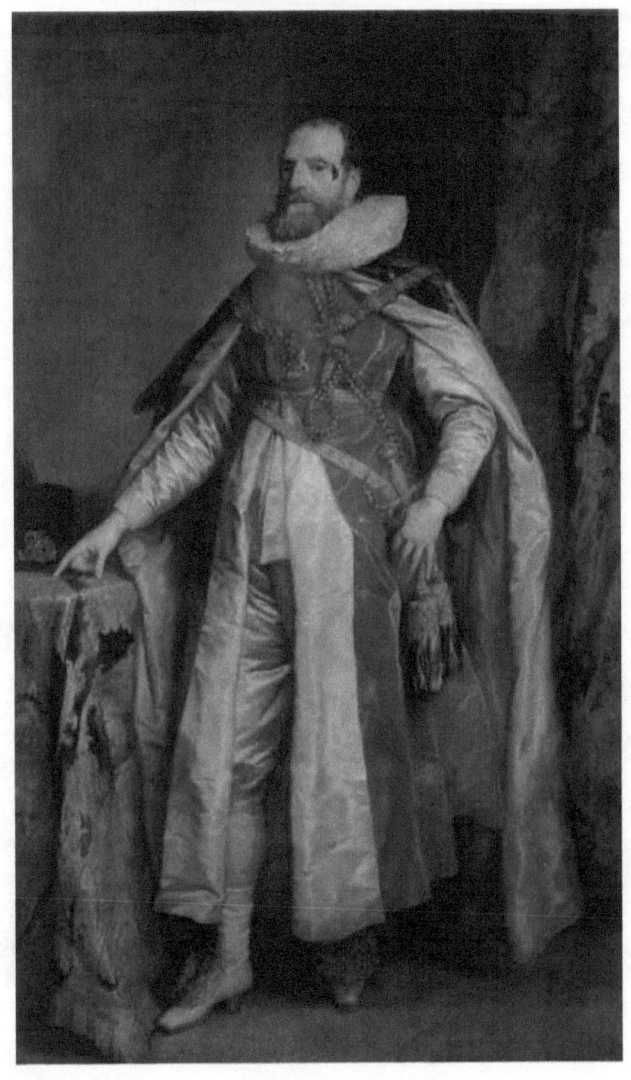

Portrait of Henry Danvers, Earl of Danby, as a Knight of the Order of the Garter, 1630, oil on canvas

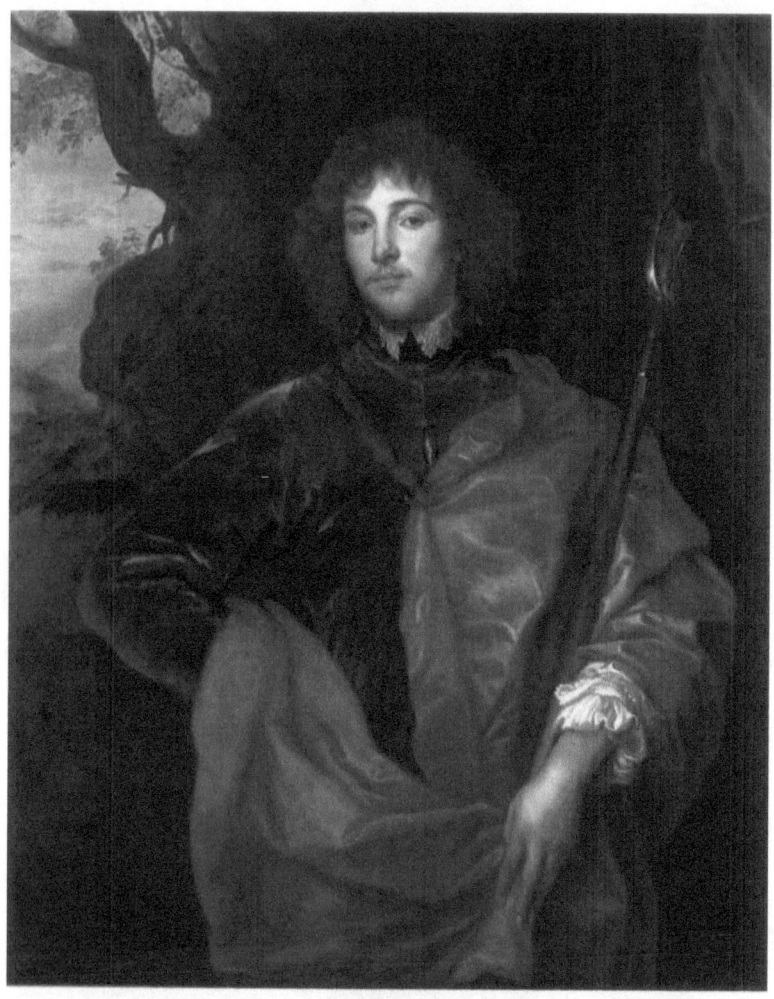

Portrait Of Philip, Lord Wharton, 1630, oil on canvas

Anthony van Dyck

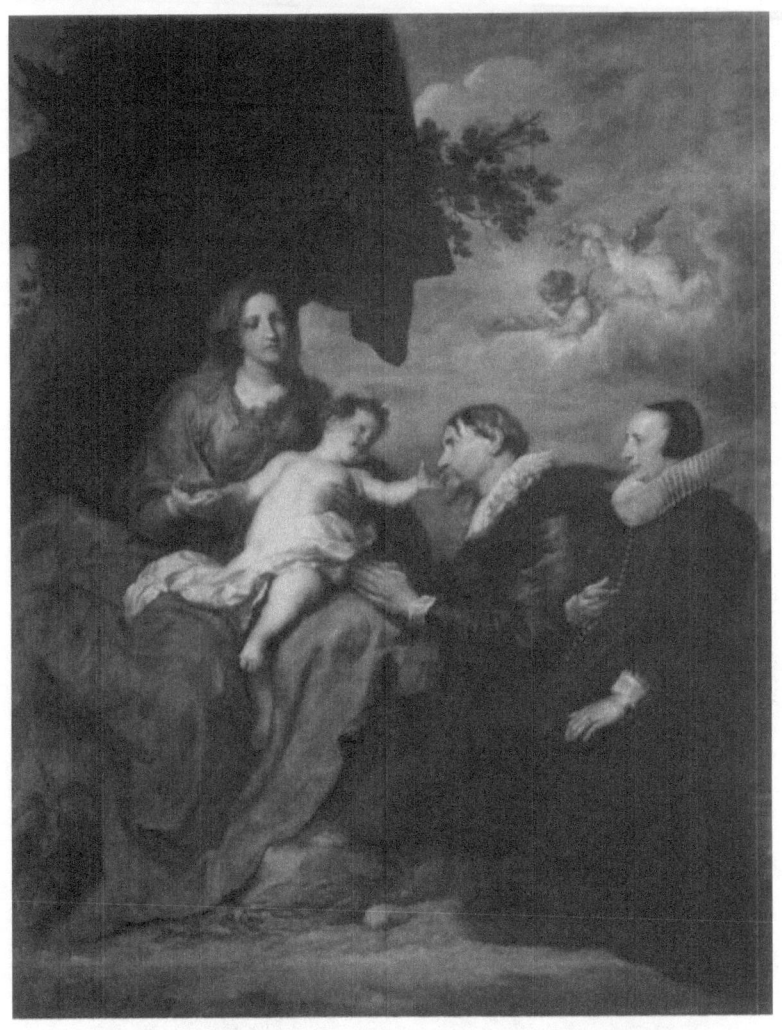

Virgin with Donors, 1630, oil on canvas

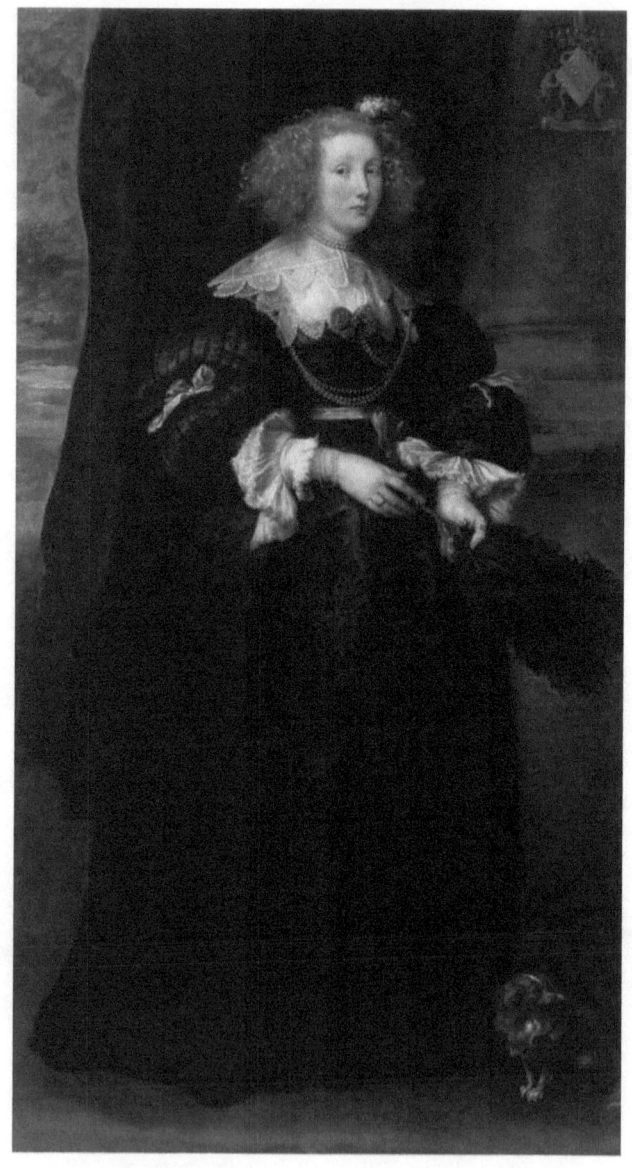

Marie de Raet, 1631, oil on canvas

Anthony van Dyck

The painting is the companion piece of the portrait of Philippe Le Roy. It was painted on the occasion of their marriage in 1631 when she was sixteen years old.

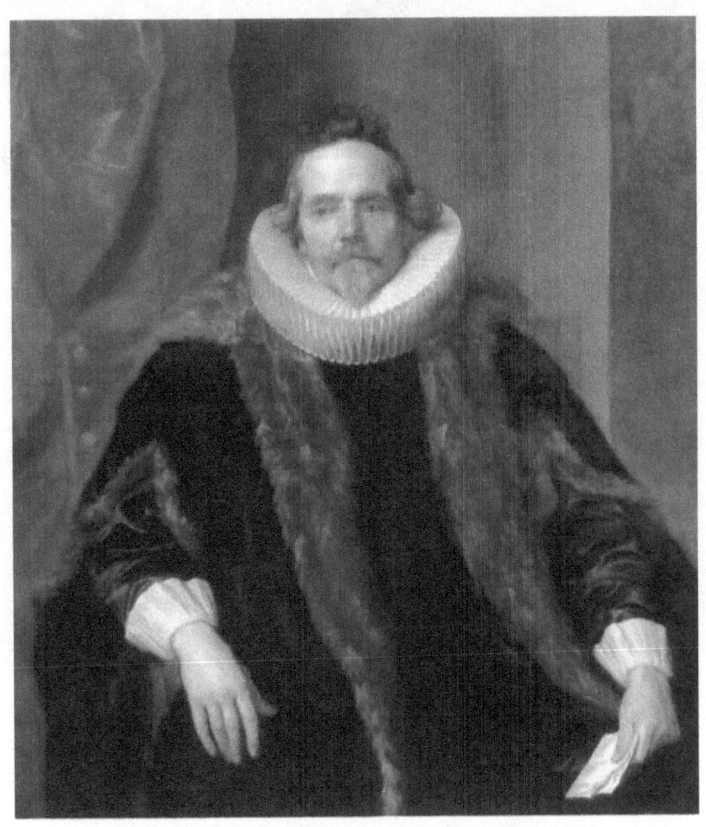

Portrait of Jacques Le Roy, 1631, oil on canvas

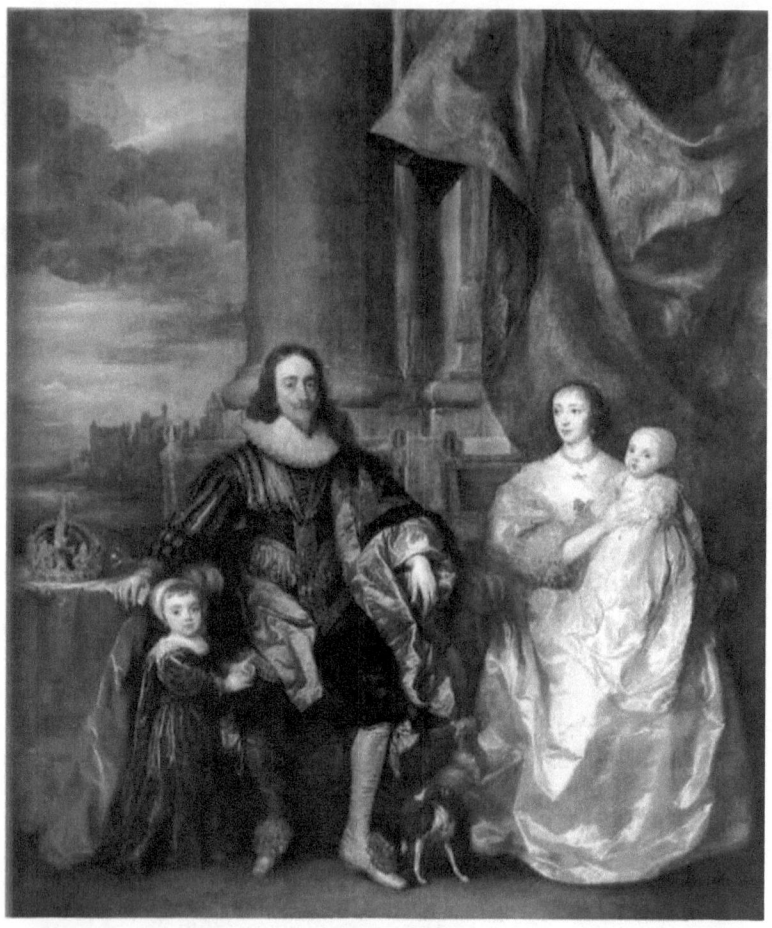

Charles I and Queen Henrietta Maria with Charles, Prince of Wales and Princess Mary, 1632, oil on canvas

Anthony van Dyck

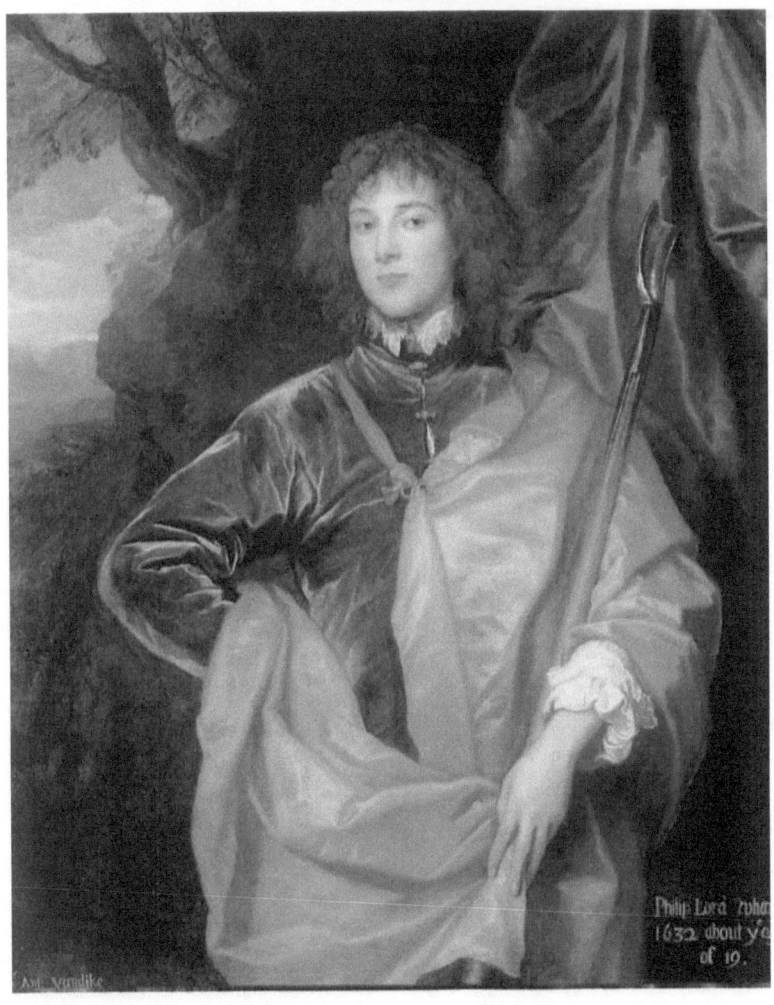

Philip, Fourth Lord Wharton, 1632, oil on canvas

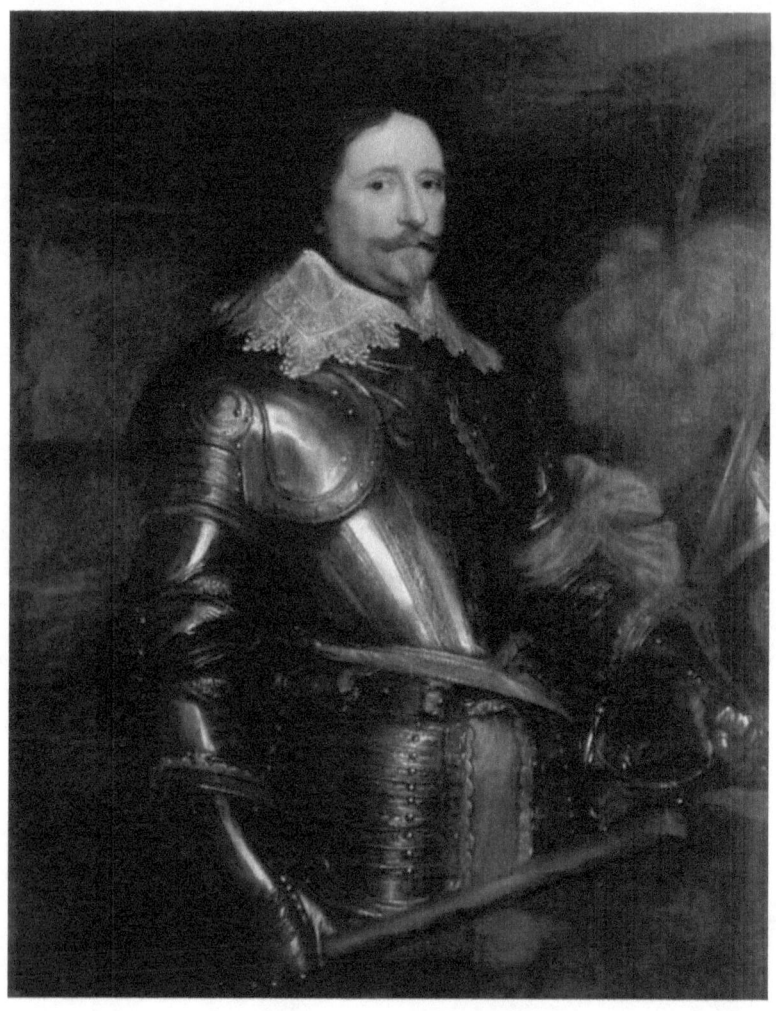

Portrait Of Frederik Hendrik, 1632, oil on canvas

Anthony van Dyck

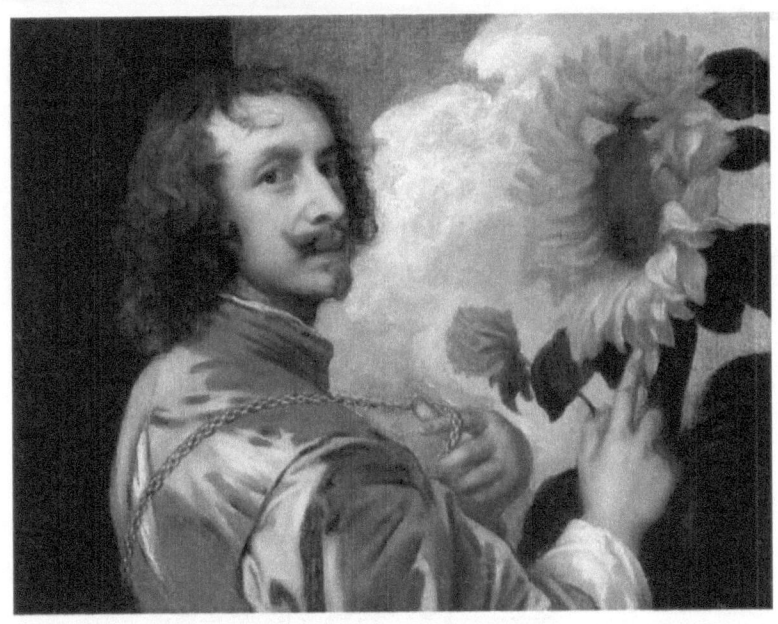

Self portrait with a Sunflower, 1632, oil on canvas

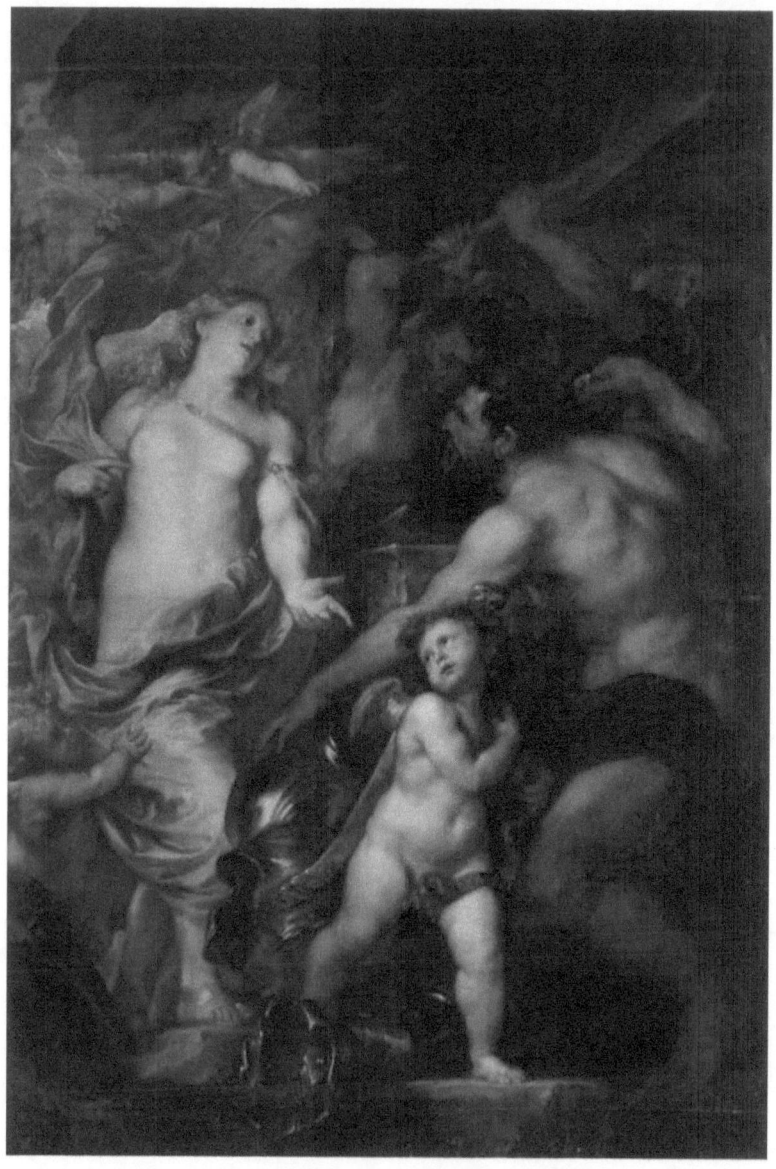

Venus asking Vulcan for the Armour of Aeneas, 1632,
oil on canvas

Anthony van Dyck

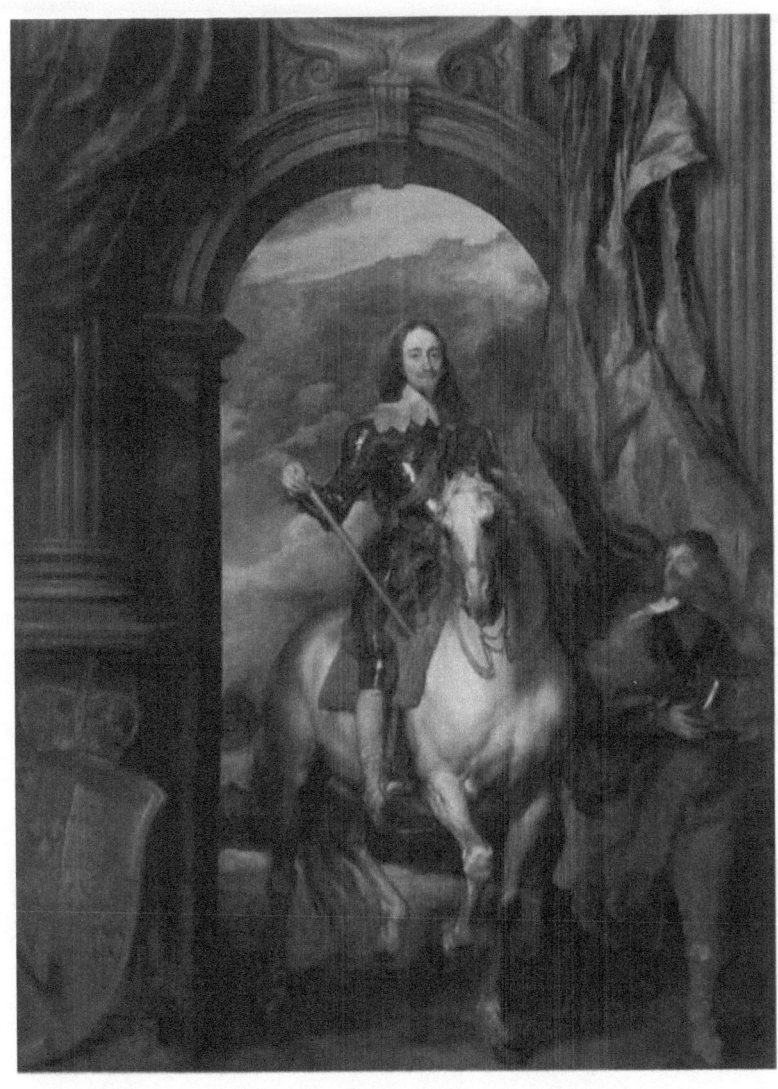

Equestrian Portrait of Charles I, King of England with
Seignior de St Antoine, 1633, oil on canvas

Jessica Findley

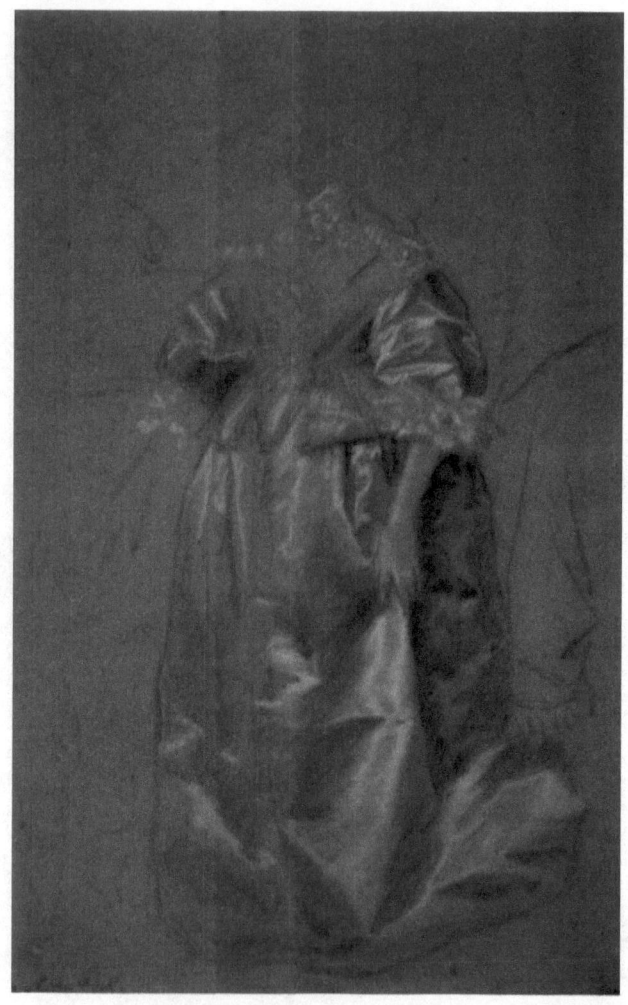

Costume study, 1633, Black chalk, heightened with white, pastel on blue paper

Anthony van Dyck

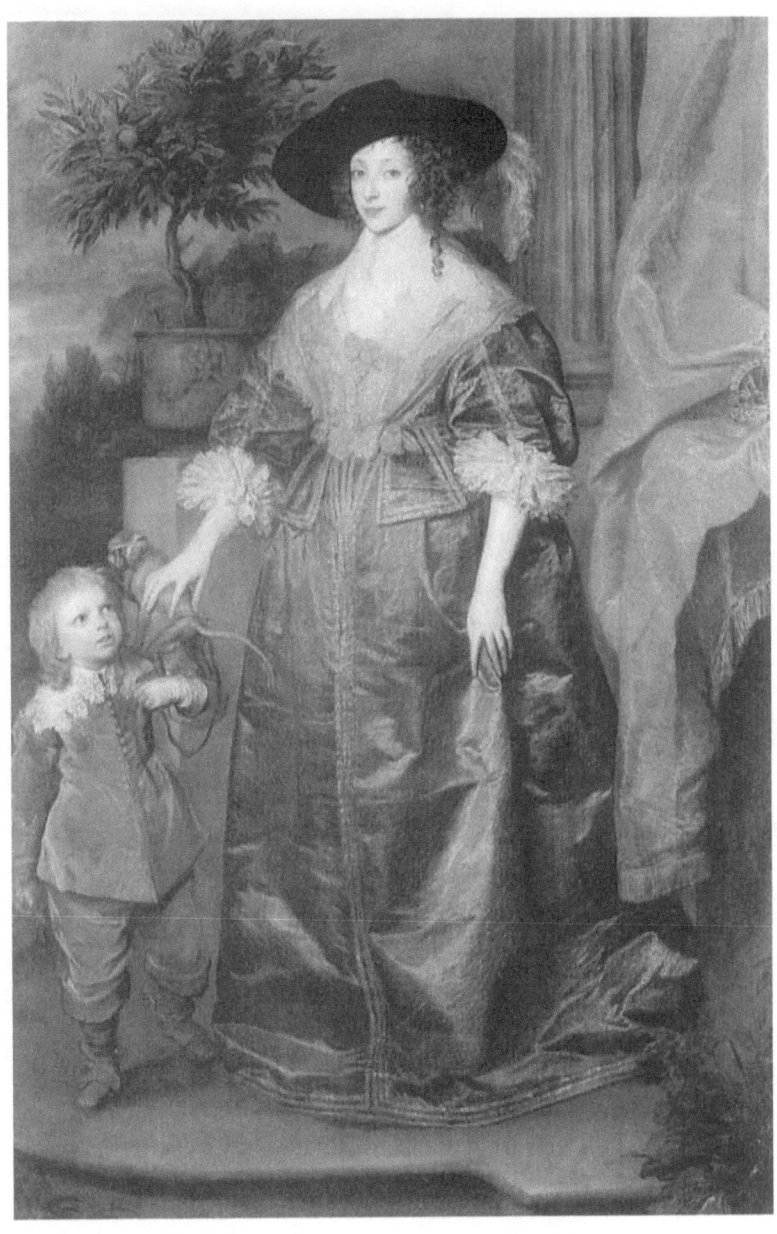

Queen Henrietta Maria and her dwarf Sir Jeffrey Hudson, 1633, oil on canvas

Jessica Findley

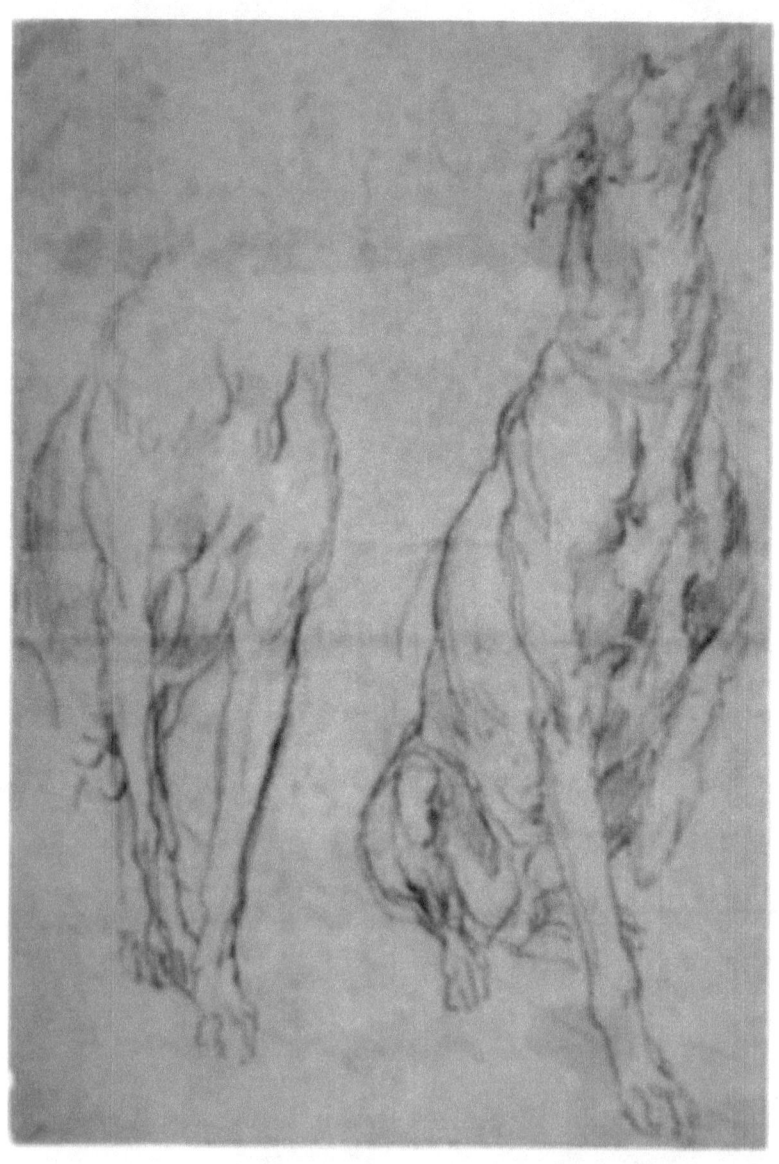

Studies of a Greyhound, 1633-1634, black chalk with white highlights

Anthony van Dyck

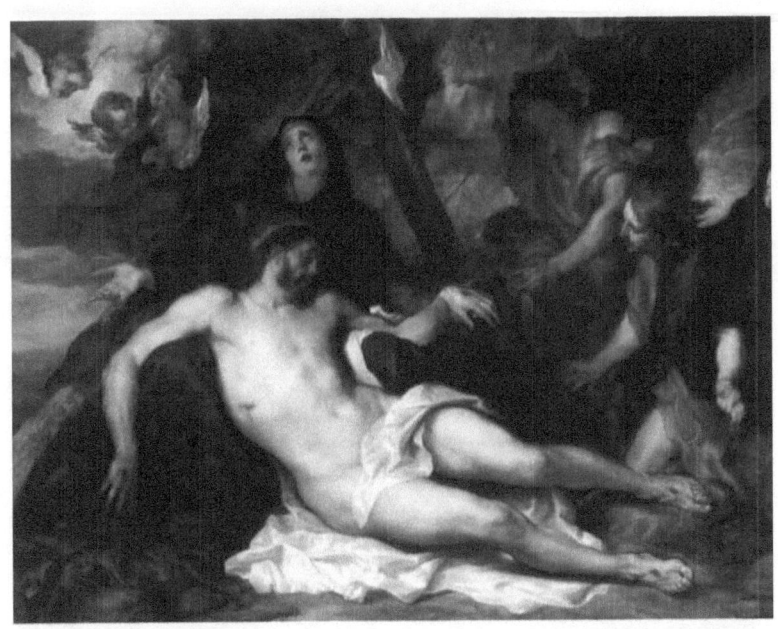

Deposition, 1634, oil on canvas

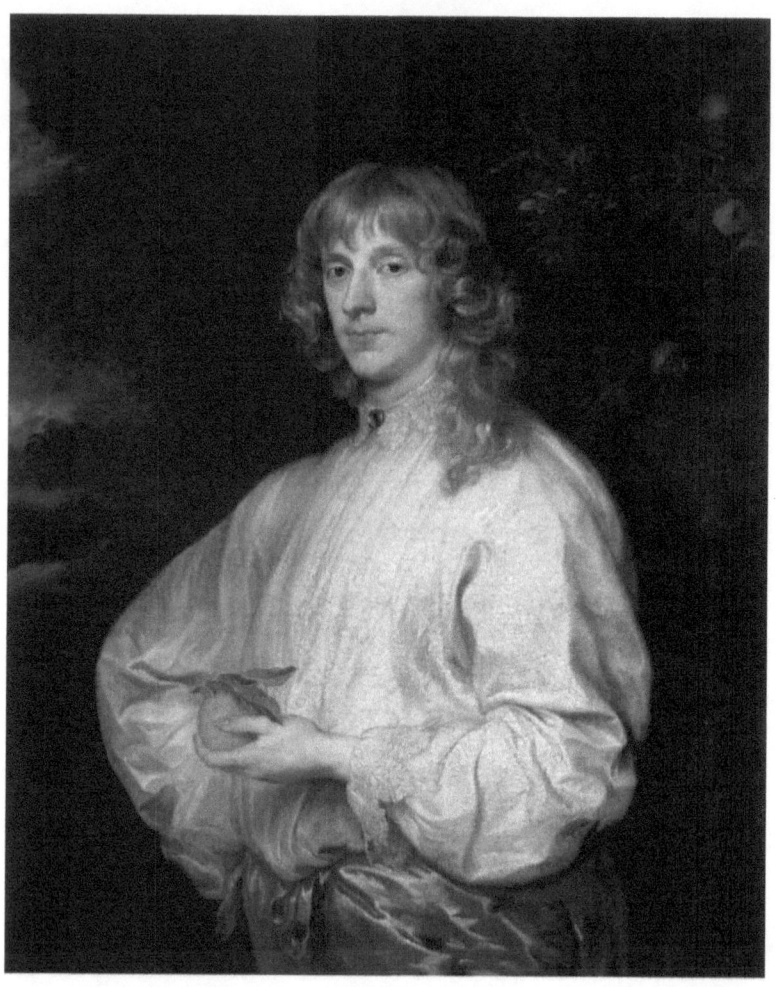

James Stuart, Duke of Richmond and Lennox with his Attributes, 1634, oil on canvas

Anthony van Dyck

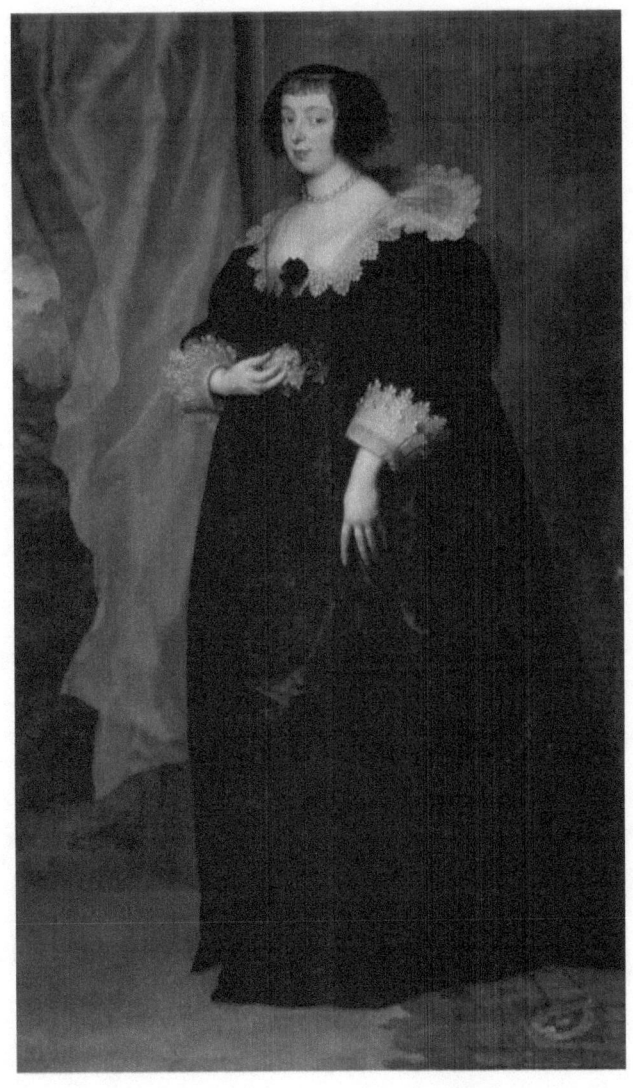

Portrait of Marguerite of Lorraine, Duchess of Orleans, 1634, oil on canvas

Margaret, a very self-possessed teenager of the ducal family of Lorraine, married Gaston d'Orlñans, the oldest surviving brother of Louis XIII of France, in 1632. Full-length portraits were reserved for royalty and the highest nobility; the curtain, in royal red, adds movement and indirectly calls attention to the rich black fabric of the princess's dress.

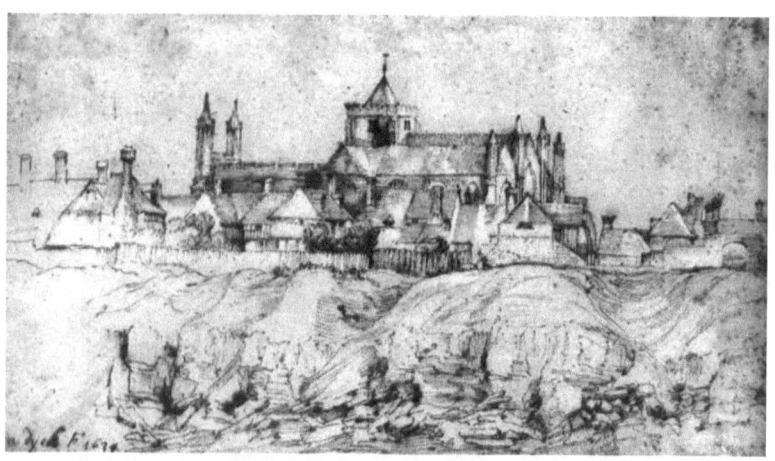

St. Mary's Church at Rye, England, 1634, pen drawing

Anthony van Dyck

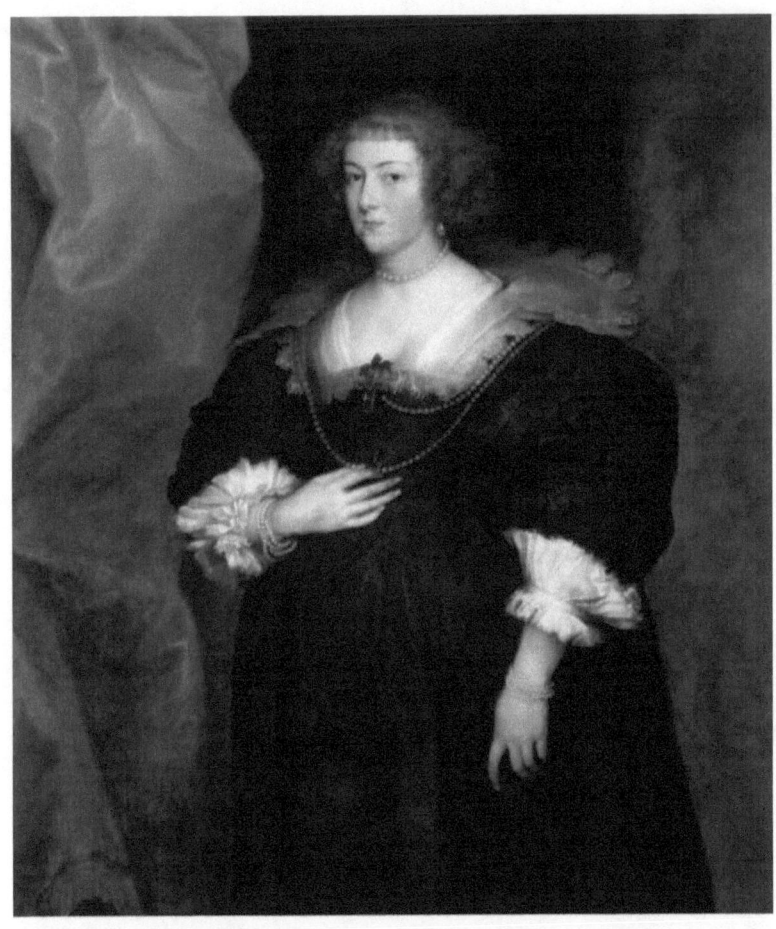

Portrait of a Lady, 1634-35, Oil on canvas, 140 x 107 cm
The sitter is probably Amelia of Solms, princess of
Orange.

Jessica Findley

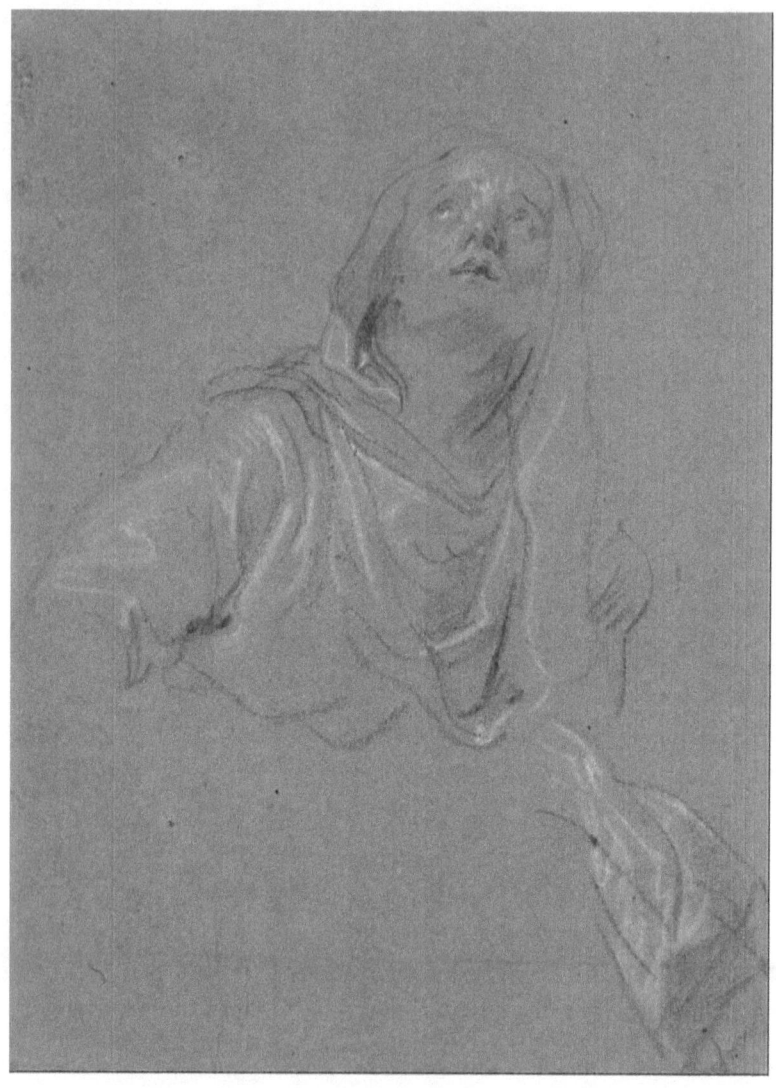

Study of a Madonna looking upward, 1634 - 1635, Black chalk with white highlights on blue paper

Anthony van Dyck

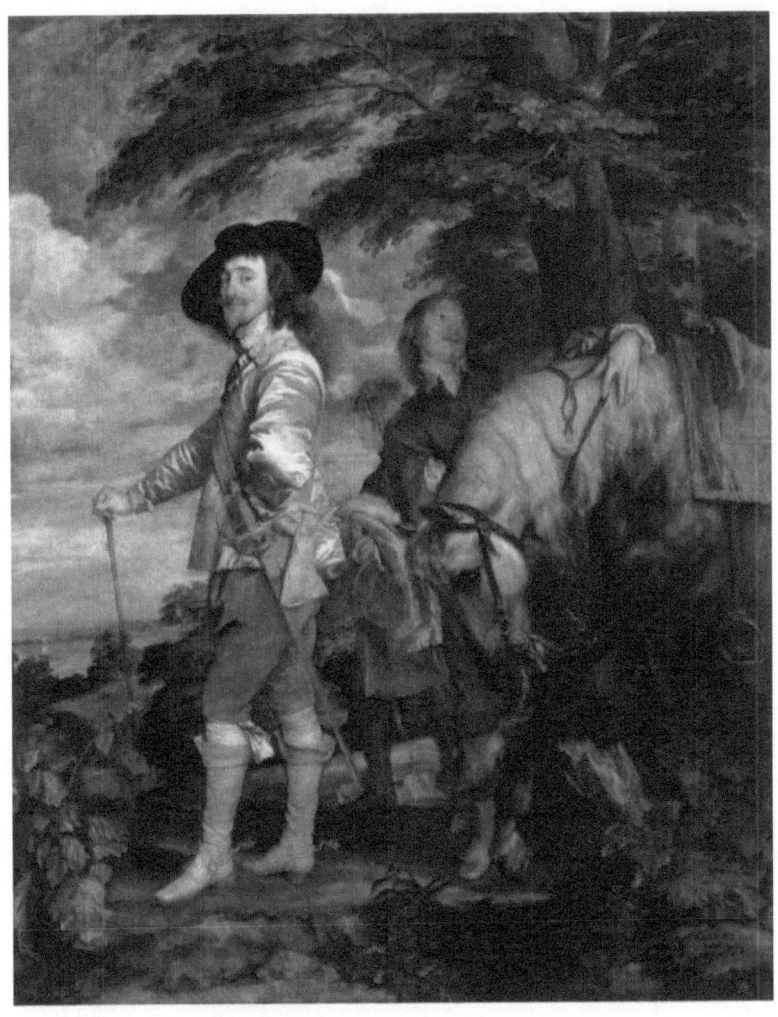

Charles I, King of England at the Hunt, 1635, oil on canvas

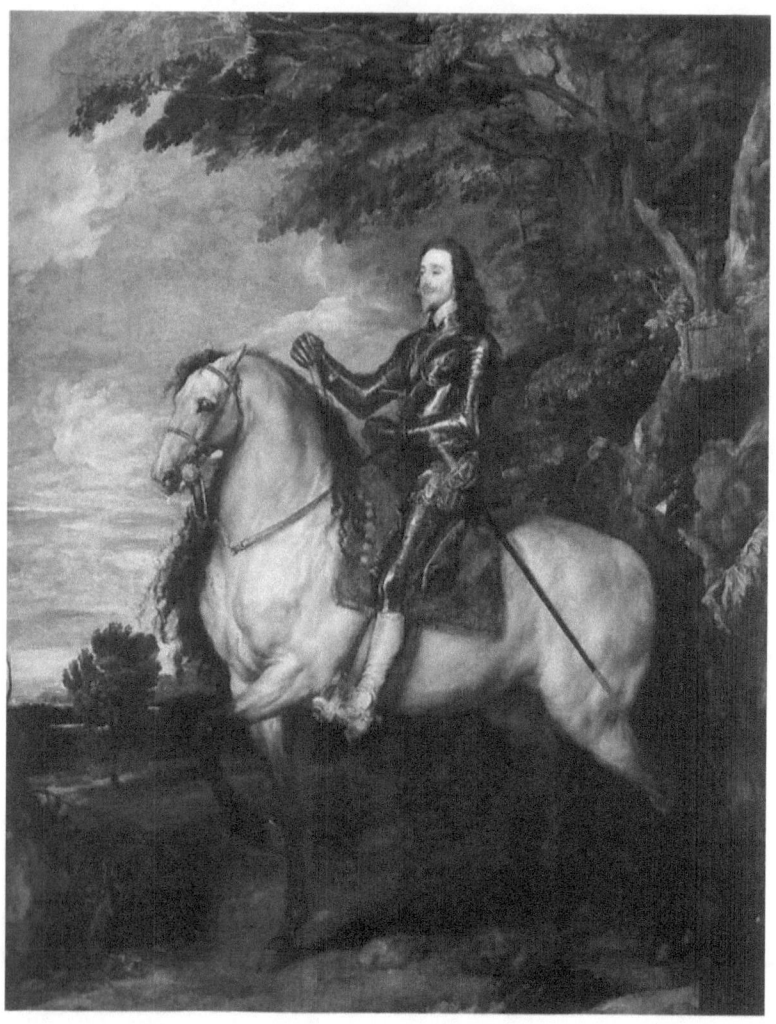

Charles I on Horseback, c. 1635, Oil on canvas, 365 x 289 cm

Anthony van Dyck

This likeness of the king on horseback takes as its point of departure the archetypal image on the obverse of all the Great Seals of England: the sovereign as warrior. King Charles is wearing Greenwich-made armour and holding a commander's baton. A page carries his helmet. In keeping with the imperial claim of the inscription (in Latin on the tablet tied to the tree in this portrait: CAROLUS REX MAGNAE BRITANIAE - Charles King of Great Britain), the pose and woodland setting echo Titian's equestrian portrait of the Emperor Charles V at Muhlberg. (Titian's painting itself recalled the famous Roman bronze of the Emperor Marcus Aurelius on horseback.) Over his armour Charles wears a gold locket bearing the image of Saint George and the Dragon, the so-called Lesser George. He wore it constantly; it contained a portrait of his wife, and was with him the day he died. Here, however, it identifies him with the Order of the Garter of which Saint George was patron. As Garter Sovereign he is riding, like Charles V, at the head of his chivalrous knights in defence of the faith. In a profound sense the portrait is a visual assertion of Charles's claim to Divine Kingship. Albeit high above our heads - the horizon line ensures that our viewpoint is roughly at the level of his stirrup - his face is undistorted by foreshortening. Van Dyck's three-quarter view refines his features, and he bestrides his horse with a remote air of noble contemplation.

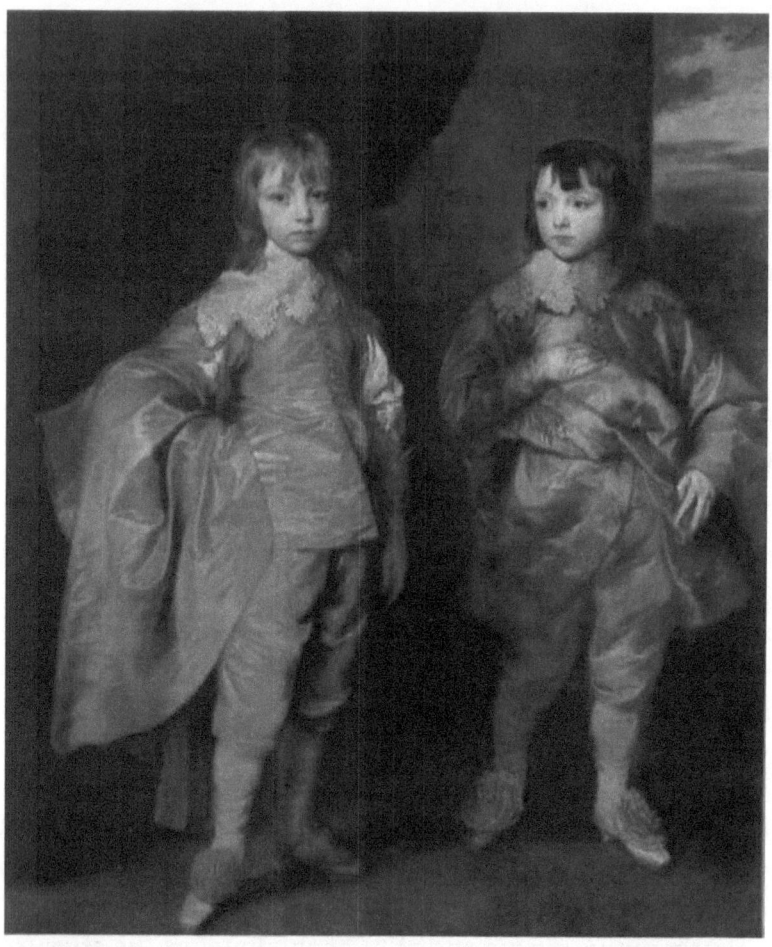

George Villiers, 2nd Duke of Buckingham and His Brother Lord Francis Villiers, 1635, oil on canvas

Anthony van Dyck

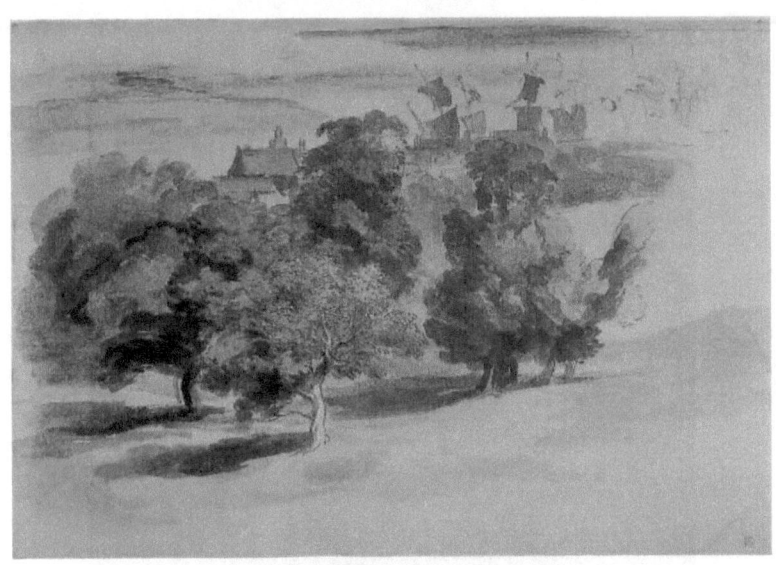

An English Landscape
1635, watercolor and gouache with pen and ink

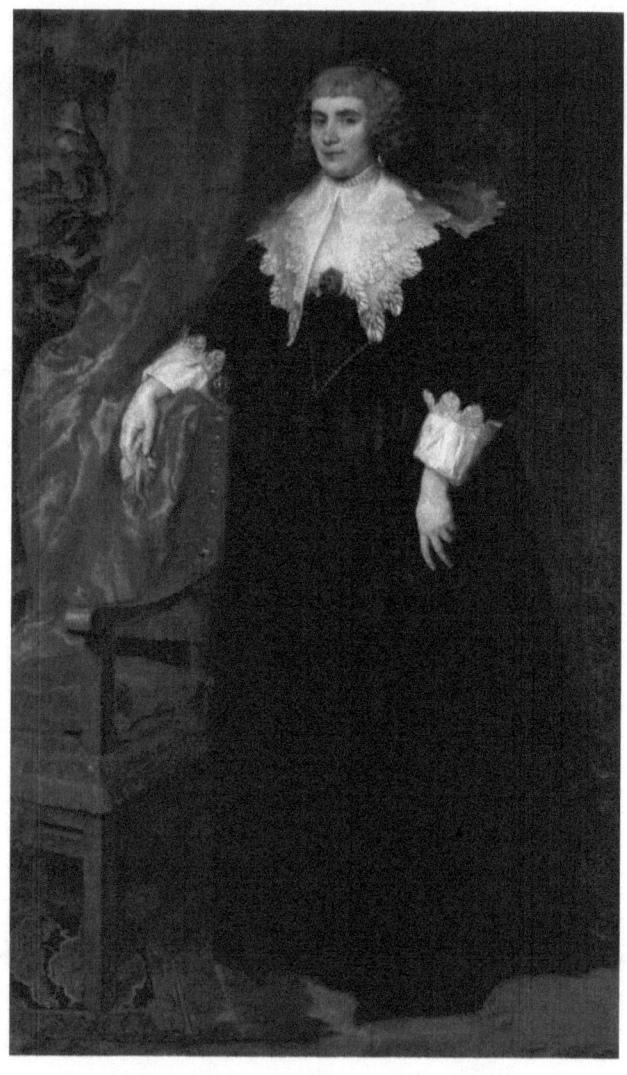

Portrait of Anna van Craesbecke, 1635, oil on canvas

Anthony van Dyck

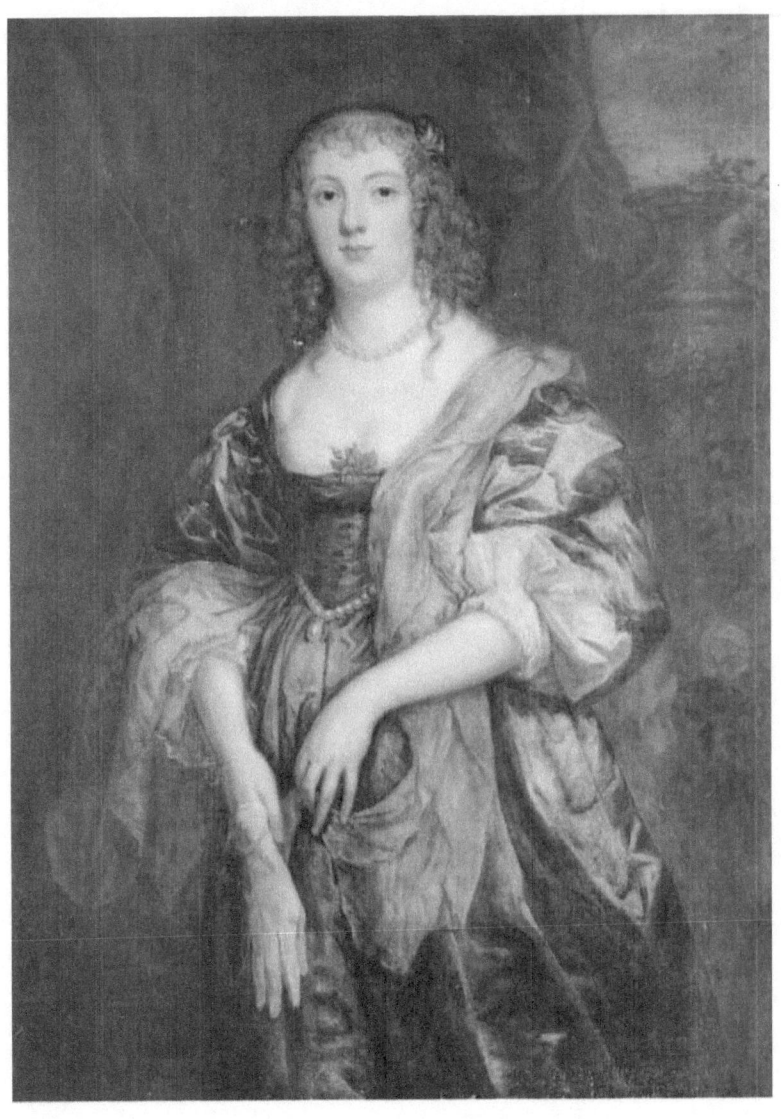

Portrait of Anne Carr, Countess of Bedford, 1635, oil on canvas

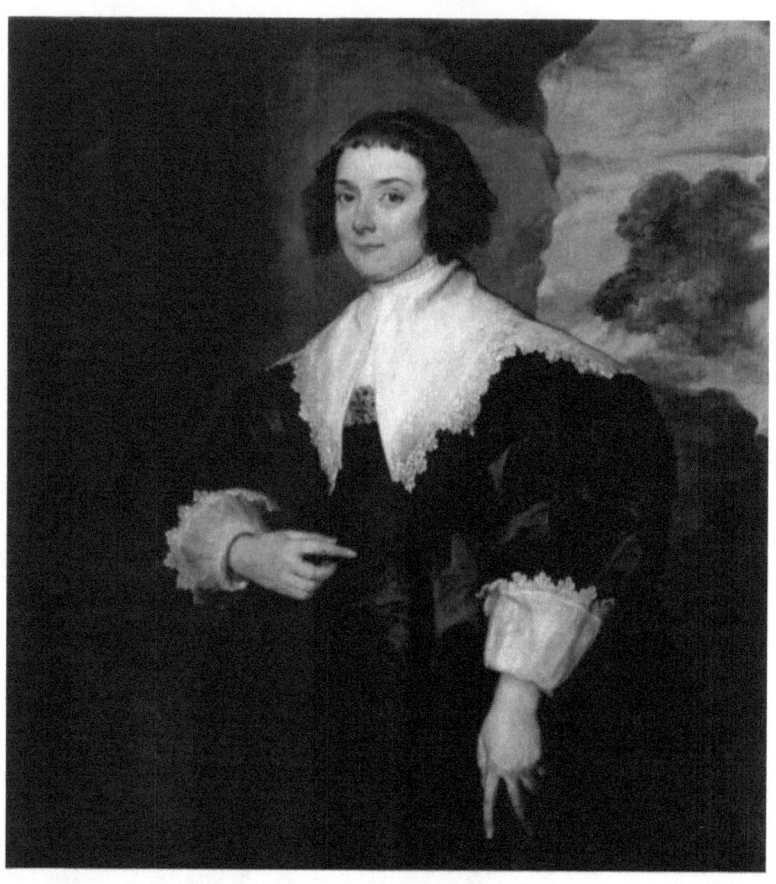

Portrait of Isabella van Assche, Wife of Justus van
Meerstraten, 1635, oil on canvas

Anthony van Dyck

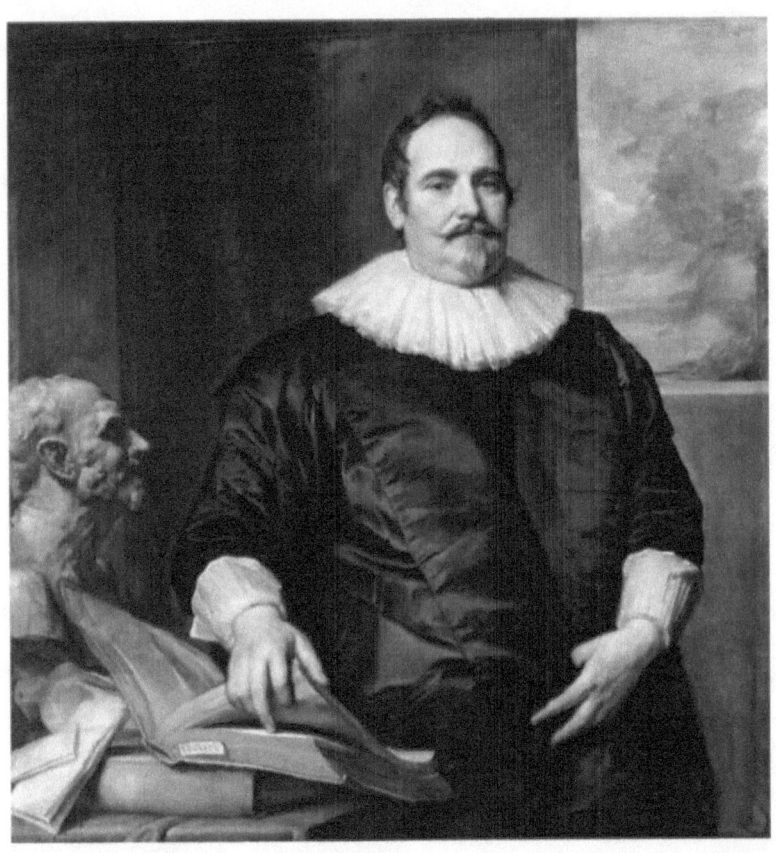

Portrait of Justus van Meerstraeten, 1635, oil on canvas

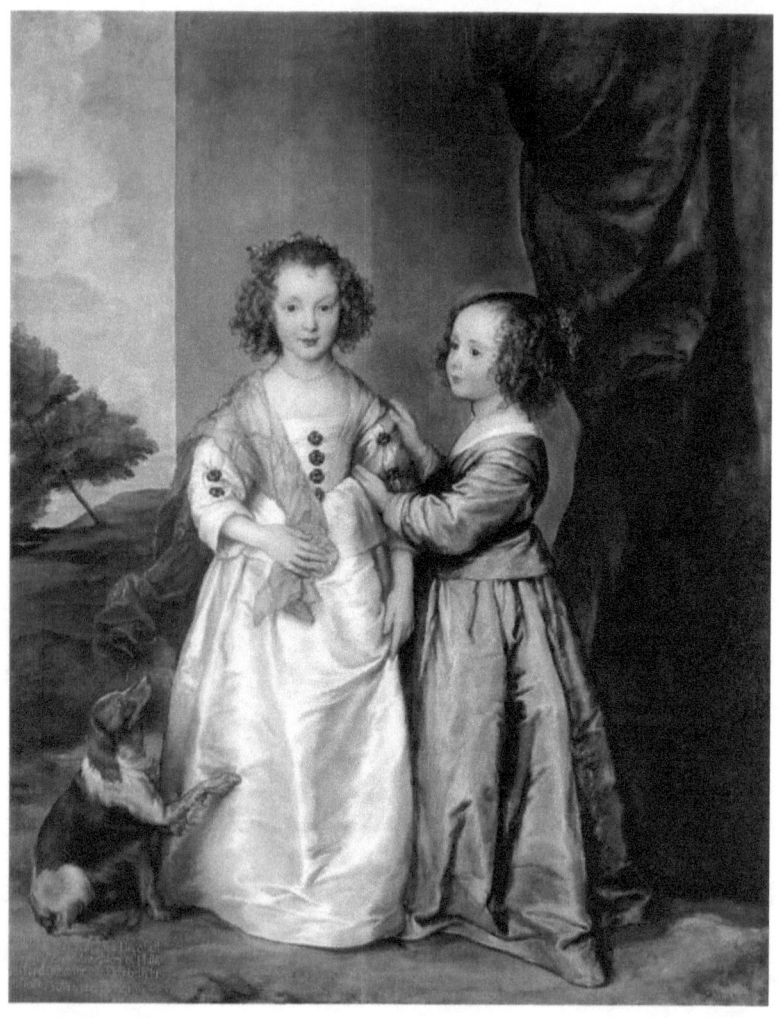

Portrait of Philadelphia and Elisabeth Cary, 1635, oil on canvas

Anthony van Dyck

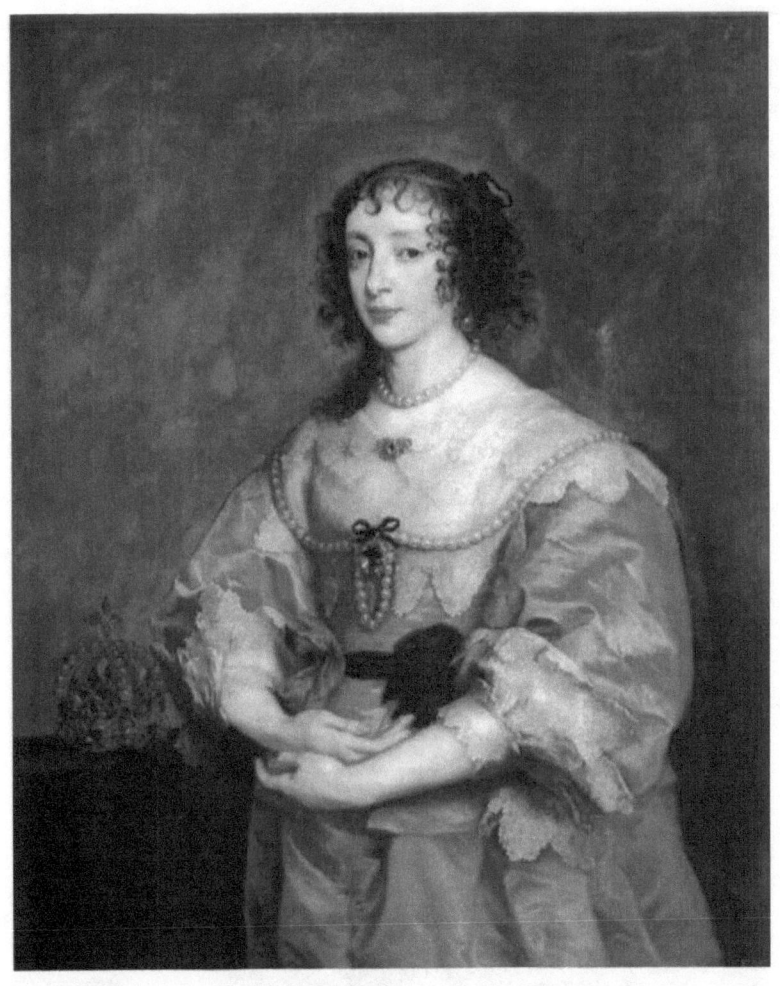

Queen Henrietta Maria, 1635, oil on canvas

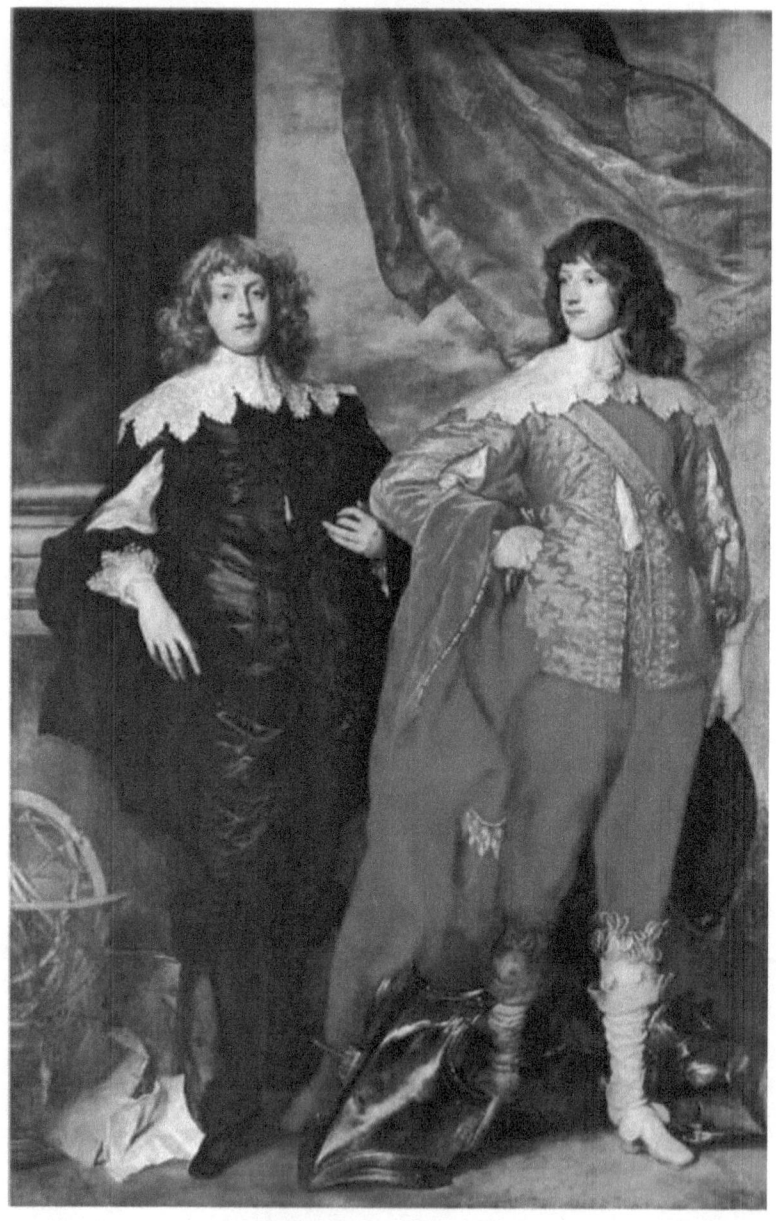

George Digby, 2nd Earl of Bristol and William Russell, 1st Duke of Bedford, 1637, oil on canvas

Anthony van Dyck

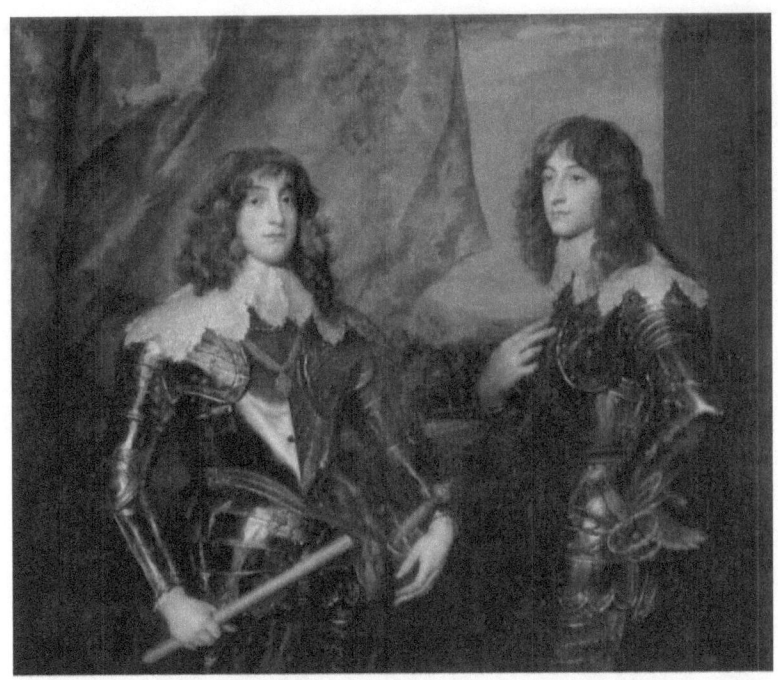

Portrait of the Princes Palatine Charles Louis I and his Brother Robert, 1637, oil on canvas

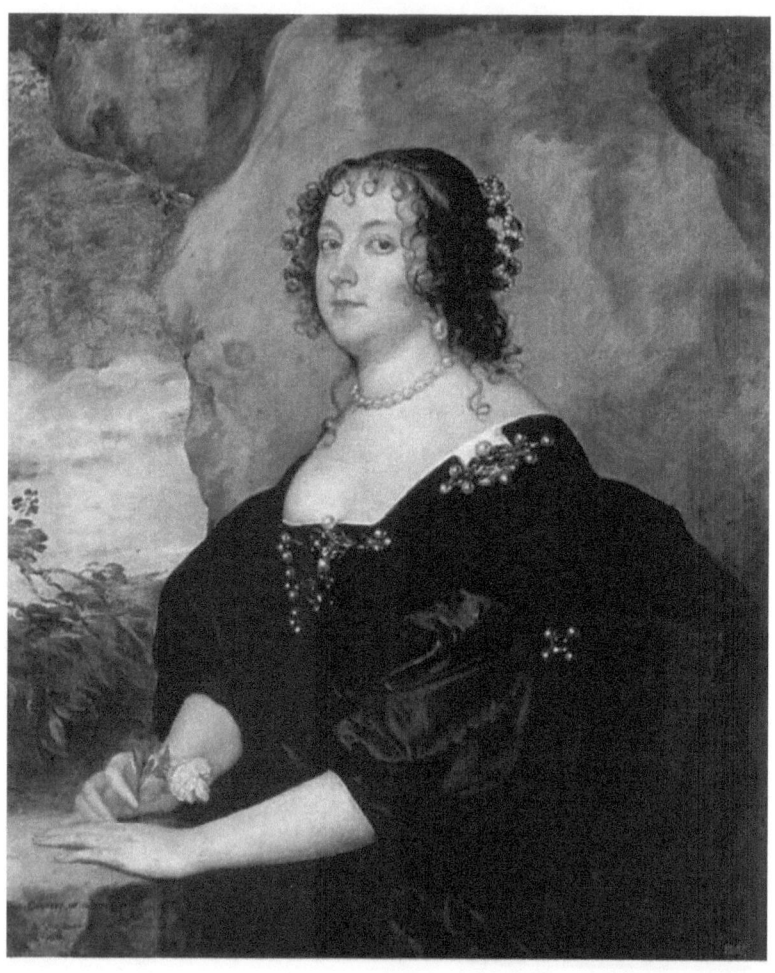

Diana Cecil, Countess of Oxford, 1638, oil on canvas

Anthony van Dyck

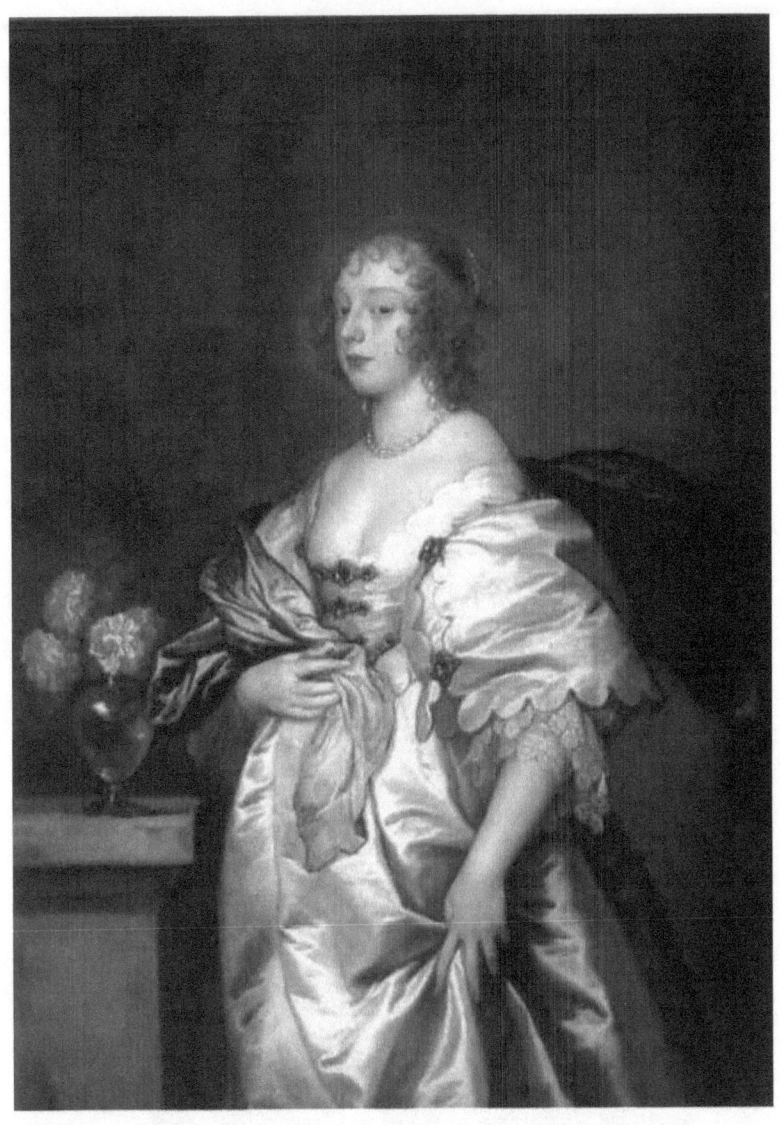

Lady Borlase, 1638, oil on canvas

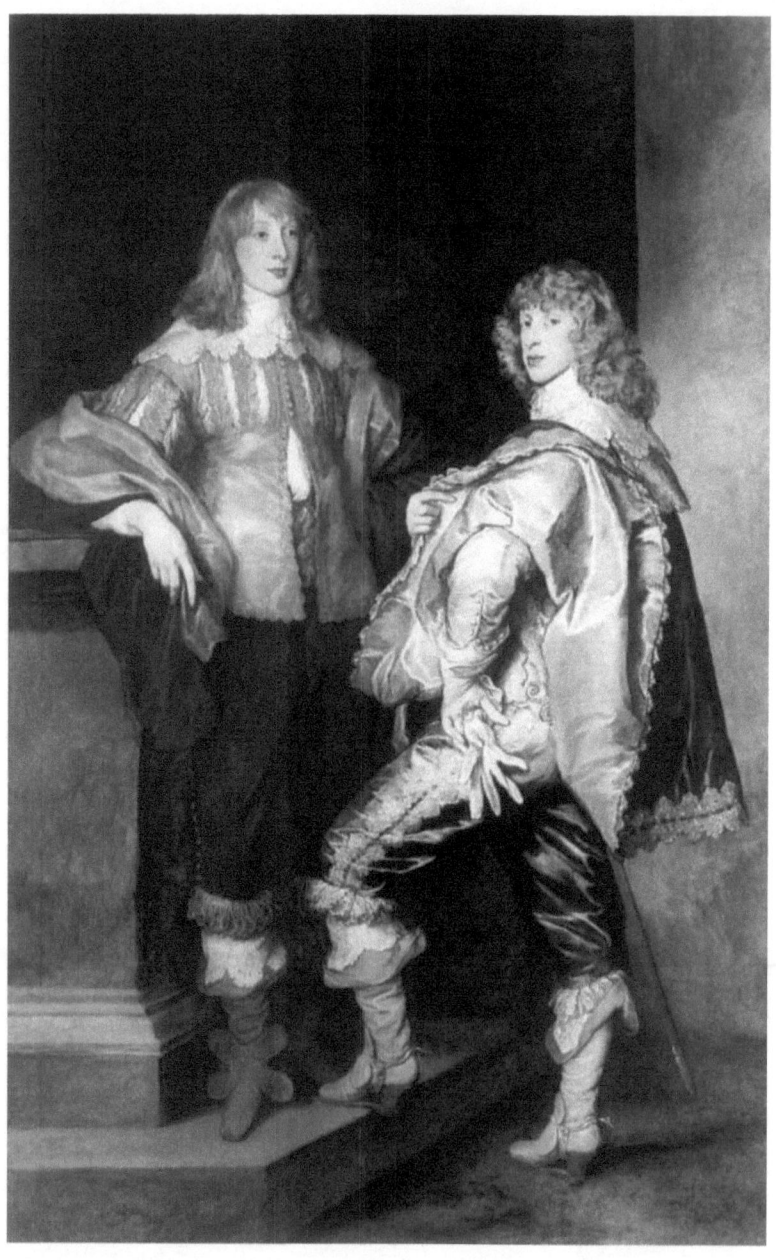

Lord John and Lord Bernard Stuart, 1638, oil on canvas

Anthony van Dyck

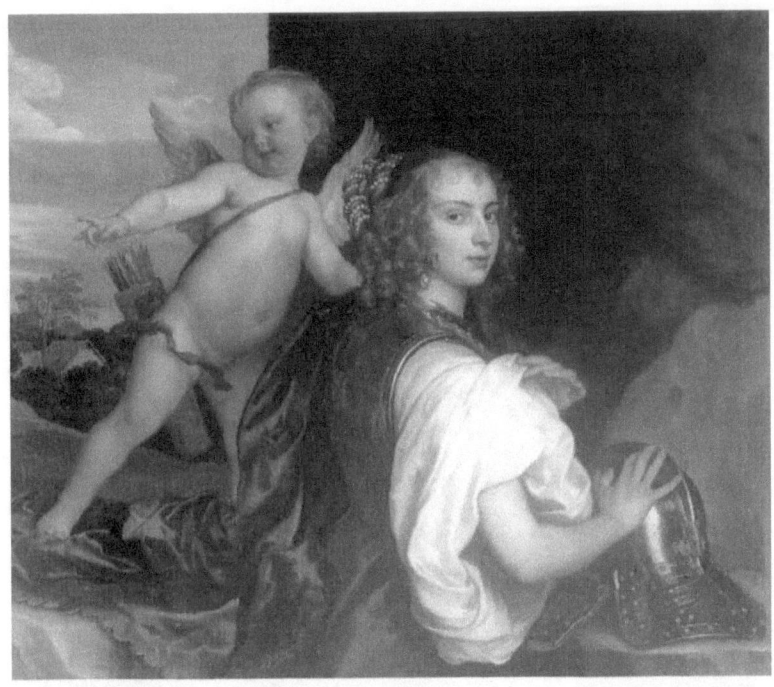

Portrait of a Girl as Erminia Accompanied by Cupid,
1638, oil on canvas

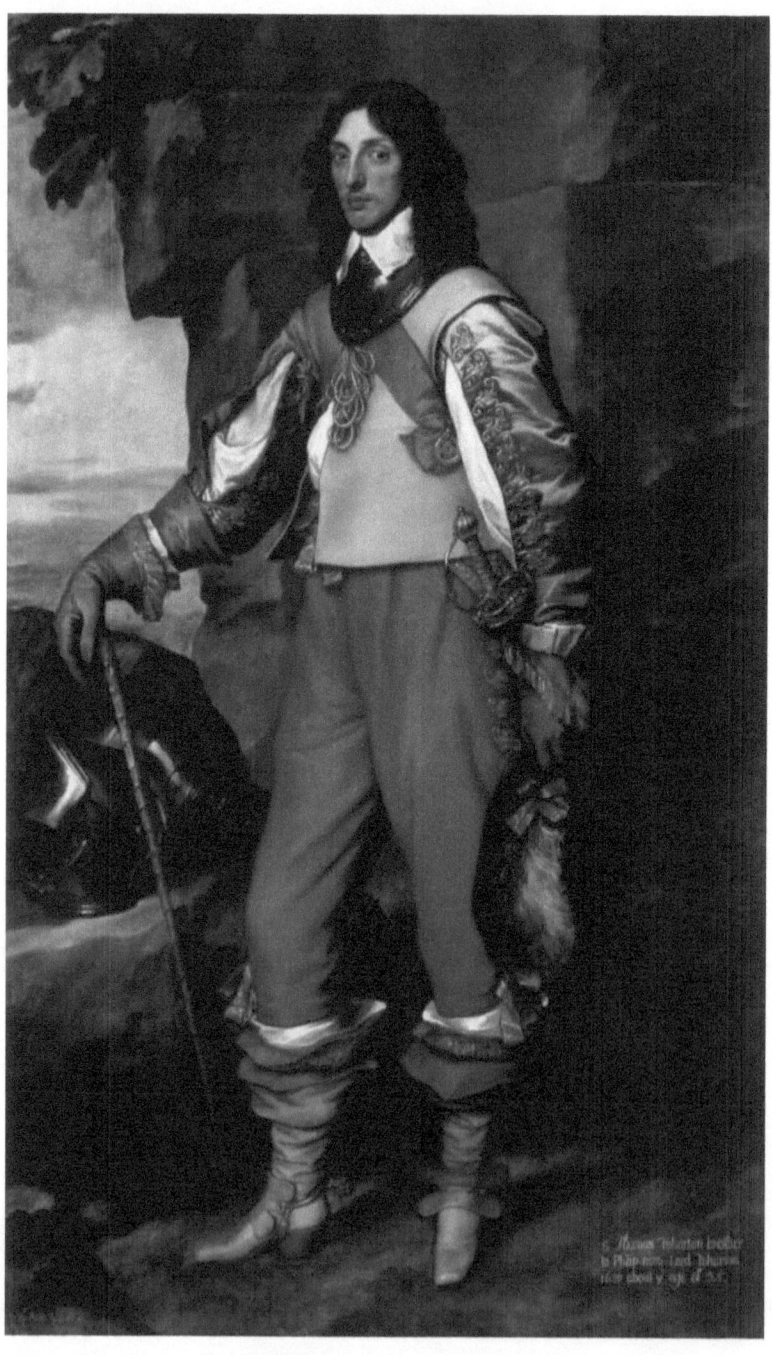

Anthony van Dyck

Portrait of Sir Thomas Wharton, 1636-39, Oil on canvas, 217 x 128 cm

As court painter to Charles I of England between 1632 and 1641 van Dyck fully revealed his talent for formal portraiture. In his depictions of English aristocrats, the subjects' lofty status and strong qualities are conveyed not just by pose and attributes, but also by purely painterly features: resonant colour combinations, exquisite texture, and free brushwork. A devotion to a grand style that permitted an artistically uninhibited manner became, through van Dyck's example, a distinguishing feature of English painting.

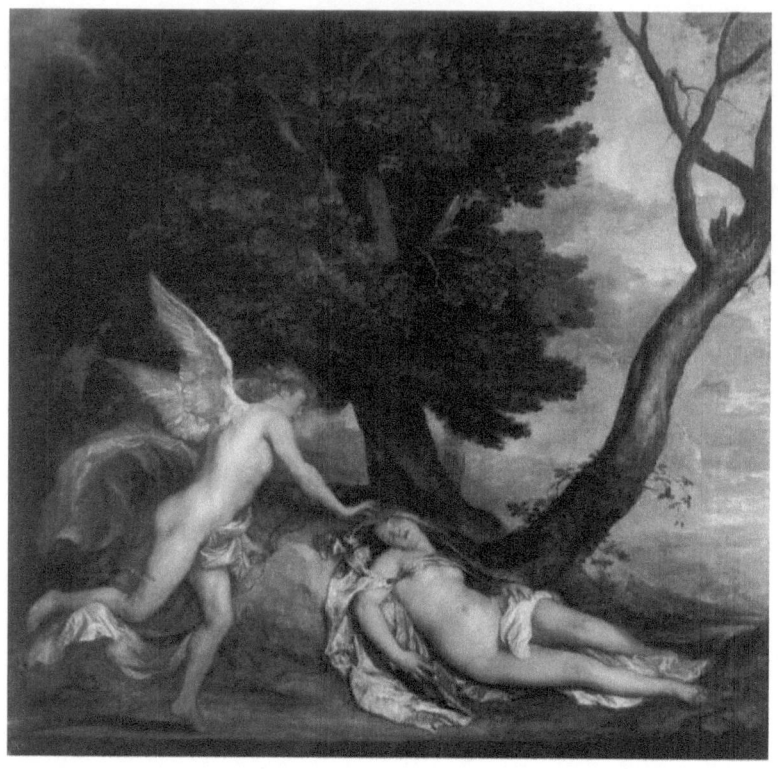

Cupid and Psyche, 1640, oil on canvas

Anthony van Dyck

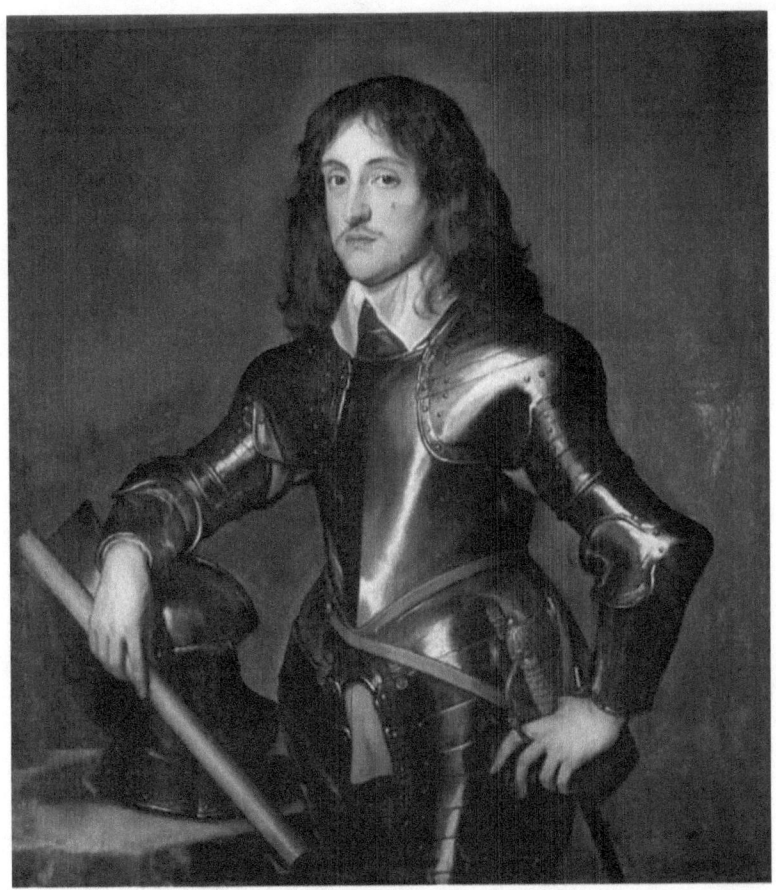

Portrait of Prince Charles Louis, Elector Palatine, 1641, oil on canvas

The sitter of this portrait is the young Prince Charles Louis (1617-1680), the nephew of King Charles I. The excellent portrait was painted directly from the life in London a few months before the death of van Dyck.

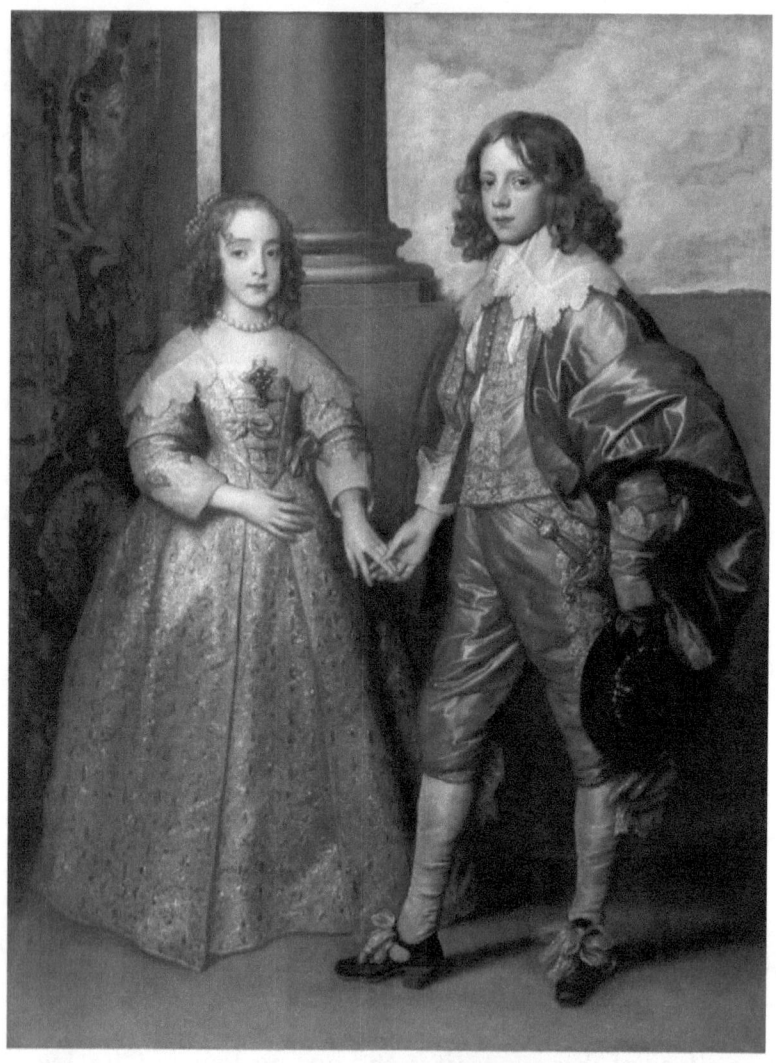

William II, Prince of Orange and Princess Henrietta Mary Stuart, daughter of Charles I of England, 1641, oil on canvas

Anthony van Dyck

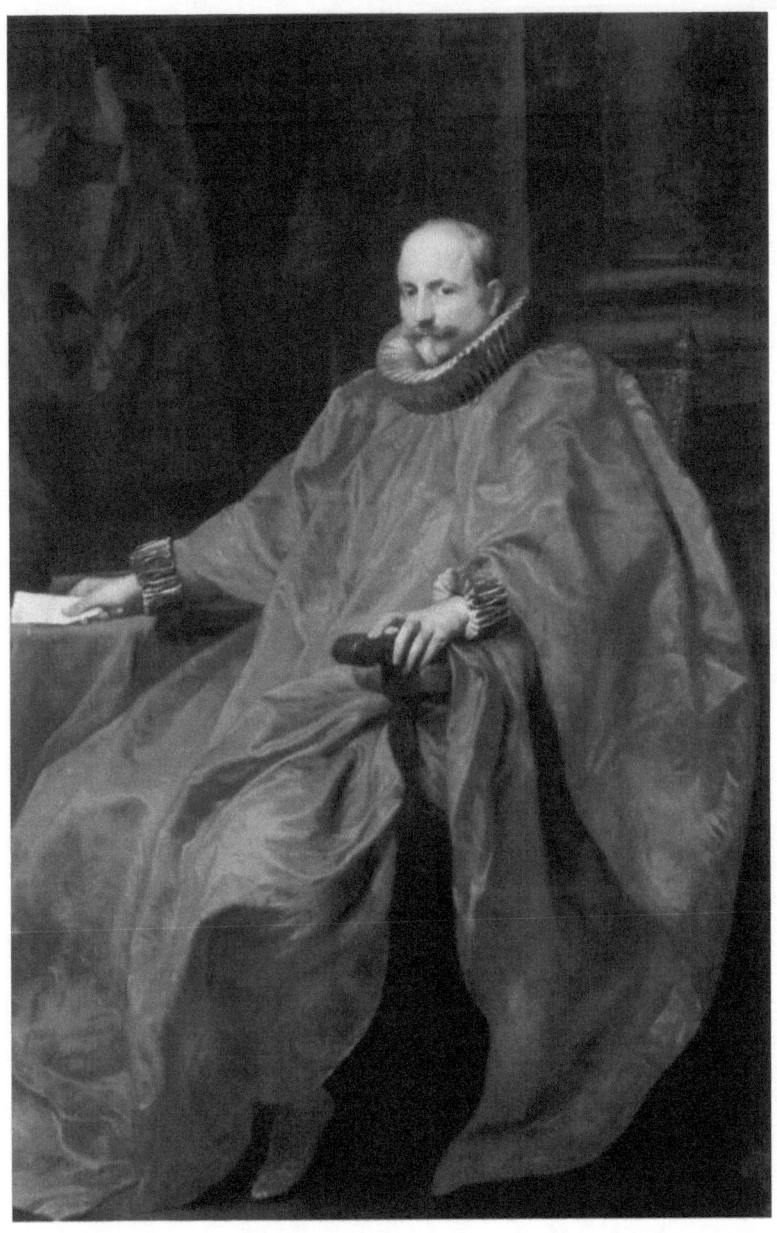

Agostino Pallavicini, oil on canvas

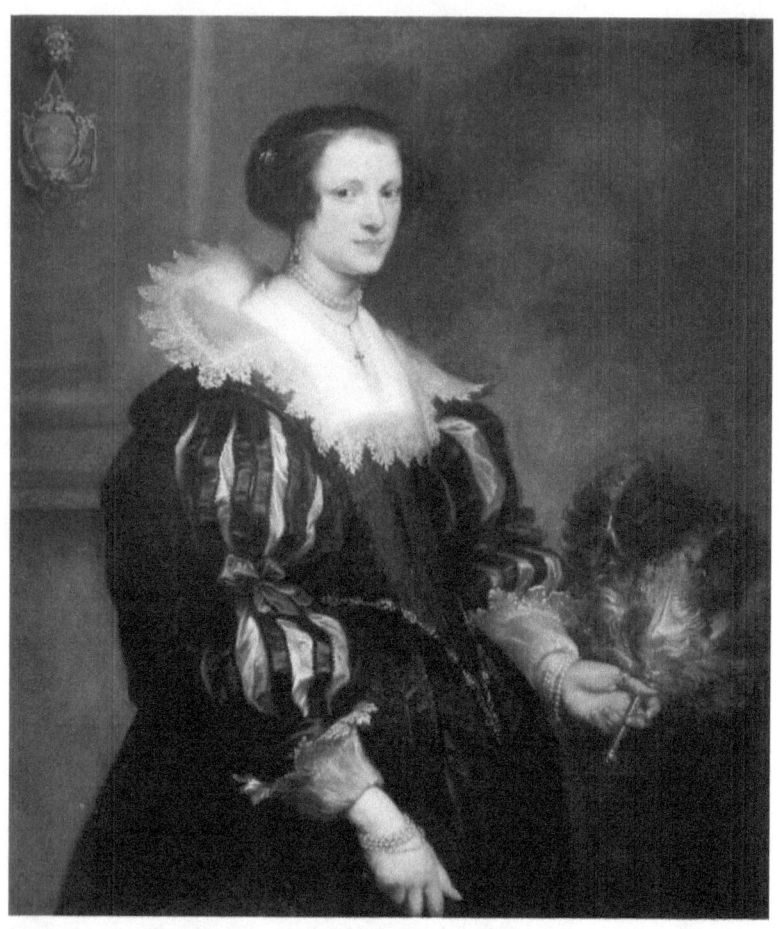

Anna Wake, oil on canvas

Anthony van Dyck

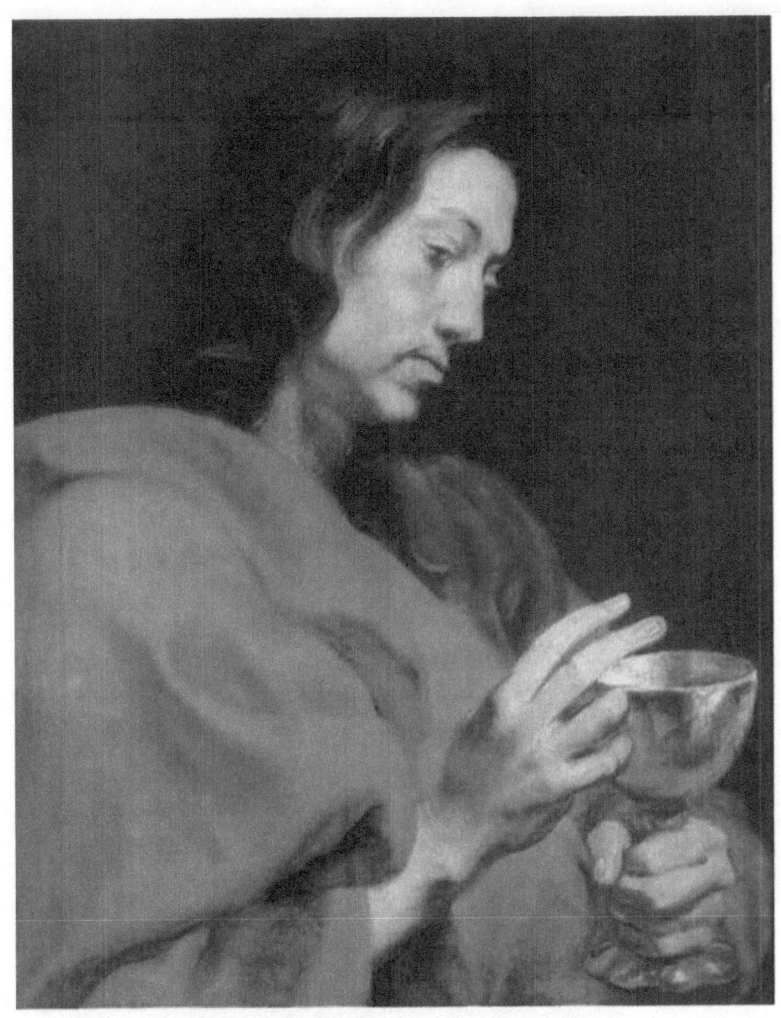

Evangelist John, oil on canvas

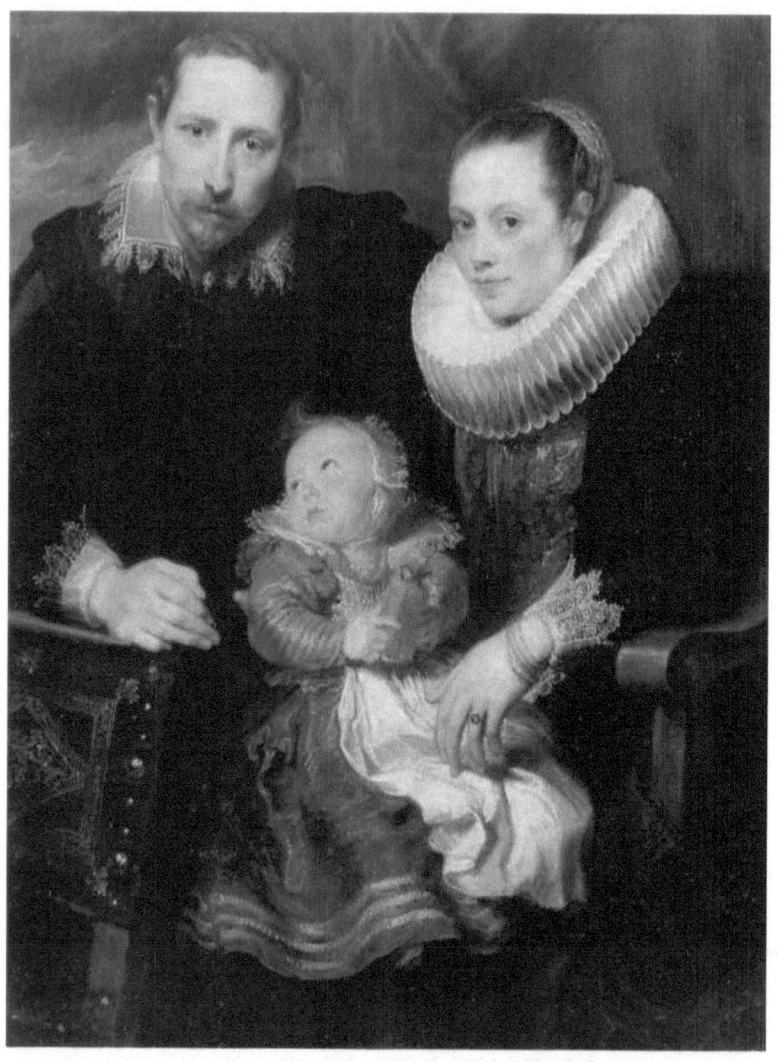

Family Portrait, oil on canvas

Anthony van Dyck

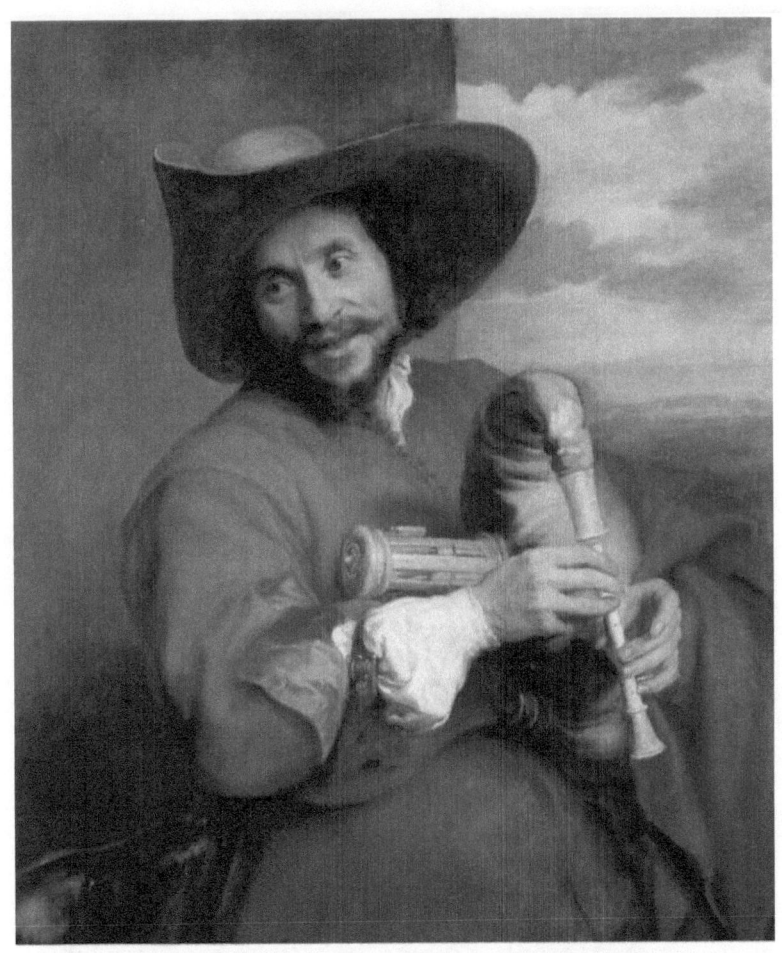

Franɜois Langlois, oil on canvas

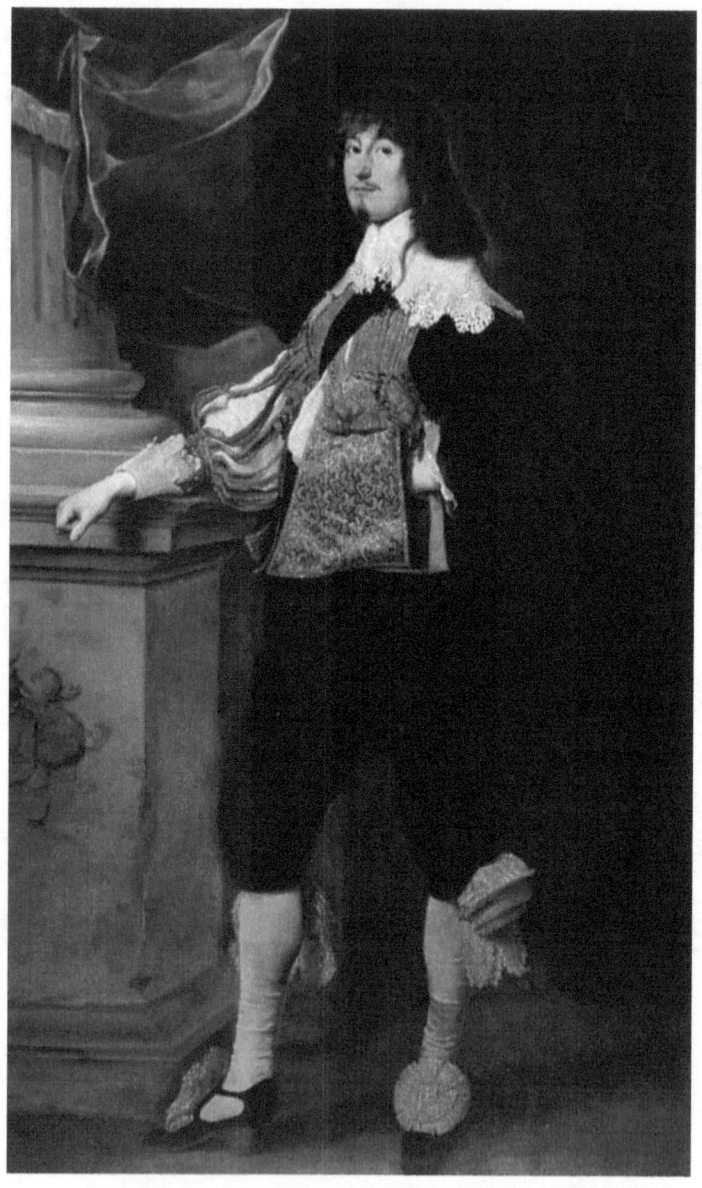

Johan Oxenstierna, oil on canvas

Anthony van Dyck

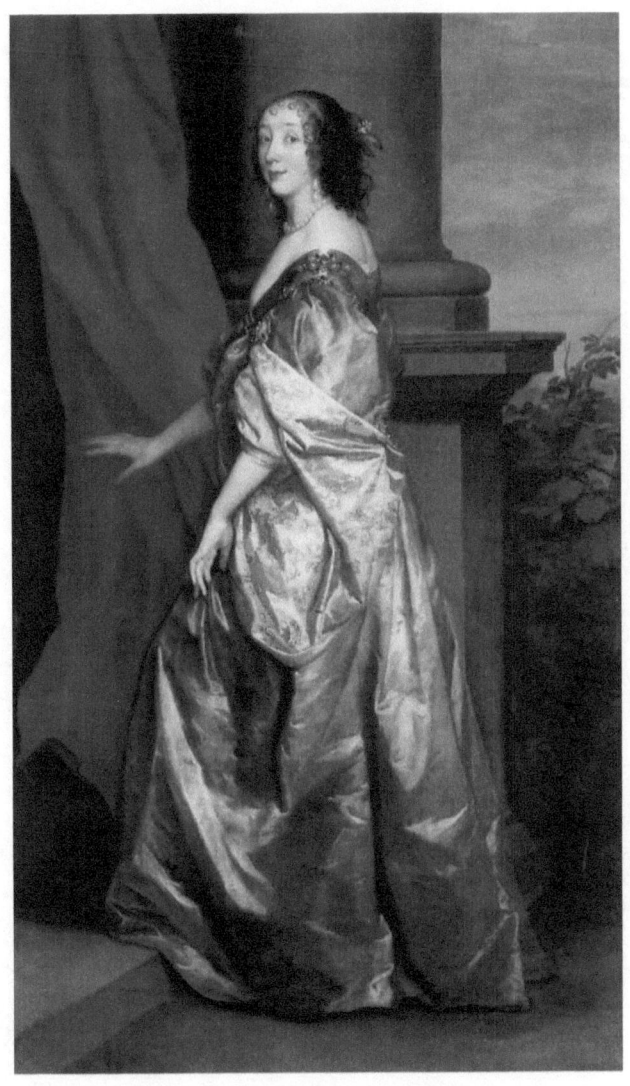

Lady Lucy Percy, oil on canvas

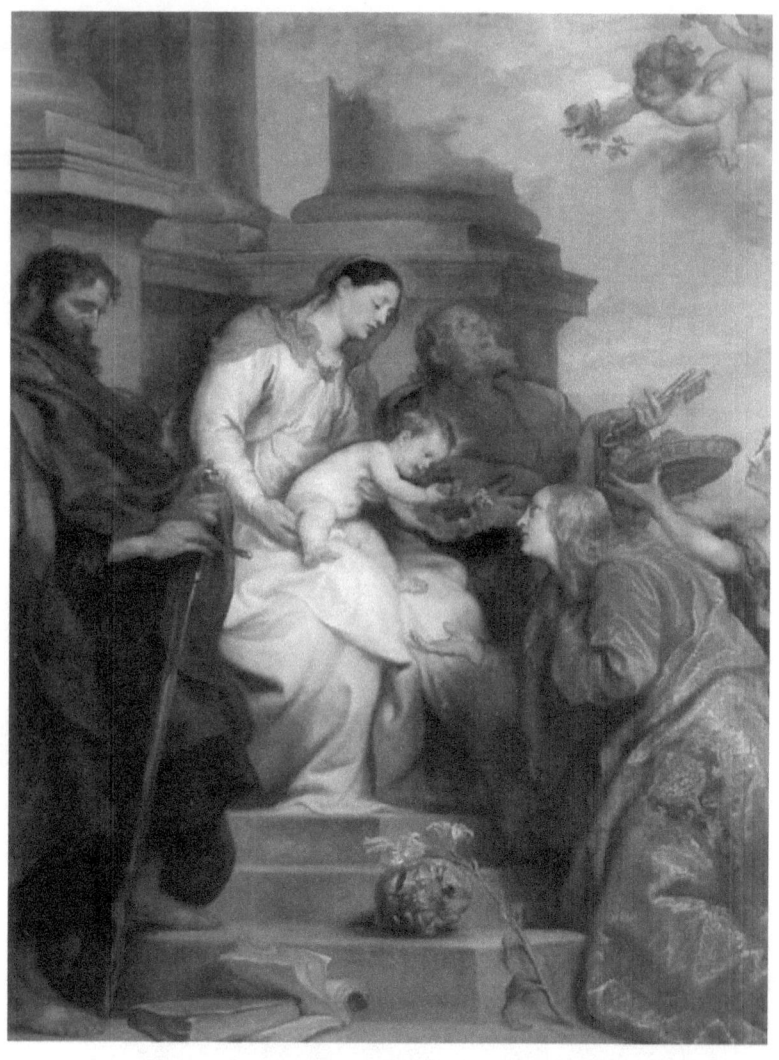

Maria and child and Saints, oil on canvas

Anthony van Dyck

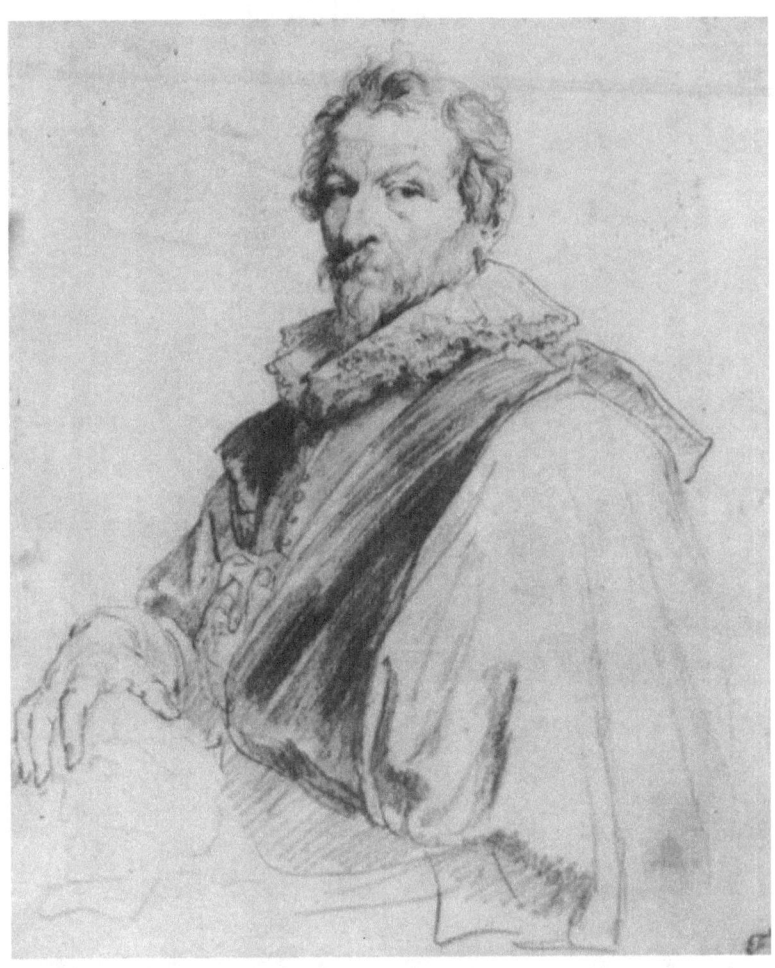

Portrait of the painter Hendrik van Balen, Black chalk on paper

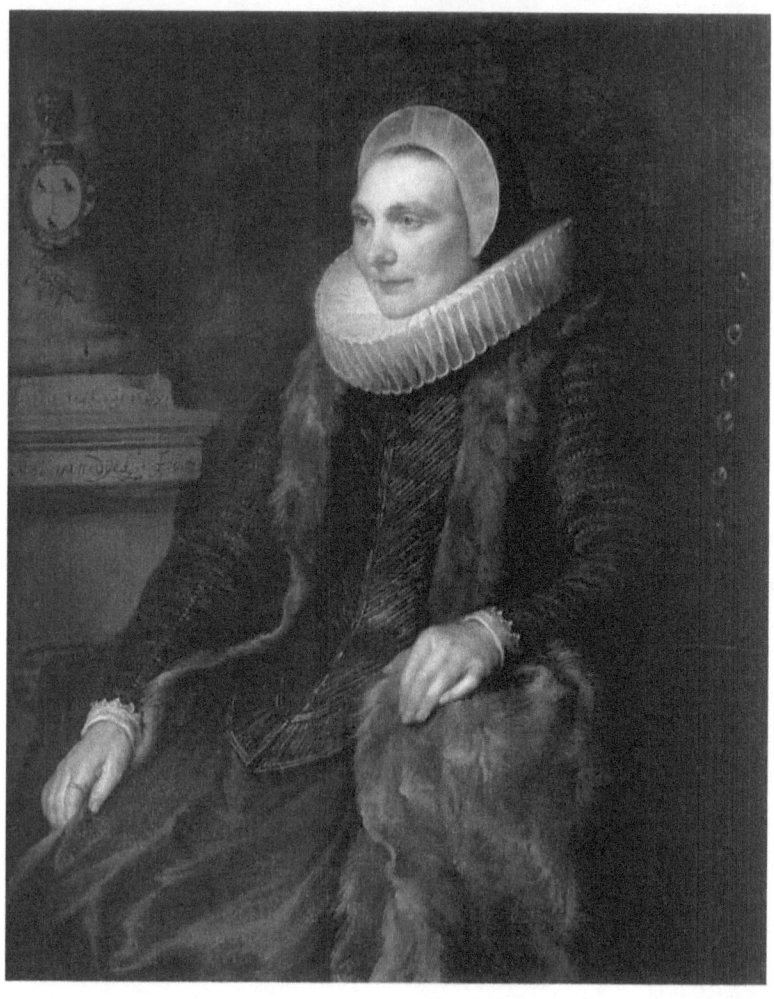

Maria Bosschaerts, Wife of Adriaen Stevens, oil on canvas

Anthony van Dyck

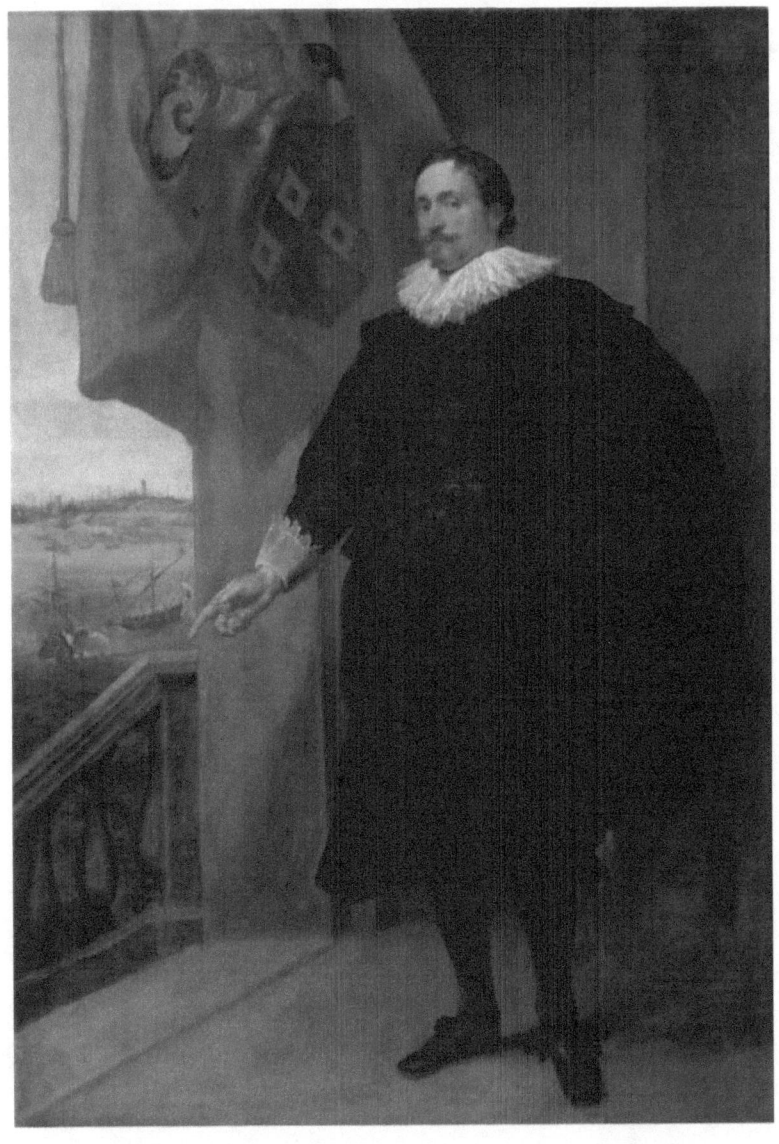

Nicolaes van der Borght, Merchant of Antwerp, oil on canvas

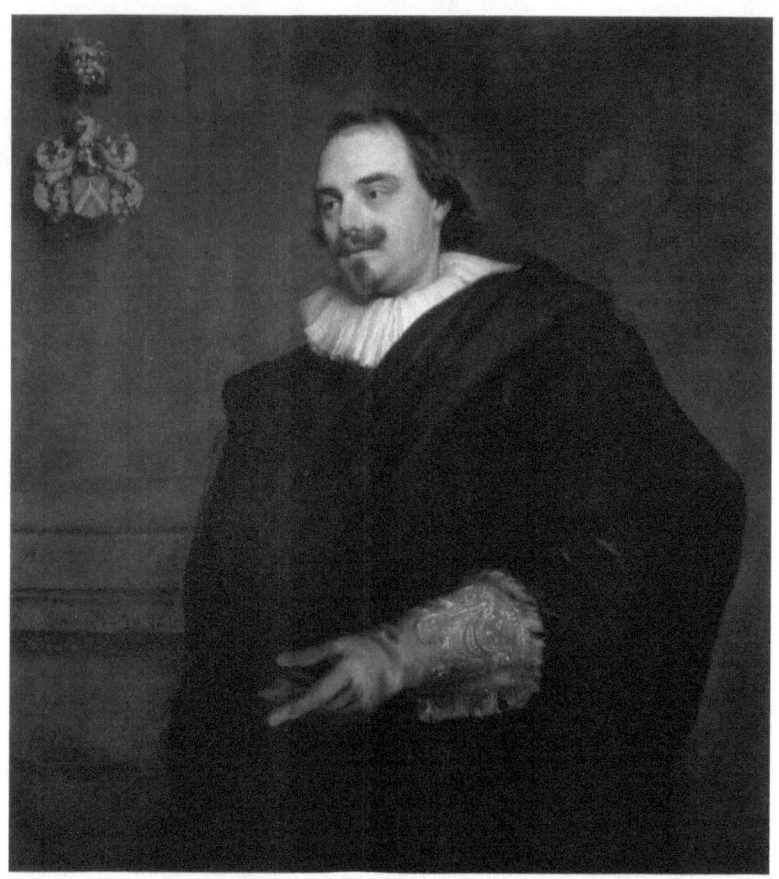

Pieter Stevens, oil on canvas

Anthony van Dyck

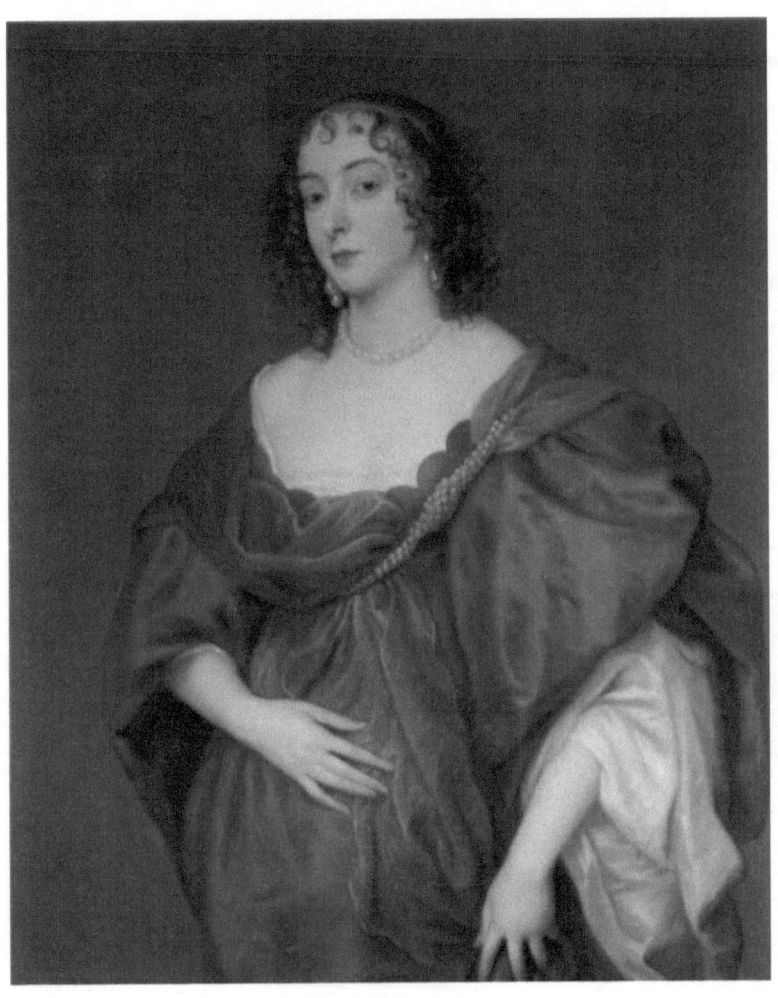

Portrait of a Lady, oil on canvas

Jessica Findley

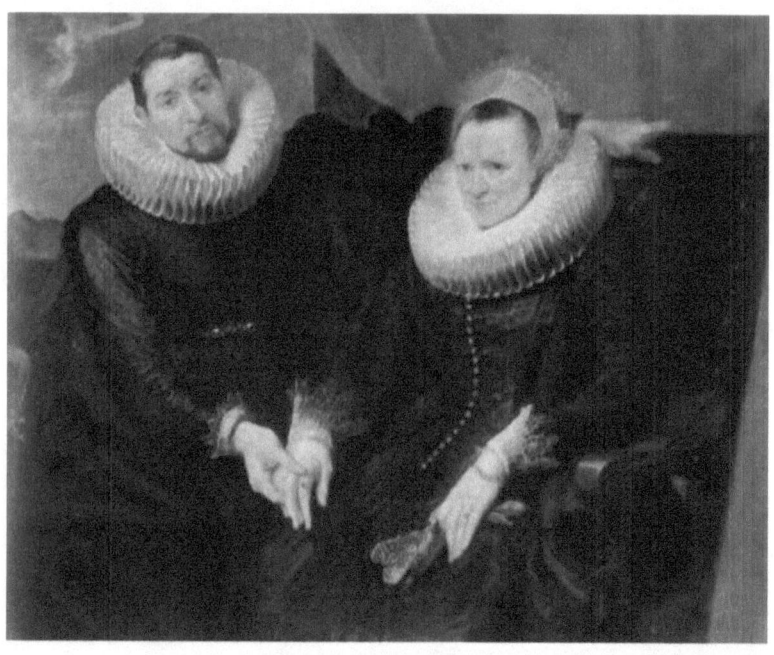

Portrait of a Married Couple, oil on canvas

Anthony van Dyck

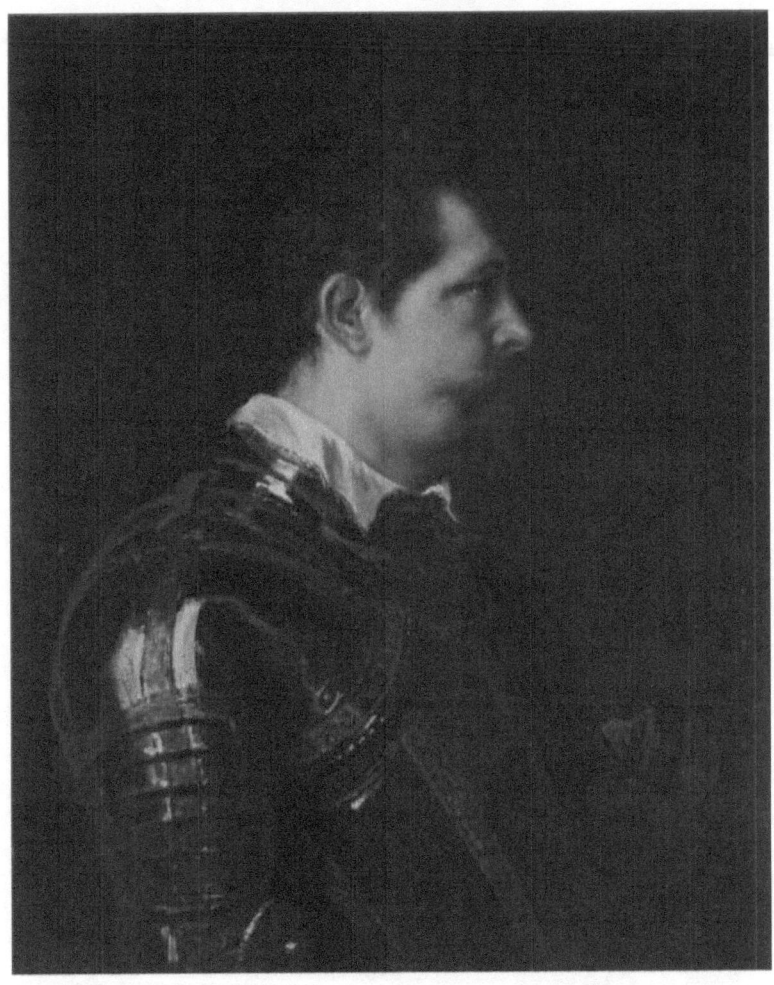

Portrait of a Military Commander bust length in Profile in Damascened armour with white colland red sash, oil on canvas

Jessica Findley

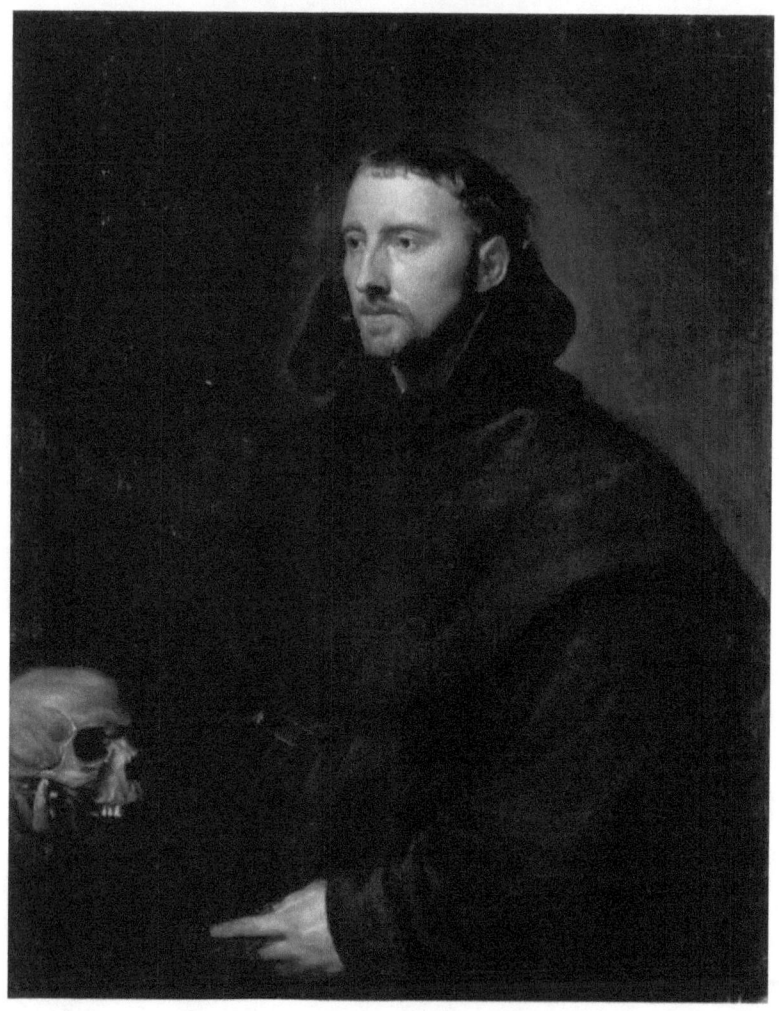

Portrait Of A Monk Of The Benedictine Order, Holding A Skull, oil on canvas

Anthony van Dyck

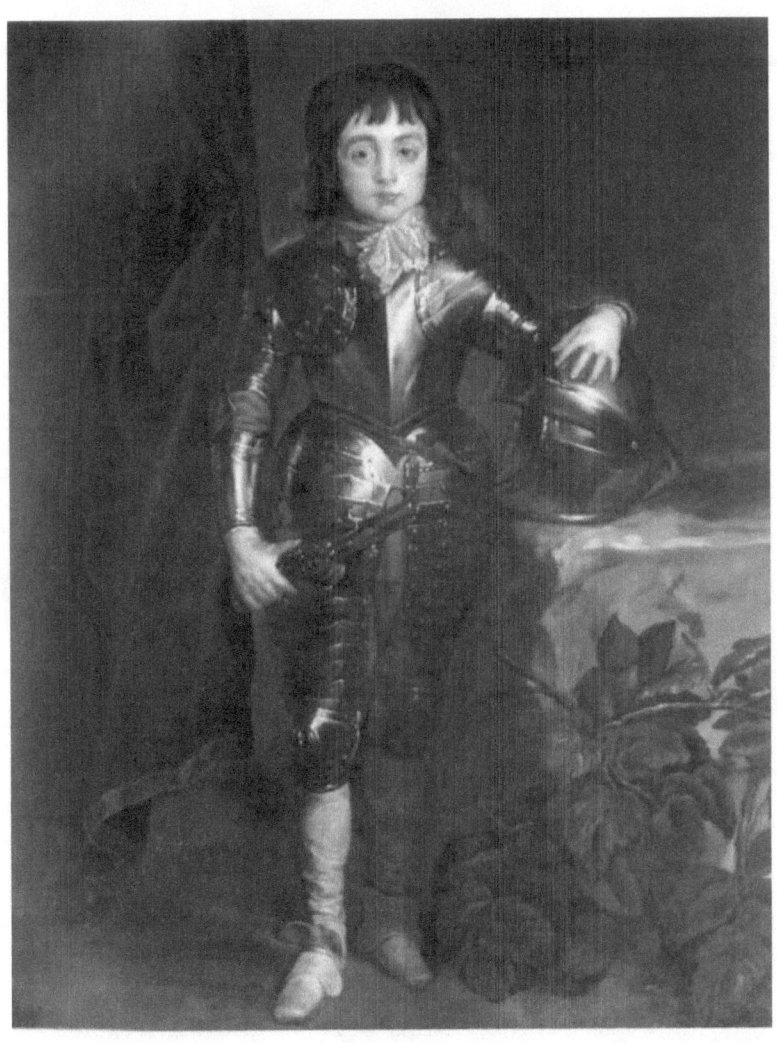

Portrait of Charles II When Prince of Wales, oil on canvas

Jessica Findley

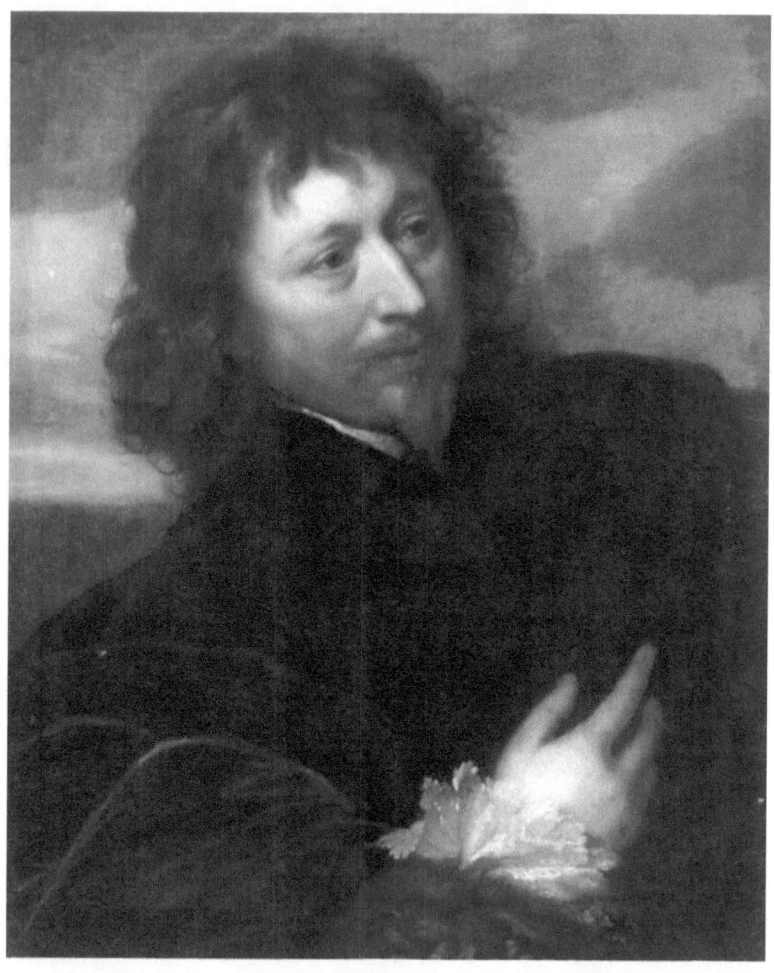

Portrait of Endymion Porter, oil on canvas

Anthony van Dyck

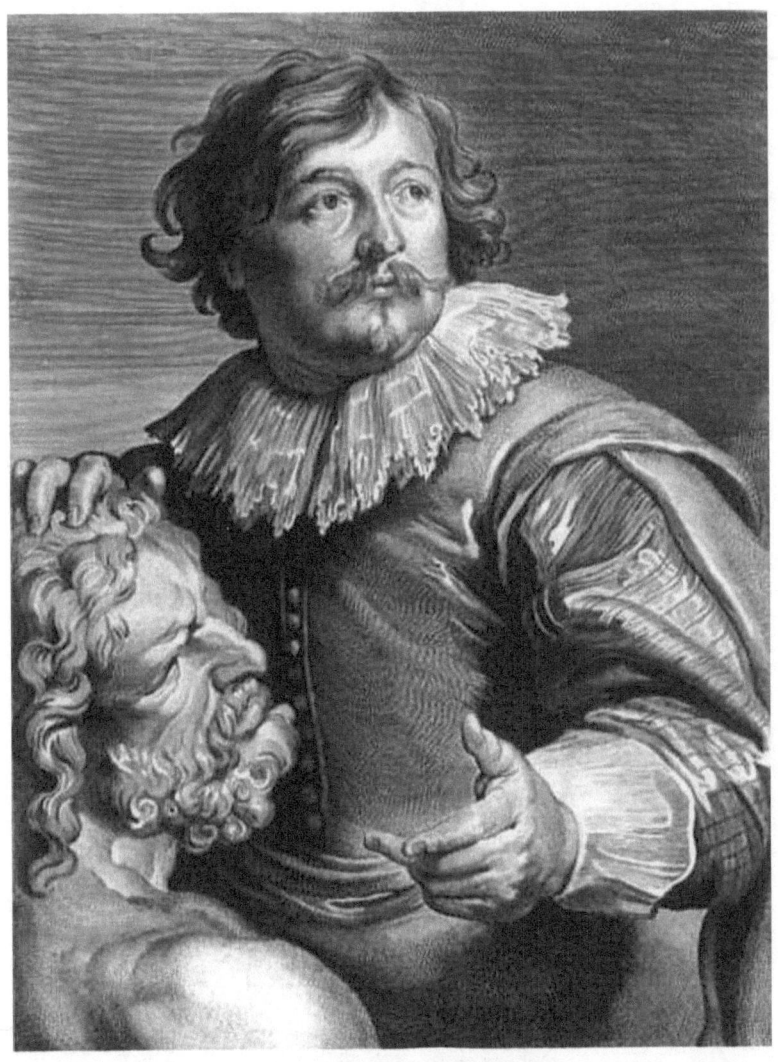

A portrait of the Flemish sculptor Andreas de Nole
(1590-1638), print

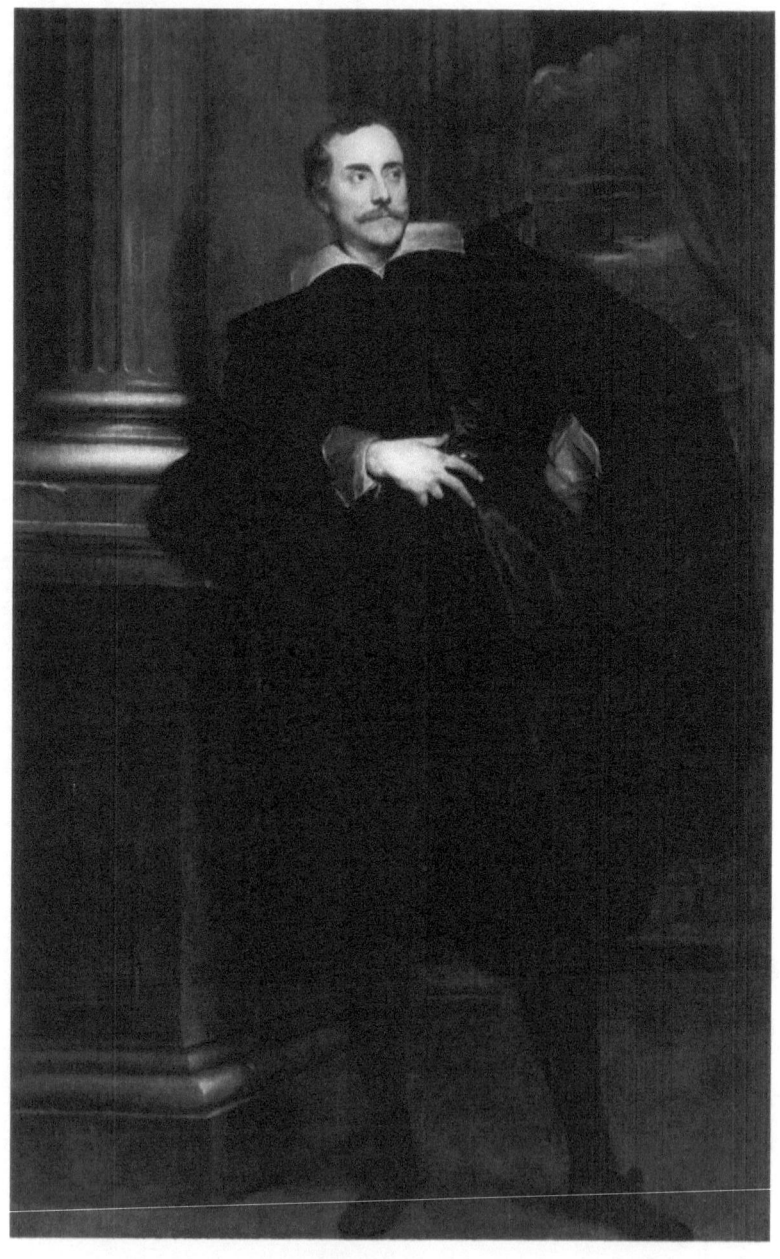

Portrait of Marcello Durazzo, oil on canvas

Anthony van Dyck

During his first three years in Genoa, Van Dyck was paid for portraits of Marcello Durazzo and his wife Caterina Balbi (now in Genoa). The traditional configuration features celebratory elements, such as the column and drapes, but the relaxed execution and the nobleman's insouciant pose point to a new and entirely individual sensitivity. With his usual freedom, Van Dyck painted this Genoese marquis leaning against a pillar in a relaxed and negligent pose; yet the keen, forceful gaze also suggests the nobleman's spirited, imperious character.

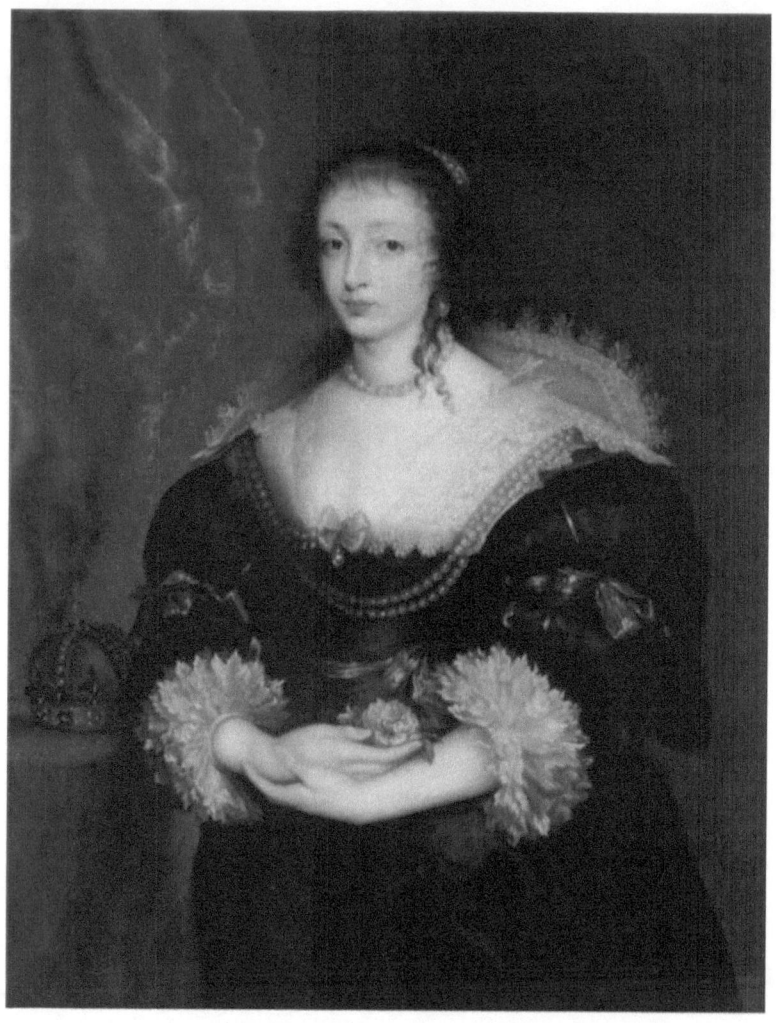

Portrait of Queen Henrietta Maria, oil on canvas

Anthony van Dyck

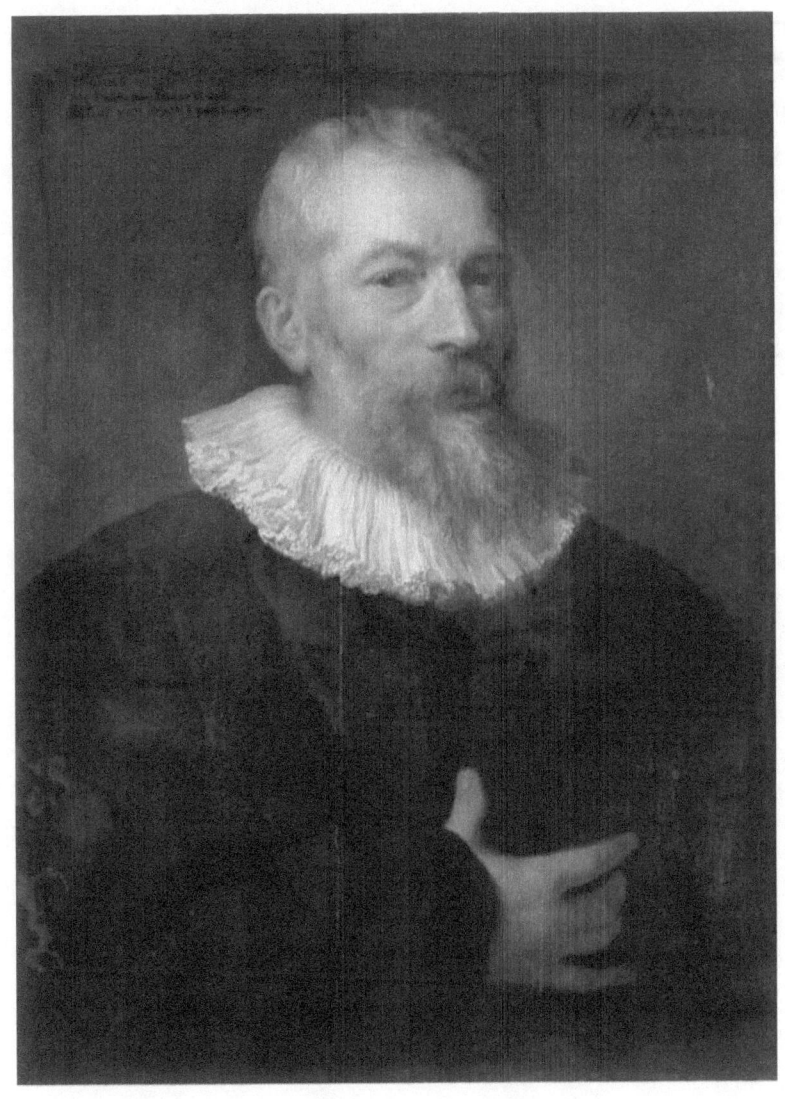

Portrait of the Artist Marten Pepijn, oil on canvas

Rubens, Van Dyck and Jordaens, often named in the same breath, are the most prominent artists of the Flemish Baroque. The trio dominated artistic life in the Southern Netherlands throughout the 17th century. All three made an enormous contribution to the fame of the city of Antwerp, but it is Rubens who bears the greatest authority, because he was the most versatile and talented. The youngest of the three great masters was Anthony van Dyck. He worked with Rubens for a time in his youth, after which he spent most of his career in England and Italy. He was even more admired in England than in his own country, and he had a significant influence upon English painting. Van Dyck's oeuvre, less varied than that of Rubens, consists mainly of brilliant portraits. His sensitive personality and restless temperament were brought to bear in penetrating psychological studies of members of leading families, the nobility and royalty. His sober Portrait of Marten Pepijn shows the artist as an energetic man of fifty-eight years, depicted in a black jerkin with a refined pleated collar.

Anthony van Dyck

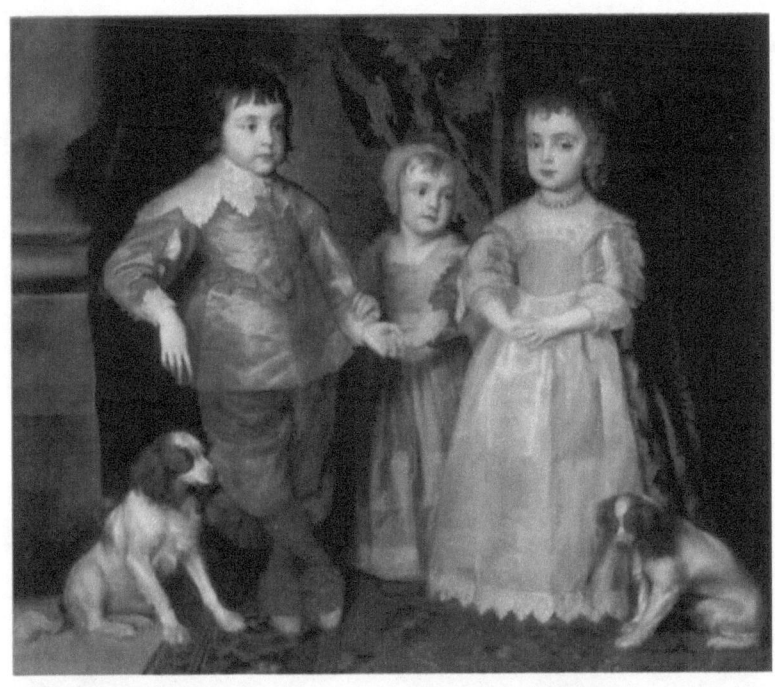

Portrait of the Three Eldest Children of Charles I, oil on canvas

Jessica Findley

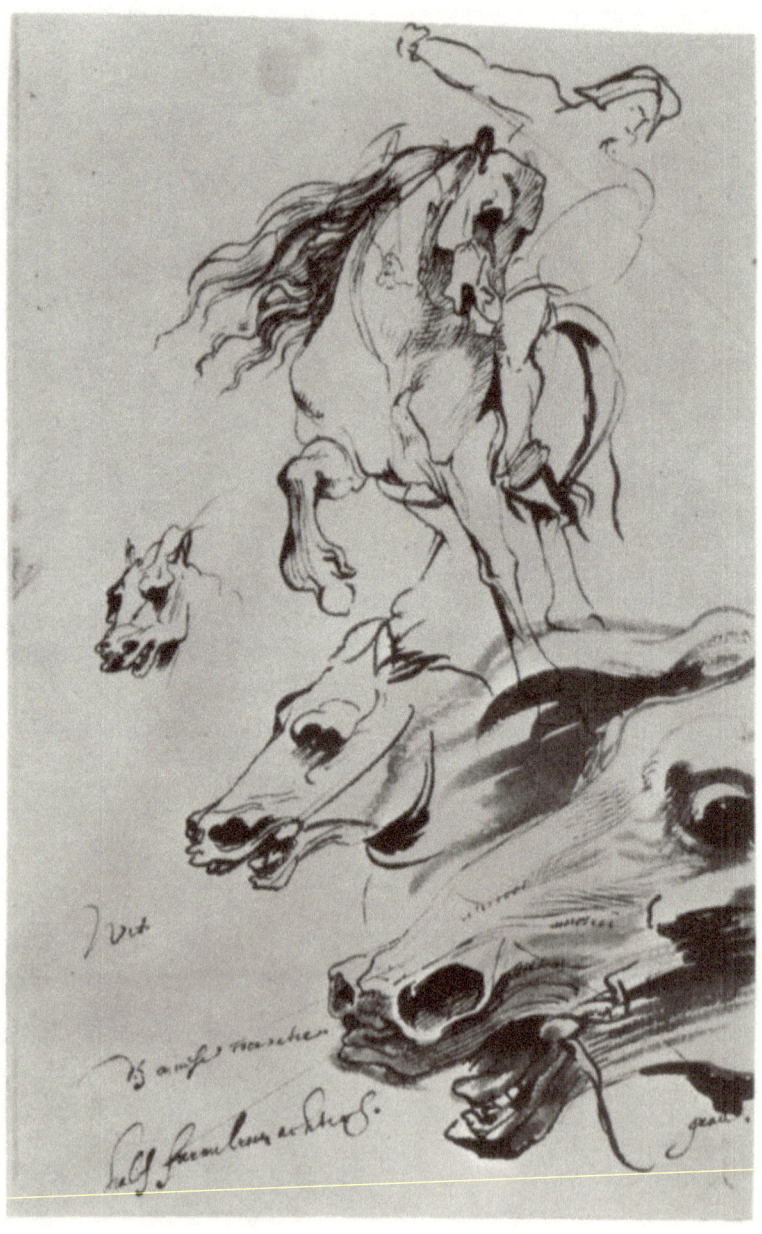

Study sheet with horses and rider's heads, Pen, brush and brown ink, on paper

Anthony van Dyck

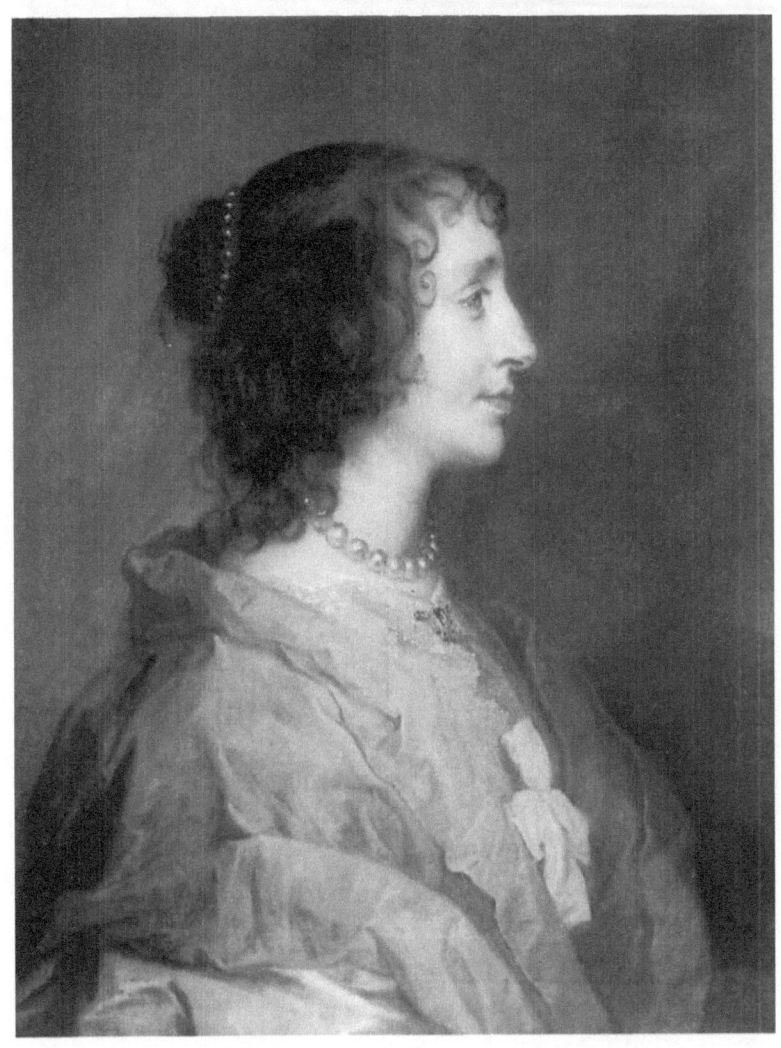

Queen Henrietta Maria, oil on canvas

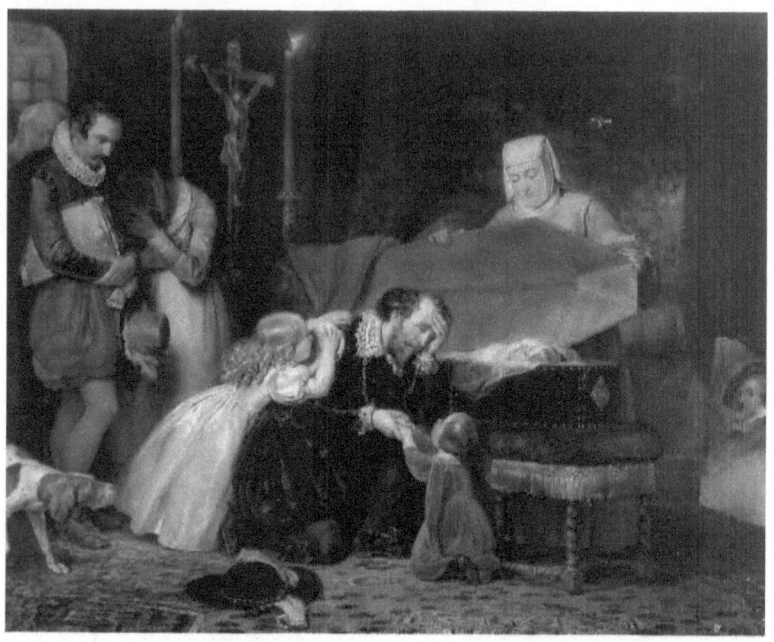

Rubens mourning his wife, oil on canvas

Anthony van Dyck

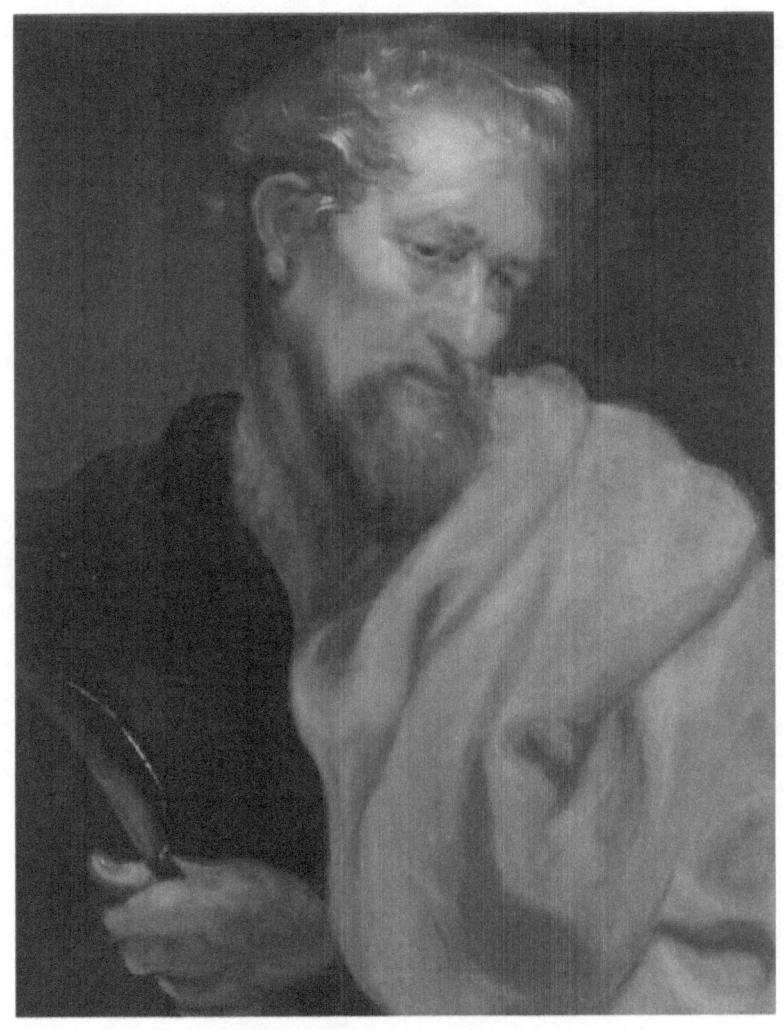

Saint Bartholomew, oil on canvas

Jessica Findley

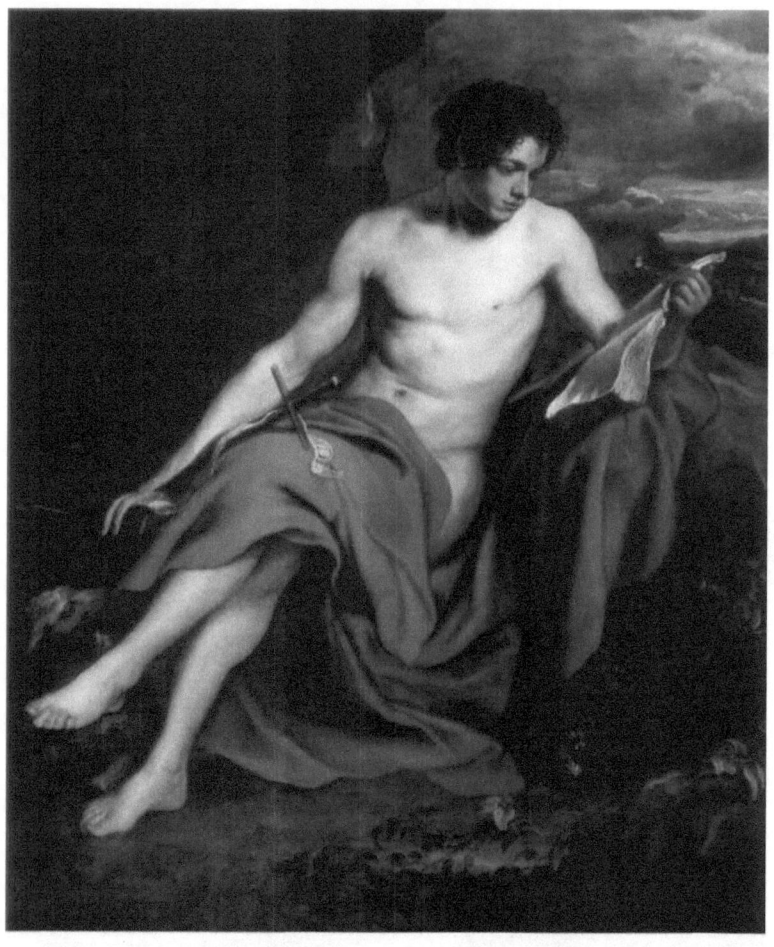

Saint John the Baptist in the Wilderness, oil on canvas

Anthony van Dyck

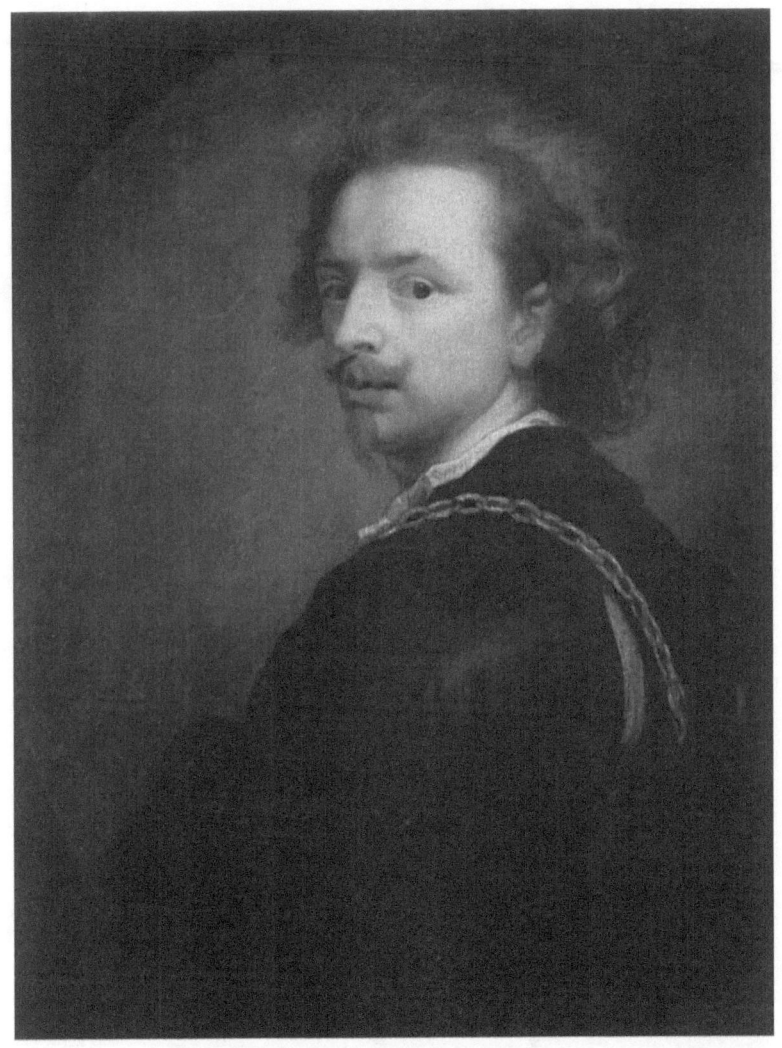

Self-portrait, oil on canvas

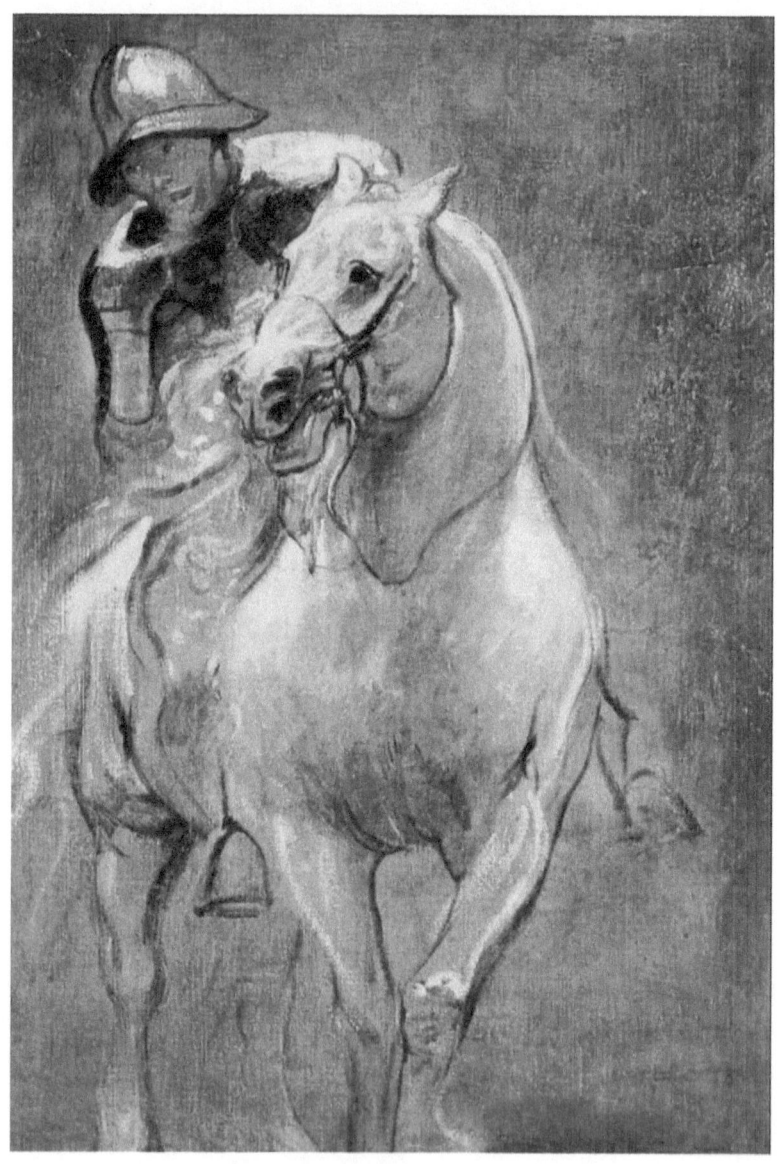

Man on Horseback, chalk

Anthony van Dyck

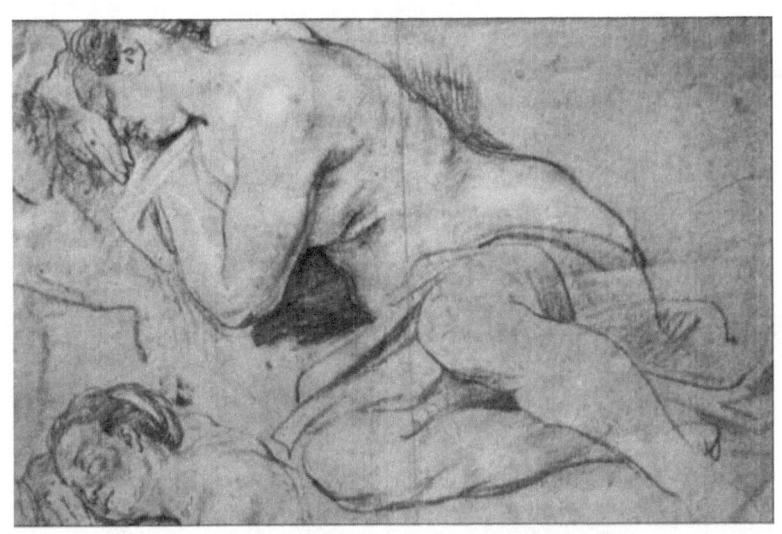

Studies of a Woman Sleeping

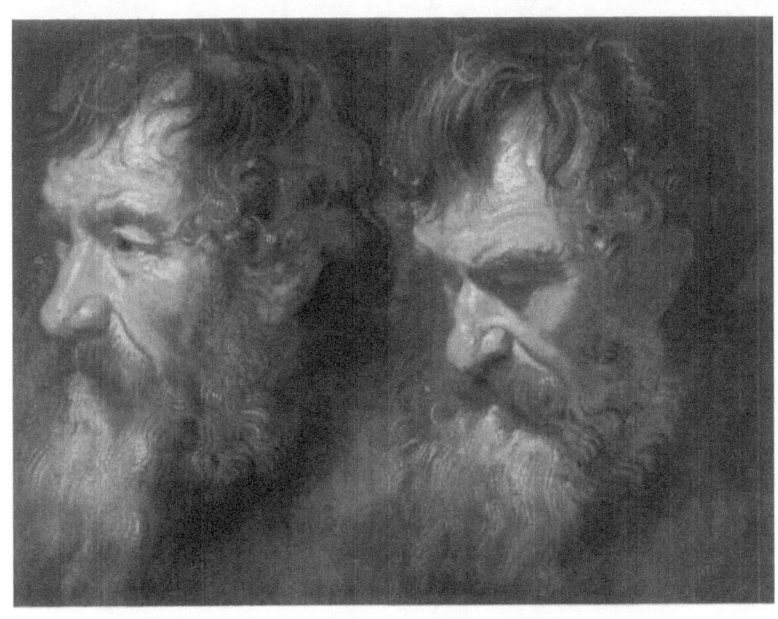

Studies of a Man0s Head, oil on canvas

Jessica Findley

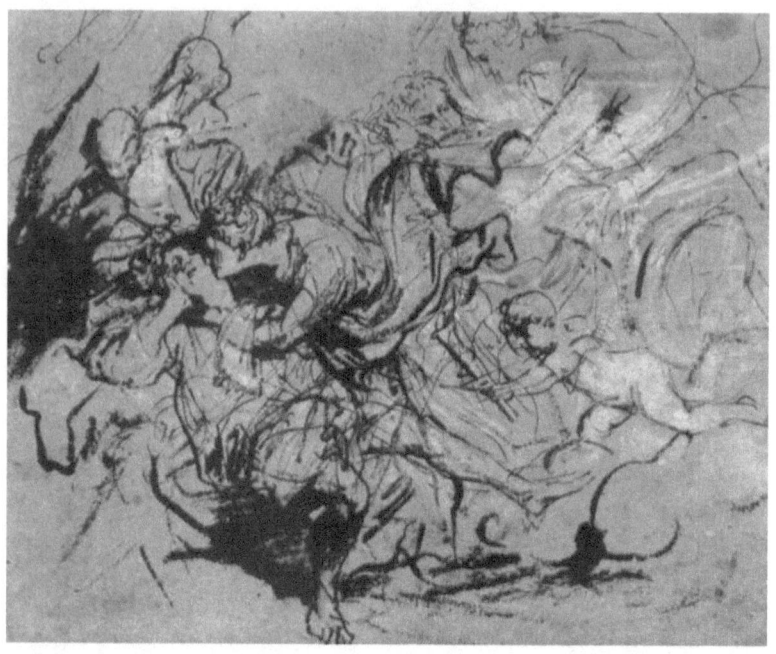

Diana and Endymion, Pen and brush, heightened with white, on blue-gray paper

Anthony van Dyck

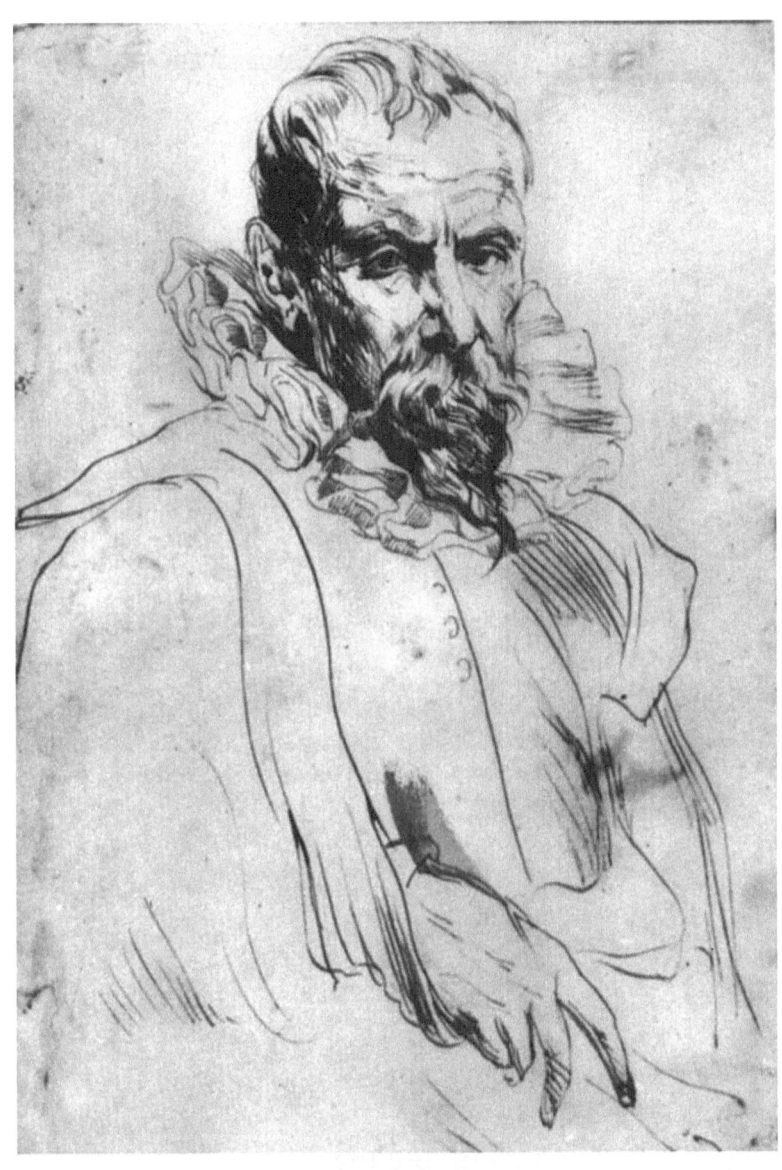

Portrait of Pieter Bruegel the Younger, Pen drawing

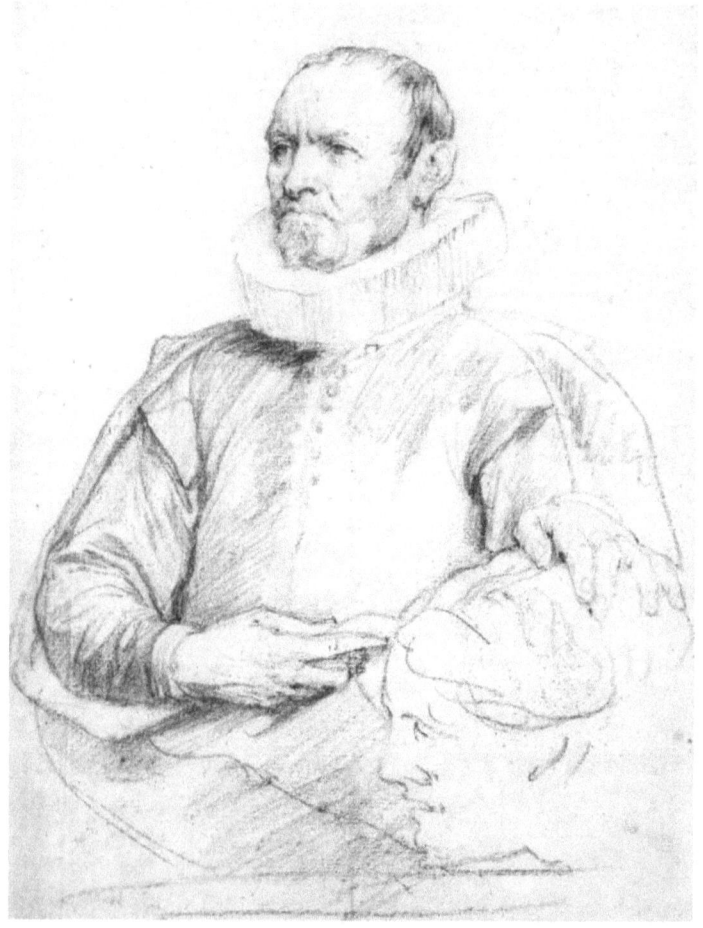

Nicolaas Rockox

Nicolaas Rockox (1560-1640) was the burgomaster (mayor) of Antwerp. His fame is largely attributed to his friendship to Rubens and the commissions he gave to this artist. His 17th-century patrician is housing a fine collection of Flemish art.

Anthony van Dyck

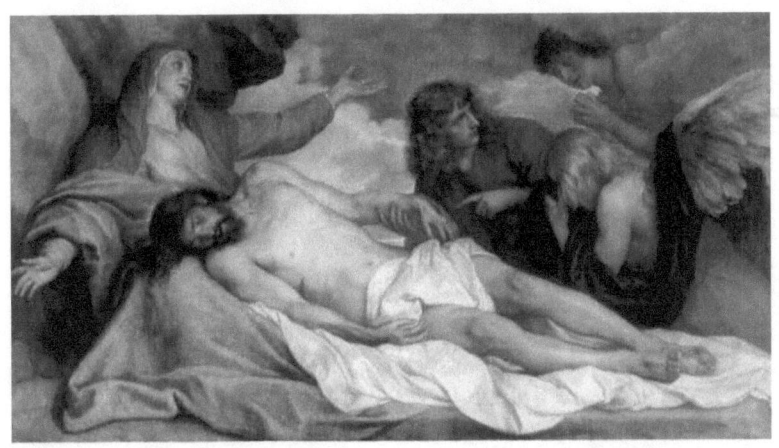

The Lamentation of Christ, oil on canvas

Jessica Findley

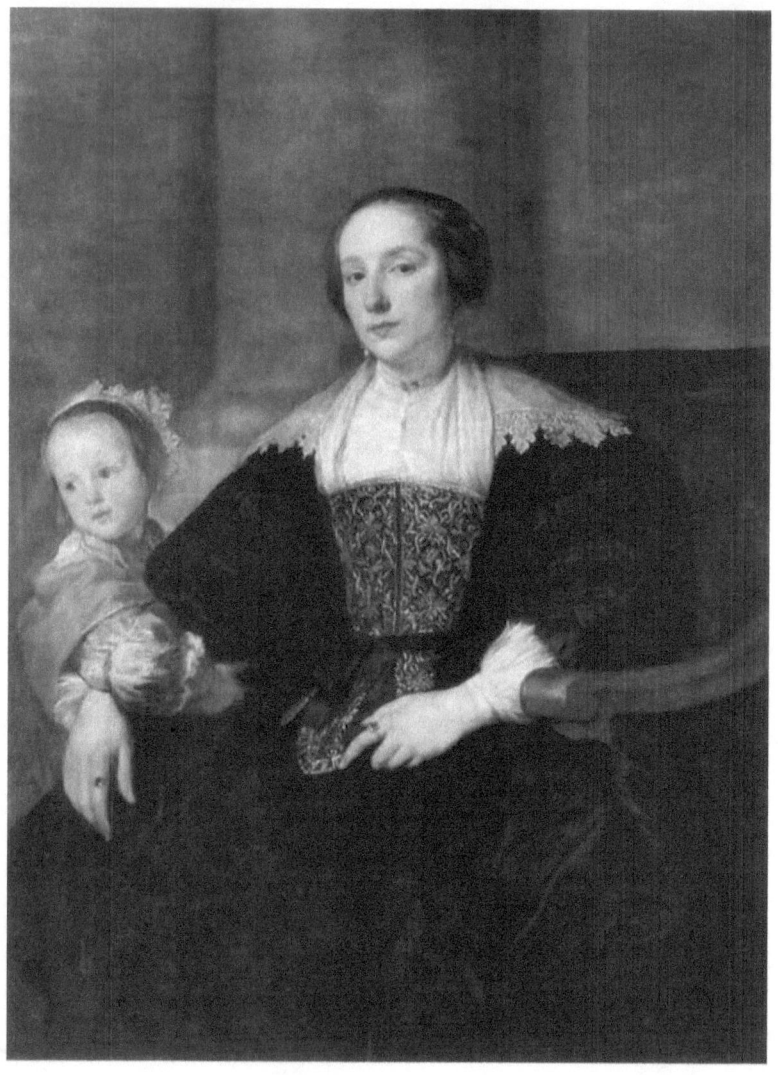

The Wife and Daughter of Colyn de Nole, oil on canvas

www.ingramcontent.com/pod-product-compliance
Lightning Source LLC
Chambersburg PA
CBHW032341200526
45163CB00019BA/2757